clementine hunter

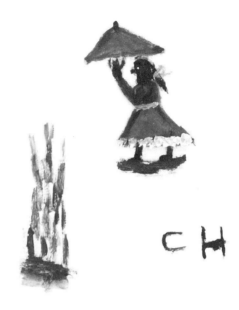

# clementine hunter

her life and art

*Art Shiver* *Tom Whitehead* (signatures)

## Art Shiver and Tom Whitehead

LOUISIANA STATE UNIVERSITY PRESS )|( BATON ROUGE

Grateful acknowledgment is made to the Cane River National Heritage Area and to the Jack and Ann Brittain family for supporting the publication of this book.

Published by Louisiana State University Press
Copyright © 2012 by Louisiana State University Press
Manufactured in the United States of America
First printing

DESIGNER: Michelle A. Neustrom
TYPEFACE: Whitman, text; Copse, display
PRINTER: McNaughton & Gunn, Inc.
BINDER: Acme Bookbinding

LIBRARY OF CONGRESS CATALOGING-IN-PUBLICATION DATA

Shiver, Art, 1946–
    Clementine Hunter : her life and art / Art Shiver and Tom Whitehead.
        pages cm
    Includes bibliographical references and index.
    ISBN 978-0-8071-4878-5 (cloth : alk. paper) — ISBN 978-0-8071-4879-2 (pdf) — ISBN 978-0-8071-4880-8 (epub) — ISBN 978-0-8071-4881-5 (mobi)  1. Painters—United States—Biography. 2. African American painters—Biography.  I. Hunter, Clementine Criticism and interpretation. II. Title.
    ND237.H915S55 2013
    759.13—dc23
    [B]
                                                                                2012011755

The paper in this book meets the guidelines for permanence and durability of the Committee on Production Guidelines for Book Longevity of the Council on Library Resources. ∞

For Our Parents

Geneva and Frank Shiver
Grace and R. T. Whitehead

# Contents

# Foreword

PROPER STUDY AND APPRECIATION of the life and art of Clementine Hunter may be likened to the experience of holding a kaleidoscope up to the light and watching its multiple surfaces refract through the movement of reflected light in time and space. Hunter's life and art deserve study from different perspectives because there are so many fascinating entry points to her life: self-taught artist, memory painter, diarist, woman, southern African American, and American artist, among them.

Hunter was sixty-seven years old when she undertook her most ambitious artistic work: painting the African House Murals at Melrose Plantation, a project conceived by François Mignon, the plantation's curator. Hunter's understated acceptance of the commission—"I don't mind," she reportedly said—suggests that she felt up to the challenge. She took on the daunting project at an age when most women are on a reduced work schedule or retired, but even more extraordinary than the physical and mental energy she summoned to complete successfully the nine large panels that would cover the four walls of the room was the speed at which she did it: six weeks during one hot summer, June 8–July 21, 1955.

Like that of many self-taught artists, Hunter's artwork arose from the well-springs of experience, imagination, and talent. Expressing themselves in a singular, direct style, Hunter and others were designated "American folk artists," a category that garnered attention early in the twentieth century (1910–20) with the emergence of a canon based on art historical criteria.

In 1910 precisionist artist Charles Sheeler began to study Pennsylvania folk art, architecture, and Shaker design. As participants of Hamilton Easter Field's Ogunquit (Maine) School of Painting and Sculpture and nearby artists' colony (1913), modernist artists such as Marsden Hartley, Bernard Karfiol, Yasuo Kuniyoshi, Gaston Lachaise, Robert Laurent, Niles Spencer, and Wil-

liam Zorach became fascinated with Americana. The artists were intrigued by the nineteenth-century weathervanes, decoys, toys, chalk figures, artisan portraits, and hooked rugs that decorated the fishing shacks they occupied. *Americana*, the term Field gave these vernacular objects, was also collected by artists Peggy Bacon, Alexander Brook, Charles Demuth, and Elie Nadelman. Nadelman and his wife, Viola, were such enthusiastic collectors, they opened the Museum of Folk and Peasant Arts (1926) on their estate in Riverdale, New York. The pared-down formal style of these works as well as the directness of the expression, subject matter, and handling of materials resonated with modernist aesthetic sensibilities.

Further reflecting the popularity of American folk art were the Whitney Studio Club exhibition organized by Henry Schnakenberg (1924) and the Early American Art Exhibition of American Folk Painting (1930) in connection with the Massachusetts Tercentenary Celebration, organized by three Harvard University undergraduates. By 1929 the contemporary art dealer, Edith Gregor Halpert, whose artist husband, Samuel, summered at the Ogunquit colony (1926), introduced American folk art at her New York City Downtown Gallery. Recognizing enthusiasm for the art, Halpert, Holger Cahill, and Beatrice Goldsmith founded the American Folk Art Gallery within it (1931).

The person most responsible for codifying American folk art using art historical aesthetic criteria was Holger Cahill, who early on curated two exhibitions of American folk painting at the Newark Museum: "American Primitives: An Exhibit of the Paintings of Nineteenth Century Folk Artists" (1930) and "Folk Sculpture: The Work of Eighteenth and Nineteenth Century Craftsmen" (1931). Cahill built on the momentum these exhibitions generated by organizing the Museum of Modern Art (MoMA) exhibition "Art of the Common Man in America, 1750–1900" (1932), whose catalog essay discusses self-taught American artists and craftsmen discovering individual qualities within communal traditions and contexts.

In his book "Masters of Popular Painting" (1938) Cahill claimed that folk art was based on early craft traditions with historical precedents; he broadened this notion to emphasize the highly personal and unique styles of self-taught artists. Cahill named nineteenth- and twentieth-century artists who interested early collectors and museum professionals: Edward Hicks, John Kane, Lawrence Lebduska, Joseph Pickett, Horace Pippin, and Patrick Sullivan were exhibited as popular painters, an American response to France's Douanier,

Henri Rousseau, first noticed by Pablo Picasso and his friends. Alfred Barr, director of the Museum of Modern Art, never called the talented painters in the book "folk artists." Cahill referred to them as "Artists of the People." Like their anonymous predecessors, they were all self-taught.

In 1937 twelve carved works by the self-taught Tennessee artist William Edmondson were exhibited at MoMA, the first public exhibition of work by an African American. Two years later the New York art dealer Sydney Janis, an ardent supporter of contemporary self-taught artists and active on MoMA's Advisory Board, launched a project called "Contemporary Unknown American Painters," consisting in part of an exhibition in the Member's Room of the museum. The same year an idealistic southern artist named Charles Shannon, an affiliate of the New South Art Center, met Bill Traylor on the streets of Montgomery, Alabama, and began collecting his drawings. Shortly thereafter, Janis wrote and self-published *They Taught Themselves: American Primitive Painters of the Twentieth Century* (1942), a book that featured thirty painters, among them Morris Hirshfield, John Kane, Anna Mary Robertson "Grandma" Moses, Joseph Pickett, Horace Pippin, and Patrick Sullivan.

Grandma Moses's first solo exhibition, "What a Farm Wife Painted," was at Galerie St. Etienne, New York, New York, in October 1940. She was "discovered" by collector/engineer Louis Caldor, who first noticed her paintings hung along with her jams, jellies, and baked goods at Thomas's Drug Store, Hoosick Falls, New York. Caldor bought a number of Moses's paintings and brought them to New York City to enlist interest and support of gallerists for her artwork.

The earliest documentation of Hunter's paintings was in François Mignon's *Louisiana Journal*,[1] in December 1939, but Hunter has been recognized as an artist since her paintings were shown in an informal exhibition by the Baton Rouge artist and professor of fine art Edith Mahier (1944). The show, arranged in Mahier's Norman, Oklahoma, home by James Pipes Register, was open to members of University of Oklahoma community. A few months later her work was shown in an exhibition at East Central State College (Ada, Oklahoma) and in women's garden club showings in Brownwood and Waco, Texas (1945). Mignon's excitement about Hunter's work displayed on the second floor of African House was shared by a group of African American teachers he brought to see it (1955).

Hunter's first major exhibition outside Louisiana was in 1952 at the Saturday Gallery, St. Louis, Missouri. Later came a public showing at the People's

Art Center, St. Louis, January 1953, the first African American venue to show Hunter's paintings, and two years later at the Delgado Museum (currently the New Orleans Museum of Art).

The American Folk Art Museum opened in 1961. In 1970, under the name Museum of American Folk Art, its first curator, Herbert Waide Hemphill Jr., an enthusiastic advocate for self-taught artists, organized the seminal exhibition "Twentieth Century Folk Art" followed by the book *Twentieth Century American Folk Art and Artists* (1974), which identified 145 self-taught artists he deemed contemporary folk artists. Included among them Clementine Hunter was firmly ensconced within the canon of American self-taught artists, further defined as artists with strong personal vision and style. Convinced of the aesthetic merit of the work of these artists and eschewing terms like *naive* and *primitive* as pejorative, Hemphill was pivotal in garnering their wider respect and acceptance. He called them contemporary American folk artists. In 1973 the American Folk Art Museum exhibited "Louisiana Folk Paintings," featuring three southern African American artists: Bruce Brice, Clementine Hunter, and Sister Gertrude Morgan. In the same year, on the West Coast, the Los Angeles County Museum of Art recognized Hunter in the exhibition "Two Centuries of Black American Art."

Robert Bishop, director of the Museum of American Folk Art (currently the American Folk Art Museum), included Hunter in his influential book, *Folk Painters of America* (1979), grouping her with African American artists and identifying her as a memory painter. Inclusion in Bishop's book solidified Hunter's placement within an art historical context—that of American art rooted in the seventeenth century and of a continuum that invokes the diversity, energy, and spirit of the American people. Bishop admired Hunter's paintings. For years he displayed in his New York apartment a Melrose Plantation wall-sized mural he owned.

Over forty years Hunter has been included in almost every important exhibition of self-taught American artists. She has been acknowledged in newspapers and periodicals such as *Look* (1953), *Holiday* (1966), *Ebony* (1969), and *Reader's Digest* (1975). Books and several graduate dissertations have been written about her. Television documentaries featuring Hunter were produced, and she was part of two oral history projects, one at Fiske University, the other organized by Radcliffe College, Harvard University. Many private and public museum collections in America and abroad contain her work, among them

the American Folk Art Museum (New York City), the New Orleans Museum of Art, the Ogden Museum of Southern Art (New Orleans), the High Museum of Art (Atlanta), the National American Art Museum (Washington, D.C.), the Fenimore Art Museum (Cooperstown, N.Y.), and the American Museum in Bath (England). She may be the only self-taught artist to be awarded an honorary doctorate of fine arts, certainly the only one to have been recognized with two such honors.

Hunter is among the self-taught artists in post-technological America who depicted idealized memories of a fast-disappearing earlier time. These artists —including Harry Lieberman (New York and California), Mario Sanchez (Florida), Queena Stovall (Virginia), and Velox Ward and Clara Williamson (Texas)—recorded memories devoid of pain, poverty, grief, and fear. Through art they transcended difficult life circumstance and then documented only what was good.

In "Telling Stories: Aging Reminiscence and the Life Review" scholar Kathleen Woodward cites psychoanalyst Helene Deutsch, who wrote that in emotional memory reconstruction "negative elements are often omitted . . . rendering the memory more supportive and protective."[2] In Hunter's pictures of wakes, funerals, and hospitals and depictions of chaotic events at the local honky-tonk and laborers engaged in backbreaking tasks, she diffuses the negative by showing, through a vibrant color palette and pleasing decorative patterning, the efforts of spirited people working together, sharing their lives within their community.

Hunter has often been compared to Grandma Moses, who for thirty years documented rural farm life in upstate New York. Both artists were praised in the popular press and welcomed visitors and interviewers. But they had very different approaches to painting. With the exception of two self-portraits, Moses's paintings were mostly generalized scenes, not based on specific occurrences. But Hunter's baptisms, Saturday night revelry, cotton planting and harvestings, washdays, weddings, and hospital scenes correlated with her daily life experiences. Especially in the African House Murals, she populated her paintings with people she knew, through painting what was "in her mind," using neither newspaper clippings nor book illustrations to trace and draw elements for her pictures.

Besides documenting everyday life, Hunter's African House and other Melrose Plantation murals fit into another American folk tradition that dates back

to the nineteenth century—that of artisans whose painted narratives on interior house walls were a monumental expression of early American folk arts. Rufus Porter (1792–1884), the best-known itinerant New England muralist, painted in a style distinguished by bright colors and bold design and execution. Unlike Hunter's, Porter's often fanciful murals were frescoes, painted directly onto plaster walls. But the stylistic abstraction, bright color palette, and adaptation to the large scale place Hunter's murals within this historical and not previously acknowledged context.

Hunter falls within another folk tradition—that of entrepreneurial artisan painters. Hunter often sold her paintings to support her family. Outside her small house near Melrose hung a sign "Clementine Hunter Artist 25¢ to look." Although Hunter received small compensation to paint the African House Murals, the proposal was presented to her as a commissioned work for which she was to receive remuneration.

We are especially fortunate to have contemporaneous accounts of the creation of the African House Murals that accurately identify some of the figures the artist did not paint realistically. A striking example is the artist at an easel under a tree. A viewer would logically assume this was Hunter herself, but Hunter never painted outdoors at an easel. As reported by Carolyn Ramsey in the *Baton Rouge Morning Advocate* in 1955, the artist shown painting magnolias in the Melrose gardens is Alberta Kinsey.[3] Hunter is serving drinks on a tray to Lyle Saxon, a Melrose resident, and to François Mignon. Aunt Attie is depicted driving a hearse at a funeral, and Uncle Israel is hitching his horse and buggy before heading to the Primer Rock Church, where he was the preacher.

Hunter's paintings demonstrate her remarkable flexibility as an artist. While many of the murals are vignettes similar in subject matter to those in her smaller paintings, Hunter adapted to the larger format with ease that would have eluded many self-taught and trained artists. She did not hesitate to relocate a structure for artistic and compositional reasons. She moved a large sundial to the side of Yucca House, for example, so as not to obscure its actual placement and to underscore its significance among the buildings and gardens.

The Cane River artist was not afraid to experiment. She worked in a variety of media—including creating quilts, lace curtains, and dolls—before devoting herself exclusively to painting. Her debut as a painter came from experimentation with discarded tubes of oil paint she found as she went about her house-

keeping chores at Melrose. She painted on a variety of surfaces—cardboard, window shades, even an old wood ironing board.

From 1962 to 1964 Hunter submitted to her friend James Pipes Register's experiment to infuse her art with new ideas. Although she found making abstracts more difficult and less enjoyable than narratives, she agreed to change her painting style. But after the two-year trial Hunter reverted to storytelling pictures, though she painted the occasional "abstract," as she said, "when the spirit moved her." Approaching her hundredth birthday with failing eyesight but still driven to create, she painted single images on different surfaces, including bottles and plastic containers. Hunter is without peer as a diarist of plantation life, which she so well knew from over fifty years at Melrose Plantation.

Hunter's reputation was nurtured through the advocacy of several key people—François Mignon and James Pipes Register, then Ora Williams, Ann Brittain, Mildred Hart Bailey, and Thomas Whitehead—and furthered by the writing of Robert Ryan, Shelby Gilley, and Art Shiver, among others.

The crisply written and readable *Clementine Hunter: Her Life and Art*, by Art Shiver and Tom Whitehead, is meticulously researched and includes new material about Hunter. Whitehead, who befriended Hunter in 1966, visited her weekly from 1969 until her death in 1988. In the last decade of Hunter's life Whitehead worked closely with Ann Brittain and Mildred "dede" Hart Bailey to look after Hunter and bring her art to a wider audience. Whitehead, the only living member of the tight-knit group, is the closest primary source for information about Hunter. An individual of consummate integrity and generosity, his insights are invaluable to advance Hunter scholarship. He worked tirelessly with now deceased Baton Rouge gallerist Shelby Gilley and now works independently to maintain high standards of connoisseurship, authenticating Hunter paintings and defending her oeuvre from fraudulent manipulation.

Journalist Art Shiver and Whitehead were the first to read Mignon's twenty-three thousand–page Melrose archival records, which contain over five hundred documents about Hunter and over five hundred letters between Mignon and James Pipes Register, with several dozen about Hunter, as well as the archives of Clarence John Laughlin. The authors have amplified early Hunter exhibition history by seeking out and interviewing individuals— among them collectors, gallerists, scholars—to contribute, corroborate, and correct the Hunter narrative. The open-ended study is especially important

because during the Mignon years accounts were often impressionistic and sometimes conflicting.

Hunter was one of the first self-taught artists to achieve wide recognition. Though Melrose was relatively insular, it was a mecca for artists and writers, encouraged by owner Carmelite "Cammie" Garrett Henry to spend time there. Hunter lived through the civil rights movement; while not an activist, she respected Martin Luther King Jr. As part of the underclass in the Jim Crow South, she was barred from the first solo exhibition of her paintings at the then segregated Northwestern State University in Natchitoches (1955). Through the efforts of dean Mildred Bailey and others, thirty years later Northwestern State awarded Hunter an honorary doctorate in fine arts.

Shiver and Whitehead present a fair picture of the complexity of Hunter's life and times. They clarify the date Hunter created her first documented painting (1939, not 1942), raise questions about authorship of some works attributed to her, and present photographs that show the evolution of Hunter's painting style through works never before seen, like a self-portrait holding a parasol painted on a program of her on the booklet that accompanied the 1955 exhibition at Northwestern State University. Shiver and Whitehead discuss in detail the recent Federal Bureau of Investigation's final resolution of a thorny, criminal forgery case of Hunter paintings.

Although there remains work to be done on understanding Clementine Hunter's life and work in terms of race, class, and gender, Shiver and Whitehead's volume advances Hunter scholarship in a major way.

Lee Kogan, Curator Emerita
American Folk Art Museum
November 20, 2011
New York, New York

# Preface

WHEN ONE EXAMINES CLEMENTINE HUNTER'S vast oeuvre, it becomes apparent that while she never learned the familiar language symbols one needs to write words or the syntactic rules used to construct sentences, she did discover a powerful visual vehicle of expression. Her life's work escapes the confines of the cultural hegemony of her day to reveal a view of plantation life from the point of view of the worker.

The accepted history of plantations is largely white-centric. Much is known about the owners of the great farms. Much has been written about their contributions to society, education, and culture. It is also fairly easy to find records showing how many slaves were owned and the dollar value of the enslaved human beings.[1]

What is overlooked is that just down the road and over the fence from the planter's mansion, the African and African American community of workers was also a significant part of the story of all successful plantations. Before the end of the Civil War enslaved people were customarily buried in unmarked graves. Their stories, if told at all, were recalled mostly among themselves in oral traditions. While conditions for African Americans improved during Clementine Hunter's day, the white-centric approach to the history of plantation life remained largely unchanged. Today if one takes a tour of the many plantations across the South, one hears well-intentioned docents tell the stories of the white owners, omitting the critical roles played by the black workers.[2]

At Melrose, Hunter personally experienced twentieth-century plantation life first as a laborer in the cotton fields and pecan groves and later as a domestic servant in the Big House. In the evenings she returned to her small cabin in the severely underprivileged community of blacks and Creoles. What she heard and saw on both sides of the segregation fence became the inspiration and source of her art. She painted her memories. In doing so, the artist created

a visual rhetoric that illuminates the historical shadows of life on a southern plantation.

Our search to understand who Hunter was and how she became an artist inevitably led again and again back to her paintings. For more than a decade Tom Whitehead and I tracked down the artist's story. In Key West, Florida, we met Whitfield Jack, who grew up near Melrose and spent his summers at his grandparents' Cane River retreat. Jack first met François Mignon and Clementine Hunter when he was a child. When we first visited with Jack, he owned one of Hunter's most famous early paintings, *Bowl of Zinnias,* the centerpiece of the 1952 Saturday Gallery show in St. Louis (see Plate 28).

Eventually, our search led to Armand Winfield at his home in Albuquerque, New Mexico. As owner of the Saturday Gallery, Winfield and Louisiana photographer Clarence John Laughlin were responsible for the St. Louis exhibition. A few days after the Saturday Gallery show, the paintings were loaned to another St. Louis art venue, resulting in Hunter's first exhibition to a primarily African American audience. Winfield, who died not long after our visit, helped us piece together missing elements of the important Saturday Gallery story.

In lower Manhattan in New York City we were invited into a penthouse gallery inside the private home of one of America's foremost collectors of Hunter's art. Likewise, only a few miles from Melrose Plantation Iris Rayford gave us access to an incredible collection of Hunter's early art that hangs in her Cane River home. Collectors in Shreveport, New Orleans, and Natchitoches allowed us access to their collections. The Ann and Jack Brittain family, long associated with Hunter and Melrose, permitted us to explore and use whatever we needed from their significant collection of Hunter's art, a collection that spans the artist's entire painting career. At Knox College in Galesburg, Illinois, the curator of the college archives, Carley Robison, revealed to us a "lost" quilt and window shade painting very few people had ever seen. Security reasons do not permit us to thank everyone by name, but without the help of others, we could not have produced the book you hold in your hands.

We owe much for the help given to us by everyone at the Watson Memorial Library at Northwestern State University in Natchitoches. Especially, we would like to thank the Cammie Henry Research Center's chief archivist, Mary Linn Wernet, who often stopped what she was doing to come to our aid. Also, Sonny Carter, the library's webmaster, proved invaluable in helping us

locate old pictures and documents. He also digitized the Bailey oral history audiotapes and updated them to current technology.

We are grateful to the staff of the Southern Historical Collection, Wilson Library, at the University of North Carolina at Chapel Hill. All of François Mignon's fifteen linear feet of gems and junk are housed there, and the library staff's assistance proved invaluable as we sifted fact from fiction from more than seventeen thousand pages of journal and six thousand pages of correspondence.

Photographer Gary Hardamon came to our rescue when we needed professional photographic expertise with the many pictures of Hunter's paintings.

We wish to thank Louisiana State University Press. Mary Katherine Callaway, the press director, recognized the value of Hunter's story and gave life to this book. Margaret Lovecraft, acquisitions editor, worked with us to improve our effort and make it better in every way.

I am forever grateful for the support, love, and understanding provided by my wife, Margaret.

Finally, I wish to thank my friend and writing partner, Tom Whitehead. Tom knows more about Clementine Hunter than anyone. When he introduced me to the artist some thirty years ago, I had no idea we had taken the first step on a journey that ends with this book. Tom's passion for the truth and his attention to detail allow me to say confidently: this *is* the story of Clementine Hunter, Cane River artist.

Art Shiver

clementine hunter

# Introduction

Tom Whitehead

THE FIRST TIME I MET CLEMENTINE HUNTER was in the spring of 1966. Ora Williams, an English teacher at Northwestern State University in Natchitoches and the supervisor of my student worker's job in the television studio, invited me to go with her and an international student from Taiwan out to Melrose Plantation.

We first stopped at Clementine's small cabin located across the road from Melrose. I met the artist and bought my first painting for three dollars, a bowl of zinnias. Then we drove around to Melrose and visited François on the porch of Yucca House. Little could I have imagined how the events of that simple afternoon trip would shape the next forty years of my life.

Before graduating in the spring of 1967, I made several more trips out to see Clementine and bought two more paintings. Those three paintings and the awe of this petite, aged black lady painting around a potbelly stove intrigued me. When I returned to teach at Northwestern State in July 1969, a weekly odyssey began that lasted from that visit to Hunter's cabin through three more moves the artist made over the next eighteen years.

The last time I visited her was in early December 1987, prior to departing on a three-week trip to England and Africa. It was on that trip I got word in early January 1988 that Clementine had died. My father called me in Mombasa, Kenya, to tell me, "Your friend has died." Within an hour I picked up the *International Herald Tribune*, and from where I was, half a world away, I read her obituary.

My story of a close friendship with Clementine Hunter and life in the historic community of Natchitoches and Cane River stretches the imagination. I have inherited the mantle of being the "Hunter Authority" after so many others who held this honor have passed away. I had never thought of my stew-

ardship role until the past few years and now see an expanded obligation to document and protect Clementine Hunter's story and her work.

The list is long of those who proceed me: Alberta Kinsey, François Mignon, James Register, Carolyn Ramsey, Clarence John Laughlin, Dr. Bob Ryan, "dede" Bailey, Ann Brittain, and Shelby Gilley. Some played larger roles than others, but all of us valued the work and life of Clementine Hunter. Some of us acquired impressive Hunter collections, but few, if any, ever made great sums of money from paintings. Most collections have been handed down in families or donated to museums. Shelby Gilley was the only commercial dealer, and he often ended up keeping the best pieces for his personal collection.

We supplied the artist with paint, boards, and brushes, and she produced art. I can honestly say I don't think Clementine ever bought art supplies. The tradition began with the Louisiana artist Alberta Kinsey, who first gave her leftover paints to Clementine. With the dabs of color from Kinsey's used paint tubes, Clementine searched and found cardboard and boards around the house, and she began to paint. Mignon and Register were the first to recognize her talent, and they encouraged and supported her early efforts. All of us through the years delivered supplies, and Clementine Hunter delivered art.

Bailey, Brittain, and I always paid whatever the artist asked for her pictures. I think everyone sold a piece or two to friends or folks that wanted a Hunter, but any "profit" went back into art supplies. I decided a few years ago that I would not buy or sell Clementine Hunter's art. On the occasion of my death my extensive collection will pass to museums for the entire world to see and enjoy in the years ahead.

For me Clementine's story is more than pictures on boards; it is the story of the most remarkable person I ever met. She was blessed with an innate brightness beyond what could be taught in a classroom. Her art is filled with examples of her wit and talent. She was not educated, she never traveled, she never had an art lesson, but Clementine Hunter taught me much. I learned from her that intelligence, wit, and talent arise sometimes from the least likely among us.

Her works inspire others in ways no one could have imagined when this all started at Melrose in the late 1930s. I recently proofread a chapter on Clementine in a new elementary math textbook that uses the works of modern artists in teaching math skills. Paintings by Picasso, Matisse, O'Keeffe, Warhol, Lichtenstein, and other modern masters are there alongside a Hunter church scene. An ensemble musical company tours nationally each spring featuring

the story of four African American women, and one is Clementine. Photographer Bruce Weber selected Hunter and her paintings as the cover for one of his annual *All-American* magazines. The movie musical *Camp* has an elaborate production number with the song "Century Plant." The first lyric is about Clementine Hunter starting to paint after age fifty. Scholars and students often contact me for information about Clementine when they are writing and researching papers.

Inspired by Hunter's African House Murals, English composer Martin Ellerby composed a concerto for woodwinds and brass that premiered in Natchitoches in the spring of 2011. His remarkable piece was commissioned by and dedicated to the hundredth anniversary of the Northwestern State Band. Ellerby said he was drawn to the rhythm of Hunter's images. "They seem to come alive in celebration of dance and color, but also encompass a darker and more spiritual truth that their initial innocence somewhat shrouds," he said. I sat in the audience that Sunday afternoon listening to Ellerby's composition and recalling my friend the artist. I was so proud for her. She has become an inspiration for so many and in so many ways.

The American avant-garde stage producer/director Robert Wilson conceived an opera based on Clementine's life. An opera! *Zinnias: The Life of Clementine Hunter*, with music by Dr. Bernice Johnson Reagon and her daughter Toshi Reagon, resulted from Wilson's visits to Melrose as an eleven-year-old child. Hanging today in his collection is the painting he bought from the artist in 1952 for twenty-five cents. Wilson's plans for the opera include a premiere in the winter of 2013, with plans for performances at prestigious venues around the word.

If only Mignon, Register, Bailey, and the others were alive to see and hear that twenty-five years after Clementine's death, her story is still being told. And if Clementine were here, well, she would have been absolutely unimpressed by all the recognition and fame.

I am reminded of the time Mary Johnston, the wife of the former Louisiana senator J. Bennett Johnston, arranged for Clementine to fly to Washington, D.C., to meet president Jimmy Carter. When Clementine was told about the trip, she studied the idea for a moment then said, "If Jimmy Carter wants to see me, he knows where I am." That was the Clementine I knew.

The quest to prevent and stop forgeries of her work has grown into what I consider an obligation to the memory and integrity of the artist. While she

was alive, there were some fakes being done of her paintings, but since her death the market has seen hundreds of paintings by several other forgers appear. More writing and exposure is needed to make it easier for collectors and authorities to discern a fake and cease the duping of innocent people trying to acquire an original Clementine Hunter painting.

We offer this book as a comprehensive source of what is known about the life and art of Clementine Hunter. From my personal files I have indexed documents, letters, audio, video, and paintings, all of which will someday become publicly accessible. My records, as well as those from libraries and interviews, make this book the most researched effort yet for collectors, scholars, and those who just wish to read a true and treasured American story about my friend Clementine Hunter.

# A Moment of Recognition
May 17, 1985

Honey, I never studied here, but I have been studying all of my life.
— Clementine Hunter, speaking to Leo Honeycutt,
  Baton Rouge television reporter

CLEMENTINE HUNTER SAT QUIETLY in the back of Prather Coliseum on the campus of Northwestern State University in Natchitoches, Louisiana. At ninety-eight years age caused her shoulders to stoop, and she slumped slightly in the blue, canvas-backed wheelchair. She appeared tiny and fragile. Her hands, crippled and gnarled from arthritis, lay folded together in her lap. Her ebony face, wrinkled by time and too many days working in the Cane River sun, showed little expression. She looked briefly around at the capacity crowd that had come to watch the spring graduation ceremony. On the main floor 568 candidates waited impatiently for their chance to walk across the stage and be awarded a college degree. On this Friday evening Clementine Hunter also received a degree, an honorary doctorate of fine arts, recognition for her accomplishments as an internationally celebrated southern artist.

Hunter was only the fourth person to be granted an honorary degree by Northwestern State University. She was the first African American. She was also the first person who could neither read nor write to receive such an award from Northwestern State. Her formal education had ended almost a century earlier, when she stopped going to first grade and began working in the cotton fields.

Clementine Hunter moved with her parents to Melrose Plantation in 1902, some fifteen miles south of Prather Coliseum. She was still a teenager. "Too young to be married, but not too young to work," she once said.[1] She went to work as a field hand, hoeing, picking, and chopping cotton. She spent almost half of her life working in the fields and eventually as a domestic servant in the

Big House at Melrose before discovering her talent for painting in the late 1930s.

On this graduation day in 1985 Clementine Hunter, the self-taught artist from Louisiana's Cane River region, may not have been a household name, but she was well-known to art collectors and museum curators around the world. She was famous. Her colorful representations of bygone plantation days, which had once hung on the bare walls of tenant farmers' shacks, were now proudly displayed on the walls of simple American homes as well as tony Beverly Hills mansions. As art experts discovered Hunter's self-taught style, so too did cultural historians, who found her work illustrative of early-twentieth-century plantation life. The scholarly attention to her paintings caused prestigious museums to take notice and acquire her works. Reporters from around the world traveled to her small cabin in search of information about the house servant who became an artist. Her story appeared in *Ebony, Holiday, Look, Reader's Digest,* and scores of newspapers. Film crews from television stations captured her image and voice for posterity. Hunter's paintings were interpreted as an important narrative of twentieth-century plantation life.

Mildred Hart Bailey, dean of the graduate school at Northwestern State, was an early supporter of Hunter. Bailey, after considerable effort, convinced Northwestern State University's president, Joseph J. Orze, and the Board of Trustees for State Colleges and Universities that Hunter was worthy of the distinction inherent in the decision to award an honorary doctorate of fine arts.

The Civil Rights Act of 1965 changed a great deal in Hunter's world. In the Jim Crow days before the Civil Rights Act, the granting of an honorary degree to a person of color would never have been considered. On this campus, thirty years earlier, Hunter had not been formally invited to a one-person exhibition of her art. Hunter's friend and supporter François Mignon and Ora Williams, a professor of English on the Northwestern faculty and a Hunter friend and patron, arranged for an exhibition of Hunter's paintings to be displayed in the gallery of the Fine Arts Building on the Northwestern State campus. In those days Clementine Hunter could not go freely into a public gallery to view her creations. Early on a Monday morning, May 9, 1955, Mignon boldly challenged racial customs and arranged for Hunter, whom he called Clémence, to visit the campus and view her exhibition.

> I got my friend, Father Roble [Fr. Norbet Rosso] of St. Augustin's [*sic*], to drive little Miss Hunter and me to town this morning. Clémence was perfectly de-

lighted with all she had to see, the beauty of the gallery and the excellence of the framing, hanging, etc. On our arrival, the head of the department greeted me cordially but lapsed into an adequate but formal, "How do you do, Clementine" to Clémence. In two minutes, Clémence had a gallery trail behind her like a prize golfer and throughout she felt perfectly secure in my close company. Many of the pictures of years back she had forgotten, as we may forget having written a letter of a decade back, and her delight was bubbling. I asked her many a question about the different characters appearing in her works, how she came to select this or that subject, etc. The gallery behind us, respectful and silent as a pin, was entranced at all they had to hear. After we had made a complete round, a secretary asked me if I would kindly sign the register. I said I should be delighted, accepted the pen handed to me, and turning to the artist—to her surprise and to the amazement of the gallery—asked if she wouldn't write her name. She said—and this delighted me—that she didn't think she could write out her whole name but she could mark down her initials. I told her that would be even better, whereupon she made a sizable "C H" after which I appended my name.[2]

Mignon pointed out how happy Hunter seemed on seeing her pictures hanging in the gallery. "She could not believe they were hers," Ora Williams told Don Walker, a reporter for the *Shreveport Times* newspaper.[3] Hunter seldom expressed delight with her art, but on this particular occasion she was apparently thrilled with what she experienced. On the exhibition's program she celebrated by drawing a small self-portrait, a tiny image holding a parasol and dancing down the road.

Hunter knew firsthand the race restrictive Jim Crow days of 1955, but those close to her said she seldom spoke of race. It is unlikely she understood the irony of her being awarded an honorary doctorate from the same institution that thirty years earlier had sponsored a "whites-only" exhibition of her paintings. Mildred Bailey said years later that her motivation in getting Hunter recognized with an honorary degree arose from the fact that it "always bothered her" that because of racial segregation in 1955, African Americans were not allowed on the school's campus.[4]

During a campus reception held in the Hanchey Art Gallery before the evening graduation ceremonies, Joseph Orze read letters to Hunter from President Ronald Reagan, Louisiana governor Edwin Edwards, and United States

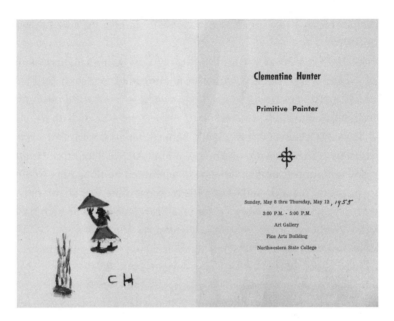

Fig. 1. Following an arranged visit to a 1955 "whites only" exhibition of her art, Hunter painted a small self-portrait on the program demonstrating the joy of seeing her paintings. It was Hunter's first visit to an art gallery and the first time she saw her works hanging in public exhibition. ANN AND JACK BRITTAIN & CHILDREN.

Senators J. Bennett Johnston and Russell Long. "Many leave their native soil to make their mark and find fame," Senator Long wrote. "But you are special in that you discovered the world around you and colored it with your own unique interpretation." The letter from Governor Edwards designated Hunter an honorary colonel on his staff. Edwards said, "Your eloquent messages, offered through the painted word, have touched the lives of so many people."[5]

Included among a processional of educators and guests, Hunter's friend Tom Whitehead, a member of the Northwestern State faculty, wheeled her to the stage for the graduation ceremony. She wore the university's traditional gown and cap with a yellow tassel. Mildred Bailey said Hunter handled the event well: "I know Clementine never really understood what was happening so far as an honorary doctorate was concerned . . . But at any rate, she was so regal and handled the whole thing as if she did this every day. She could not walk down the aisle . . . there were two of our honor students, two young men,

who helped her up the steps and she was able to stand at the edge of the stage by herself."[6]

In his brief remarks Orze told the story of the granddaughter of an enslaved woman whose career took her from field hand to famous artist. "This self-taught artist continues to be a productive memory painter and cultural historian who commits to canvas her life experiences on a southern plantation," he said. Orze went on to quote Robert Bishop, director of what was known then as the Museum of American Folk Art. "Clementine Hunter of Melrose Plantation is perhaps the most celebrated of all southern contemporary painters," he said. And finally, the moment came for the presentation. "Northwestern State University," Orze said, "is privileged to present the honorary degree of Doctor of Fine Arts to Clementine Hunter."[7]

The crowd in Prather Coliseum stood and cheered. Clementine Hunter raised her head slightly and looked around the coliseum at the approving crowd. Her rhinestone cluster earrings sparkled for an instant in the bright lights. She gently took the sheepskin handed to her by President Orze. This

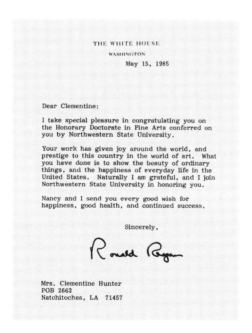

THE WHITE HOUSE
WASHINGTON
May 15, 1985

Dear Clementine:

I take special pleasure in congratulating you on the Honorary Doctorate in Fine Arts conferred on you by Northwestern State University.

Your work has given joy around the world, and prestige to this country in the world of art. What you have done is to show the beauty of ordinary things, and the happiness of everyday life in the United States. Naturally I am grateful, and I join Northwestern State University in honoring you.

Nancy and I send you every good wish for happiness, good health, and continued success.

Sincerely,

Ronald Reagan

Mrs. Clementine Hunter
POB 2662
Natchitoches, LA 71457

Fig. 2. President and Mrs. Reagan sent congratulations to Hunter for receiving an honorary doctorate of fine arts. THOMAS N. WHITEHEAD.

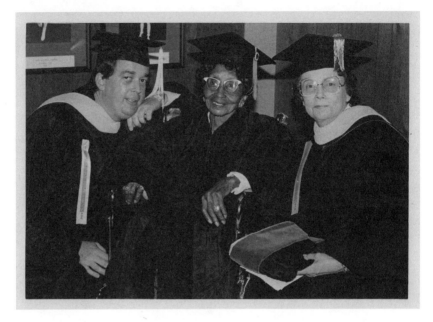

Fig. 3. Tom Whitehead, Clementine Hunter, and Mildred Bailey celebrate Graduation Day, May 17, 1985. NEWS BUREAU, NORTHWESTERN STATE UNIVERSITY OF LOUISIANA.

fragile, illiterate woman had worked hard at backbreaking labor all of her life, just as her mother and her enslaved grandmother had done. The same hands that hoed cotton, washed clothes, prepared food, and cleaned house now held an honorary college degree. The same hands, often stained from late nights painting pictures by the dim light of a kerosene lamp or a single hanging bulb, had also held the brushes that created the art that made her famous. Orze asked her if she would like to say something. Mildred Bailey recalled the moment: "There were all of those faces looking at her and there she stood, this little person. And she looked out and said, 'Thank you.' And that was it. She took her diploma, and was helped down the stairs and Tom [Whitehead] took her back down the aisle and there were people standing and applauding. She handled all of this, as I said, as though she had received an honorary doctorate every day."[8] Ora Williams remembered well that Hunter could not freely enter the whites-only campus thirty years earlier. Williams, also in a wheelchair, smiled with approval and joined the audience in the thunderous applause.

The following year, 1986, Southern University in Baton Rouge granted Hunter an honorary doctorate of humane letters. The artist was too ill and frail to attend the fall commencement ceremony. Her granddaughter Willie Mae Jefferson accepted the award on her behalf. While it is rare for a self-taught artist to be awarded an honorary academic degree, Clementine Hunter's receiving two such awards was unprecedented. The academic recognition from two universities reconfirmed Hunter's significance as an American artist and underscored the importance of the contributions she made during her long life.

# From the Cotton Fields to the Big House

I come from Marco, way down yonder.
Ain't no trees, no birds, no nothing.
—Clementine Hunter

AS CLEMENTINE HUNTER'S SIGNIFICANCE as an American artist grew, those who valued her art realized the importance of documenting the artist's life story. Mildred Hart Bailey, dean of the Northwestern State Graduate School in Natchitoches, who was instrumental in having the honorary degree granted to Hunter, also played a major role in recording Hunter's recollections of her youth and family.

Bailey first saw Hunter's paintings in the 1940s, when they were on display on the walls of Millspaugh's Drug Store located on Front Street in Natchitoches. Years later she began seriously collecting Hunter's art with plans eventually to write a book and build a Hunter museum. During the 1970s Bailey, who became a close friend of Hunter's, often visited the artist in her home near Melrose and made long, rambling recordings of the artist's memories of her family and life on the plantation. These oral histories became the only first-person account of what we know about Hunter's ancestry.

## The Artist's Family Tree

Hunter's parents were Janvier Reuben and Mary Antoinette Adams.[1] Clementine Hunter preferred the name John for her father and never used the French version, Janvier. She was born at the community of Marco, a few miles south of Cloutierville, Louisiana, on Hidden Hill Plantation.

Some still believe this was the land of the infamous Simon Legree, the cruel plantation owner in Harriet Beecher Stowe's 1852 novel, *Uncle Tom's*

*Cabin; or, Life among the Lowly.*[2] Truth seldom trumps legend in the stories passed from generation to generation. Whether Hidden Hill was the model for Stowe's Little Eva, whether Robert McAlpin was the real-life version of Simon Legree, and whether there ever was an actual Uncle Tom's Cabin will probably never be confirmed. Modern study suggests none of these details may be true. What is certain is that the timeless story of the heroic Uncle Tom and his cruel master, Simon Legree, was told and retold. Although the book was fiction not history, it was, and is, often believed to be true. At the time of Clementine Hunter's birth, some forty years later, only the legend remained. McAlpin was long dead, and the Chopin family owned and operated Hidden Hill Plantation.

Uncertainty surrounds the date of the artist's birth, but she was about three months old when she received a Roman Catholic baptism on March 19, 1887, in Cloutierville, Louisiana. The records indicate some fifteen other children were also baptized on that day. In the custom of the day priests traveled among

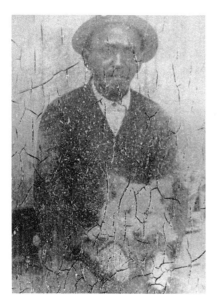 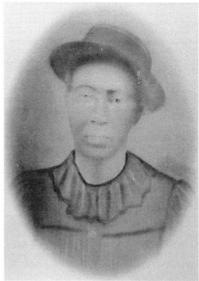

Fig. 4. Janvier Reuben, Clementine Hunter's father. CAMMIE G. HENRY RESEARCH CENTER, NORTHWESTERN STATE UNIVERSITY OF LOUISIANA.

Fig. 5. Mary Antoinette Adams, Clementine Hunter's mother. CAMMIE G. HENRY RESEARCH CENTER, NORTHWESTERN STATE UNIVERSITY OF LOUISIANA.

Fig. 6. *Uncle Tom's Cabin.* Hunter was born at Hidden Hill Plantation, which many believe was the model for Harriet Beecher Stowe's famous novel. Hunter heard the tale of Uncle Tom and painted her version of the story. THOMAS N. WHITEHEAD.

the rural communities baptizing the children born since their last visit. Often months would pass between the day of birth and a child's baptism. On several occasions Clementine Hunter said she had been born around Christmas, and there was never any reason to doubt her claim. At her baptism she was given the name Clementiam, but for half her life she used the name Clémence, a French version of her Latin Christian name.[3]

Clementine Hunter's father, John Reuben, was an African man of French and Irish descent. The first language the artist heard was the Cane River Creole French spoken at home. Hunter was well into middle age when she decided to change her name to the less French-sounding Clementine.[4] She pronounced it *Clem-en-teen,* as opposed to the more traditional pronunciation, *Clem-en-tīne.* Although Clémence was the oldest of the Reuben's seven children, she was the smallest and given the nickname Tebé, meaning "little baby." As an adult, members of her family called her Mama Tebé.

Clementine Hunter told Bailey that Billy Zack Adams was her maternal grandfather. He was a carpenter or handyman and died when he fell from a roof and broke his neck. Her maternal grandmother's name was Idole. Hunter said her grandmother had been enslaved and came to Cloutierville, Louisiana, from Virginia. When she spoke of her grandmother Idole, Hunter always said she came from "ol' Virginie."[5]

Apparently, Hunter's paternal grandfather was a horse trader of African, French, and Irish descent. "He was an Irishman," Hunter told Bailey. "He traveled everywhere," she said. She did not remember his name and never knew him. Because she did not yet speak English, Hunter probably confused Irish with European.[6] She said, her "daddy's mamma was an Indian lady [native American]." She was "a little old black Indian who wore her hair long." She claimed her grandmother lived to be 110 years old. "I knew her well," she said. "We called her Meme." Hunter told Bailey that her grandmother Meme died when a hammer she was using to hang a picture fell on her toe. "She got blood poisoning and died," Hunter said.[7]

As a young child, Clémence moved with her family from place to place, from job to job. When she was about five years old, the family moved to Cloutierville. Her father traveled several miles daily from the little community to work on a nearby plantation. When not working for the farm owner, the entire Reuben family tended their personal, small patch of cotton early in the morning or late at night. For their efforts they received as payment a tiny percentage of the harvest's sale. "We worked hard," she told Bailey, "but we did okay."[8]

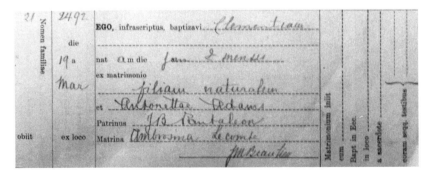

Fig. 7. Records indicate Hunter received a Roman Catholic baptism on March 19, 1887, several months after she was born. THOMAS N. WHITEHEAD.

## Education

Clementine Hunter never received a formal education. For a short time in her childhood she attended St. Jean Baptist Catholic Church School. The white and black children attended classes in separate buildings, and outside there was only a fence between them. At lunchtime or recess, around the fence, fights would break out between the two races of children.[9] Young Clémence expressed her dislike for the fights and the restrictions imposed on the students by the nuns. She longed for the freedom she found in the fields. On more than one occasion she claimed she enjoyed the freedom when working in the sun. Hunter told the story of asking Sister Benedict, the nun in charge of her first grade class, if she could get a drink of water, but rather than stopping at the cistern for a drink, she ran home. She said her mother spanked her and sent her back to school.

Running away from school, being punished, and sent back apparently happened on numerous occasions. In another story Hunter said Sister Benedict

Fig. 8. *Melrose Plantation* by Alberta Kinsey. ASSOCIATION FOR THE PRESERVATION OF HISTORIC NATCHITOCHES.

wanted to prevent her from eating a slice of salt pork she had in her lunch bucket. Catholic religious law in those days forbade the consumption of meat on Friday. Young Clementine refused to give up her piece of pork and found herself in trouble again. "Sister Benedict was mean, mean," she said.[10]

She eventually convinced her parents she would be more valuable working in the fields than going to school. "They tried to keep me in the schoolhouse, my folks did," she said. "I was a mean little girl. I'd run out of that building every time."[11] Even as child, she was a hard worker, and there was no doubt the family needed all the help they could get scratching out an existence from their meager sharecropper's income.

Her elementary schooling lasted less than a year; the only other schooling she attempted took place after she was a teenager, when she attended a few night classes in a home on Melrose Plantation.[12] Just as she had when she was a child, she decided she was learning nothing and stopped going to class. Clementine Hunter never learned to read or write. While she seemed to have a limited understanding of how to count money, there was no indication she understood simple arithmetic.

## The Move to Melrose

In 1902 John Reuben moved his family for the last time. John H. Henry hired the Reuben family to work at his plantation, Melrose. While Melrose was only ten miles from Cloutierville, it was a world dramatically different from what the family had known. Melrose was a self-contained community where scores and scores of African Americans lived in poverty and worked hard to maintain the Henry plantation. Melrose was the most successful, most beautiful of the plantations along Cane River. Clémence was probably fifteen years old when her family moved into a cabin on the Melrose grounds.

John Reuben's decision to accept a job at Melrose and move his family proved to be the most important single event in shaping the life of his oldest daughter, Clémence. It was at Melrose where she eventually found the creative environment that fueled her talents as an artist. This did not happen immediately; more than three decades passed before she picked up a brush and painted her first picture. In the meantime she went to work in the fields.

"I love to pick cotton," Clementine Hunter told those who inquired about her days in the field. "Yes, I liked picking cotton, hoeing cotton. I just liked it."

She said when she was picking cotton she would sing or pray to pass the time. She picked cotton from midmorning, after the overnight dew had dried, until late in the day, sometimes after sunset. When you pick cotton, she said, "you don't have to think, you just do it."[13]

Mildred Bailey said she never understood why Clementine Hunter claimed it was "easier to pick cotton than it was to paint a picture": "It certainly was not the money that she made because she used to say she could pick 150 to 200 pounds a day. Now you have to pick up a cotton boll to know that is a lot of cotton. She was paid fifty cents for 100 pounds of cotton, which meant that if she picked 150 pounds of cotton, she made 75 cents that day. She made more than that from her paintings even in the very early days. I don't know why she remembered [picking cotton] as a happy occasion."[14]

In the fall, after the cotton harvest, Hunter's work continued in the pecan orchards. The plantation produced prodigious crops of unusually large pecans known as "Melrose Pecans." The ripened nuts were gathered by hand after they fell from the trees to the ground. "I liked to pick pecans too," she said. "It's hard work because you have to stoop over a lot."[15]

Many years later she painted memories of her pecan harvesting days, but the orchard days she recalled in paint were not always representative of those times when the laborers worked in sight of the overseer. She said on Sundays families would sneak into the groves and gather pecans for their personal use. Hunter painted children hanging from the limbs to shake the nuts free from the trees. She remembered these occasions, *with no overseer present,* as joyous family events.

## Husbands and Children

Clementine Hunter had two husbands and gave birth to seven children, two of whom were stillborn. Although they were never legally married, her first husband was Charles Dupree, a Creole, who was some fifteen years older than Hunter. He was said to have a sharp mind and an above-average mechanical aptitude. He was also called "Cuckoo Charlie." Their union produced two children: Joseph Dupree, known as Frenchie, and a daughter, Cora. Frenchie, her oldest child, was born in 1907, when Clementine was twenty years old. Charles Dupree died in 1914, and Clementine reared her children alone until 1924, when she married Emmanuel Hunter, a woodchopper.

Fig. 9. *Pecan Threshing.* Hunter painted many versions of her pecan-picking memories. A similar painting was selected for a 1976 UNESCO calendar. THOMAS N. WHITEHEAD.

Clementine Hunter spoke Creole French until she married Emmanuel. She said Emmanuel spoke both French and English, and he taught her to speak English. They had three surviving children: Agnes, King, and Mary (also called Jackie).

Hunter continued to work in the fields throughout the term of her pregnancies, usually returning to work a day or so following a birth. On one morning she claimed she picked seventy-eight pounds of cotton before stopping to give birth.[16] She took her children with her to the fields and put them in the shade of a tree, where they would spend the day napping and playing while she picked cotton. This was a common practice among the women who worked in the fields.

Another way the women cared for their small children was to place them in a *brandiller*, commonly called a "branie." The *brandiller*, from the French verb *to shake*, was a makeshift swing hung from a tree branch. Women could

be sure their babies would be safe, swinging back and forth in the breezes. "One day a friend of mine, Ethel, had her baby in a branie," Hunter recalled. "We looked back and the whole thing was on fire. The baby and the branie both burned up. What happened was a bird picked up a lighted cigarette and dropped it right on the cradle. Wasn't nothing anybody could have done about it."[17] Hunter said after the unfortunate incident Ethel went home, and the other women went back to work. She said at the end of the day, they told the timekeeper to give all their pay, about seventy-five cents each, to Ethel.

From the time young Clémence Reuben arrived at Melrose, she worked six days a week picking cotton in the summer or gathering pecans in the fall. Her

Fig. 10. Clementine Hunter and Mary Frances LaCour. In the 1930s and 1940s Hunter cared for a young girl who also demonstrated a talent for painting. CAMMIE G. HENRY RESEARCH CENTER, NORTHWESTERN STATE UNIVERSITY OF LOUISIANA.

husband, Emmanuel, was by all accounts a good father and a gentle person. He became ill and bedridden, and Hunter worked alone supporting her husband and children. Nevertheless, it was during this period, the late 1930s, that Hunter discovered her talent for painting. She worked all day, came home to care for her children and invalid husband, and then painted by lantern light. She went to bed long after the others. Emmanuel Hunter died in 1944, and Hunter was once again a widow with children.

In addition to her own children, there was another child under Clementine Hunter's care. Mary Frances LaCour, an eleven-year-old child from a broken family, moved in with the family and remained until she was into her teens. With Hunter as her teacher, Mary Frances demonstrated a talent for painting. The two painted together and hung their finished art on the fence near their cabin.

Observers commented at the time that Mary Frances demonstrated as much, if not more, artistic talent than Hunter.[18] Mary Frances led a short, sad life. She eventually moved to California to live with her father. She became pregnant at a very early age and gave birth to a stillborn child. Word reached Melrose in February 1951 that Mary Frances had died. She was not yet twenty years old.

While none of Mary Frances LaCour's pictures is confirmed to have survived, students of Hunter's art ponder whether Mary Frances painted some of the earliest works now attributed to Hunter. Her paintings were said to "resemble the style of Clementine Hunter."[19] It is likely that LaCour's paintings became comingled with those of Hunter's earliest works.

Hunter's days as a field hand ended as she entered her fifth decade of life. Her duties gradually shifted from the fields to the plantation Big House, where she assisted with cooking, washing, ironing, cleaning, and babysitting. The late 1930s marks the beginning of the most significant period in the life of Clementine Hunter, the developing artist. Her work in the Big House brought her into daily contact with many of Louisiana's most successful artists and writers. She blossomed in the creative environment, and the experience forever influenced her life. After working all day, she came home at night and began to paint.

# Memory and a Sense of Place

This place has produced the most amazing women.
—Olympia Dukakis, actress

TO UNDERSTAND THE COMPLEXITY OF Clementine Hunter and her art, one must understand her relationship to the land from which she came. She was very much an "artist of place," and that place is an area of north-central Louisiana known as Cane River Country. It is an area defined by geography and made significant by culture.

Called by the early French settlers "Rivière aux Cannes," the Cane River today is one of two small oxbow lakes, the other being Old River, that split away from the larger Red River as a result of a shift in the river's course.[1] It is from this picturesque thirty-mile meandering stretch of water that the region takes it name. Cane River Country begins at Natchitoches to the north and extends south just past Cloutierville, bounded today on the west by U.S. Interstate Highway 49 and on the east by the Red River.

The center of government and commerce for the area was, and is, the city of Natchitoches. The name comes from the Caddo Indian term *Nakatosh*, which means "place of the chinquapin," a tree similar to a chestnut that bears an edible nut.[2] Natchitoches developed from the site of a French fur-trading outpost that began with only a few buildings in 1713. The small settlement grew in earnest when French Canadian Louis Juchereau de St. Denis founded a colonial fort in 1714. Natchitoches eventually became one of the significant early European settlements west of the Mississippi River.

Clementine Hunter spent her life in the heart of Cane River Country. Here the fecund river land produced cotton, corn, indigo, sugarcane, pecans, and many other cash crops for hundreds of years. In more recent times the fertile farmland seems to be losing out to developers, as homes and subdivisions are

being built along the historic waterway. For more than two hundred years large working plantations thrived along the banks of the Cane River. Today, some of the old mansions have been renamed and most have been restored. Oaklawn, Cherokee, Oakland, Magnolia, and Melrose can still be seen along Cane River Road (Louisiana State Highway 119) south of Natchitoches.

As late as the first half of the twentieth century, these grand farms were labor-intensive and required scores of workers. Since the days of enslavement, the land-rich planters' success depended on the sweat of the brows of men and women who traced their ancestry to Africa. After the Civil War thousands of enslaved workers suddenly discovered they were free to walk away. They began leaving the plantations and moving north. To replace the loss of

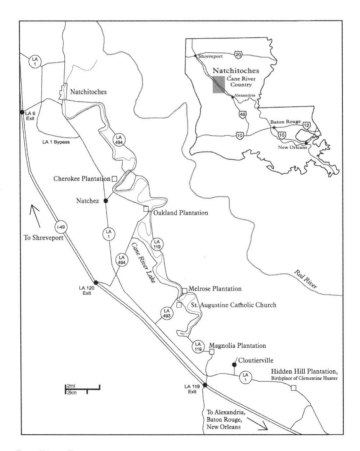

Fig. 11. Cane River Country. SHAYNE CREPPEL.

forced slave labor, farm tenancy became the means to rebuild the war-torn plantations. The former enslaved laborers who chose to stay on the farm and exchange their work and a percentage of their crop for the basics of life were called "sharecroppers." Their duties changed little from the work done by their enslaved ancestors, and though they were free to leave, many had no means to do so. The chains of slavery were replaced by an ever-growing debt to the plantation store.

By the 1930s more than half of Louisiana farmers were sharecroppers. Sharecropper families moved often, trying to improve their lives. They had little or no access to basic schooling or medical support. While the plantation owners lived at the top of the agricultural hierarchy, the sharecropper lived at the bottom.

Clementine Hunter was born into a family of sharecroppers. They moved several times during her childhood before the Henry family hired them and they settled down at Melrose to jobs that paid wages. Working at Melrose for tenant farmer wages was far better than sharecropping, but Hunter's family never escaped the grueling, backbreaking labor necessary to sustain the plantation.

The population shift from the South to the North that resulted from the end of the Civil War grew significantly during the twentieth century. The exodus of people of color from the South created monumental changes to American society and culture. By the middle of the century racial unrest swept the South, eventually changing forever many accepted southern laws and customs.[3]

During this period of dramatic social and political transition Clementine Hunter grew into adulthood, raised her family, worked at Melrose, and experienced firsthand the waning decades of the traditional plantation life. Her memories from her experiences as a plantation field hand and later a domestic servant became the inspiration for much of her artistic expression.

## Isle Brevelle and the Creole Influence

A discussion of Hunter's home would not be complete without mention of a culturally unique area of Cane River geography, the Isle Brevelle. Though not really an island in the true sense of the word, Isle Brevelle is a narrow stretch of land about three miles long and three to four miles wide between

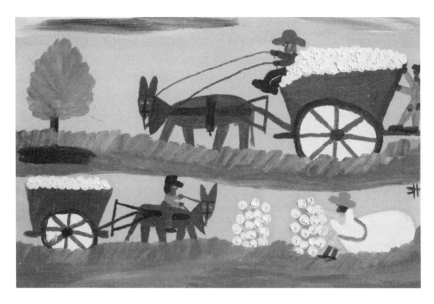

Fig. 12. *Cotton Wagons Goin' to the Gin.* Hunter's memories included hundreds of paintings of wagons loaded with cotton on the way to the gin. THOMAS N. WHITEHEAD.

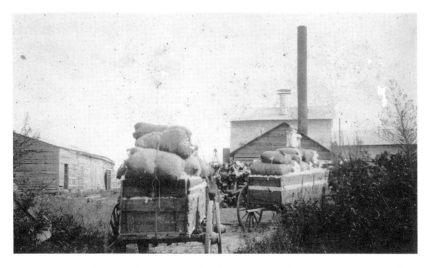

Fig. 13. Vintage photographs of laborers hauling cotton to the gin in the 1930s confirm Hunter's memories. CAMMIE G. HENRY RESEARCH CENTER, NORTHWESTERN STATE UNI-VERSITY OF LOUISIANA.

the ancient remains of Old River to the west and Cane River to the east. Old River was originally part of Red River but shifted long ago, before the area was inhabited. This region is the home of the Cane River Creole community. If one thinks of the land between Cherokee Plantation and Magnolia Plantation as the geographic heart of Cane River Country, then Isle Brevelle, just across Cane River from Melrose Plantation, is the cultural soul.

To the Creoles of Cane River, Isle Brevelle is their ancestral homeland. The bloodlines and traditions of the French, the Spanish, the Native Americans, and the Africans blended here to produce a proud and aristocratic people who were forced, or in some cases chose, to live outside main society. Over time these people developed a cultural memory and shared cultural experiences enriched by tradition. The Cane River Creole people, with their strong religious ties and historical awareness, created many of the legends and tales that have been told from generation to generation along the banks of the Cane.

The most influential of these stories is that of Marie-Thérèse Coincoin, the freed slave and mistress to the Frenchman Claude Thomas Pierre Metoyer. While this story is based loosely on fact, myth and legend cloud the truth. The Metoyer families of Isle Brevelle trace their ancestry to this relationship. Marie-Thérèse is said to have been the first owner of the farm that eventually became known as Melrose.[4] No documents are known to support Marie-Thérèse Coincoin's ownership of the property. Documents confirm she owned another large farm some ten miles upriver. Her son apparently owned and worked the land that eventually became Melrose Plantation, but scholars today doubt Marie-Thérèse ever traveled to the property.[5]

Clementine Hunter knew the legend of Marie-Thérèse. She was told Marie-Thérèse was the original mistress of Melrose Plantation and that Marie-Thérèse, a woman of color, owned slaves. It was possibly true that Marie-Thérèse owned slaves and bought the freedom of her enslaved children. As is often the case in history, fact and legend blend, and the resulting story, while not totally accurate, is told and retold as truth. Hunter paid maternal respect to Marie-Thérèse in her mural paintings created during the 1950s.

## Cane River Women

Marie-Thérèse Coincoin's story becomes a metaphor for the matriarchal influences that dominated Cane River society for generations. These influences

crossed racial and cultural lines and are apparent today not only among the Cane River Creoles but also among white and African American communities.

The author Kate Chopin, who lived part of her life in this area during the 1880s, is considered today to be an early feminist writer. She wrote what for her day was a daring story of a young woman's coming of age in her book *The Awakening*, addressing women's issues at a time when such writing was considered scandalous. In her collection of short stories, *Bayou Folk*, published in 1894, Chopin collected tales from Cane River, the most famous of which is "Désirée's Baby," a story of conflict surrounding a child of mixed race from the Creole community.

Clementine Hunter worked for another powerful woman of Cane River Country: Mrs. John Henry, known as Miss Cammie or Aunt Cammie. Cammie Henry and her husband owned and operated Melrose Plantation. When her

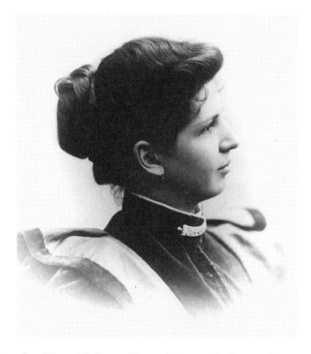

Fig. 14. Carmelite "Cammie" Garrett Henry (1871–1948). Cammie Henry ran Melrose Plantation from 1917 until her death. Hunter worked for her both in the fields and in the plantation Big House. CAMMIE G. HENRY RESEARCH CENTER, NORTHWESTERN STATE UNIVERSITY OF LOUISIANA.

husband died in 1917, Cammie Henry had six children to rear. With no apparent hesitation, she immediately took charge and successfully ran Melrose Plantation alone for thirty-one years. Cammie Henry is one of the few white people who figure in Hunter's Melrose paintings.

It is no wonder Hunter often painted images of women larger than those of men. Women always played an important role in Cane River history. The Cane River Creole people prized their French ancestry and built their community around powerful, influential women. Hunter could have had no idea that in time she would become the most famous woman to call the banks of the Cane home.

The actress Shirley MacLaine lived for a short time in Natchitoches in 1988 while filming the motion picture *Steel Magnolias*. She told the playwright Robert Harling, who spent his youth in Natchitoches, she felt "an undeniable feminine energy" there.[6] Clementine Hunter clearly sensed "feminine energy." Women dominate her canvases and are often depicted hard at work, while the men are sitting, fishing, and drinking away their time.

While geographic and cultural memories inspired much of the autobiographical content of Hunter's art, the inspiration to pick up a brush and paint came from influences outside the Cane River region, specifically visitors who came to Melrose. Because the artist never traveled, the only place she could have learned about the magic that comes from the combination of oil paints and canvas was at Melrose. Art and artists literally walked through the front door of the Big House where she worked. She saw paintings hanging on the walls and watched artists as they painted. Hunter did not seek to understand art, but an understanding of art came to her. Through observation she absorbed the abstract concept of art that ignited her innate creativity.

Cammie Henry opened the doors of her plantation to writers and artists, who were encouraged to come for extended periods to Melrose to work and live. The artists Hunter met included E. H. Suydam, who made numerous line drawings of the buildings on the Melrose grounds. Suydam also illustrated the Louisiana author Lyle Saxon's book *Fabulous New Orleans*. One of the most famous photographers of the early part of the twentieth century, Doris Ulmann, was a close friend of Lyle Saxon's and came with the writer on several visits to Melrose. Ulmann's highly unique photographic style resulted in her work often being compared to painting. Ulmann was known to have photographed Hunter.[7] Probably the most influential of all the artists Hunter knew was a woman who moved to Louisiana from Ohio, Alberta Kinsey.

Clementine Hunter's association with the famous guests at Melrose was limited because she knew them only from her role as a domestic servant. What she observed and overhead clearly influenced her, but because of her station in life, she would not have engaged them in social conversation and most certainly was never invited to sit down with them at dinner. Cammie Henry could have never imagined that her decision to encourage an art-friendly milieu at Melrose would ultimately serve as inspiration for her cook and housekeeper.

Henry expressed her surprise at Hunter's talents, especially her ability to make fringe, the decorative border of thread or cord found on drapes and clothing.[8] While she was aware Hunter painted, there is no definitive evidence indicating Henry's support or appreciation for Hunter's art. Cammie Henry's role in the development of Clementine Hunter as an artist was unintentional but significant nevertheless.

Born Carmelite Lou Garrett on January 14, 1871, at Scattery Plantation in Ascension Parish, Louisiana, Cammie Henry was the only daughter of Leu Divine Erwin and Captain Stephen Garrett. She studied to become a teacher and graduated in 1892 from the State Normal School in Natchitoches, the institution that eventually became Northwestern State University. It was during Henry's first year of teaching that she met John Hampton Henry Jr. They were married in 1894 and established residence in Natchitoches, where they began their family. John Henry Jr. farmed the land at Melrose with his father, but initially no one lived on the property. The plantation buildings had fallen into disrepair and were considered unfit for occupancy.

Following the death of John Hampton Henry Sr., the property passed to his son John Henry Jr. and his wife, Cammie. In 1899 the couple restored the plantation's principal residence; they called it the "Big House." While John Henry continued the hard work begun with his father to build the property into a successful farm, Cammie Henry focused her attention on the residence, the gardens, the outbuildings, her scrapbooks, and the family.

Cammie Henry was a youthful, educated woman who valued historic preservation. She collected regional art, rare books, and period furniture. By the 1930s, when Clementine Hunter came to work in the Big House, Miss Cammie had turned the plantation into a significant repository of outstanding art and furnishings reflecting the history of Louisiana and the Cane River region.

Cammie Henry's appreciation for knowledge and information resulted in her assembling a large library of books and documents. Her seemingly un-

quenchable interest in history led her to keep journals and to collect clippings, photos, cards, telegraph messages, and pamphlets. She assembled her collections into a series of some 250 scrapbooks. The scrapbooks reflected her passions for gardening, weaving, art, architecture, and history. Fully aware the scrapbooks would become part of her legacy, she wrote, "Someday someone will hunt history in these very old notices."[9]

Under Cammie Henry's management Melrose thrived and grew more financially rewarding. She restored the plantation's smaller outbuildings and moved other historic Cane River buildings to the Melrose property. She converted these restored structures into guesthouses. In response to the isolation of rural life, she expanded her interests in arts and crafts, and she invited creative and interesting people to come to Melrose and visit. She enjoyed the company of artists and writers. They accepted her invitation to stay for long periods while they worked. In exchange for her hospitality she asked only that each guest be productive.

Cammie Henry's cultivation of Melrose as a creative community is appreciated today in relation to the larger Arts and Crafts movement in the United States during the early part of the twentieth century. American Anglophiles, inspired by the movement that began in England in the 1870s, brought the passion for architecture and the decorative arts to this country and gave them an American interpretation. Much like Henry Ford's efforts with Greenfield Village, Michigan, Cammie Henry's intentions to identify and preserve the history and arts of Louisiana and the South clearly reflected the goals of the national Arts and Crafts movement.[10] Irma Sompayrac, a close friend of Cammie Henry's, established the Natchitoches Art Colony in 1926. The writers and artists who came to Natchitoches frequently traveled the short distance to Melrose and were welcomed guests of Mrs. Henry.

## Monsieur Mignon Moves to Melrose

Cammie Henry's Melrose Plantation guestbook became a list of who's who of the South's literary and artistic community of the 1930s and 1940s. Lyle Saxon, possibly the most famous Louisiana writer of the day, was a favorite of hers. Saxon helped in the restoration of the outbuildings and lived for long periods in a building known then as Lyle's Cabin. That building is today called Yucca

House. It was in Yucca House that Saxon wrote *Children of Strangers,* a fictional account of the Cane River Creole people of Isle Brevelle.

Melrose's guest list also included Roark Bradford, Caroline Dormon, Rachel Field, Harnett Kane, Frances Keyes, Alberta Kinsey, Anne Parrish, Doris Ulmann, and Alexander Woollcott. In 1939, adding to the list of celebrity writers and artists, Mrs. Henry encouraged an unabashed Francophile from New York, François Mignon, to come for an extended visit to Melrose. His acceptance of her invitation proved in time to be one of the significant developments in the history of Melrose and in the life of Clementine Hunter.

Cammie Henry lived a long life and left an impressive legacy. In 1948 she had a stroke in her library and fell from a stool on which she was standing. Injuries from the fall caused her to be bedridden for many difficult months before she ultimately suffered a second fall that proved fatal. The responsibility of running the plantation business continued under her oldest son, John Hampton "Jady" Henry.

François Mignon had lived at Melrose for a decade by the time Cammie Henry died. He initially attempted to carry on the literary and artistic traditions she had begun, but even before Cammie Henry died, national interest in the Arts and Crafts movement had begun to decline. Without the strong guiding hand of the well-known châtelaine of Melrose, the concept that a working plantation in rural Louisiana could also be a working home for writers and artists abruptly came to a close.

Cammie Henry's style, Melrose's creative guests and the Cane River legends all profoundly influenced Clementine Hunter. She knew well the details of the fashionable residence with the well-appointed rooms. As a cook and house servant, Melrose was where she spent her day. She observed painters at work and listened to the conversations of writers and others when she served them afternoon coffee or evening highballs. She tended the verdant flower and vegetable gardens. The perfectly pruned pecan orchards, the cotton fields, and life in the Big House all became part of her life experience. Young Clémence Reuben, who had assimilated into Melrose's community of African American laborers as a child, grew to adulthood on the plantation grounds. She experienced the lifestyle of the African and Creole cultures and witnessed the lifestyle of the white culture. These life experiences at Melrose became the major themes in her art.

Following the death of Cammie Henry, the family permitted François Mignon to become officially a permanent guest and continue living in Yucca House. In exchange the Henry family asked Mignon to serve as tour guide for the increasing number of tourists and celebrities who came from around the world to visit the fabled plantation. With Cammie Henry gone, the daily demands on Mignon's time diminished. With his newly found freedom he turned his attention to Clementine Hunter. He recognized she was a self-taught *artist of place;* it was his recognition and willingness to promote her that ultimately brought her talent to the attention of the world.

# The Remarkable and Enigmatic Mr. Mignon

The man known as François Mignon, said to have been born
in France . . . was in fact born on May 9, 1899, in Cortland,
New York, to Walter Fish Mineah and Mary Ella Mineah.
   —Oliver Ford, researcher

All this happened more or less.
   —Opening line to Kurt Vonnegut's novel
   *Slaughterhouse-Five*

CLEMENTINE HUNTER'S MOVE TO MELROSE PLANTATION proved to be the
most significant event in her life. Unquestionably, the second most important
event occurred when François Mignon moved from New York City to live at
the plantation. Mignon's early recognition of Hunter's art, coupled with his
willingness to promote the artist and her work, set her on the road that took
her from unknown domestic servant to one of the most celebrated self-taught
African American artists.

Mignon's role in developing, encouraging, and promoting Hunter as an art-
ist remains undisputed. Hunter held the brush, but Mignon owned the type-
writer. He cleverly crafted the Hunter story, often with little regard for truth,
and his words have been published and republished far and wide. His frequent
disregard for facts notwithstanding, Mignon's writings about Hunter remain
the best source of material about the artist and her life.

When François Mignon died, those close to him discovered that he had
also carefully crafted the story of his own life. He adopted the name François
Mignon, and he created his life's story. Nothing explains his decision. The
reason may never be known.

## Mignon Meets Cammie Henry

In 1937 Lyle Saxon, the writer and famous Melrose guest, introduced Cammie Henry to François Mignon. Mignon was traveling in the South with his companion, Christian Belle, a native of France who worked in the French diplomatic corps. As a result of Saxon's introduction, Henry, Mignon, and Belle became acquainted while on a pilgrimage to Natchez, Mississippi. Mignon and Belle traveled on to New Orleans with Saxon but stopped briefly at Melrose to visit Cammie Henry before returning to New York.

Mignon was only forty years old, but his eyesight had begun to fail. Cammie Henry, obviously impressed with him, saw an opportunity to lend a helping

Fig. 15. François Mignon, ca. 1972, holds a copy of his book *Plantation Memo: Plantation Life in Louisiana.* THOMAS N. WHITEHEAD.

hand. She wrote numerous letters begging Mignon to leave New York City and come for an extended visit at Melrose. This correspondence took place over several months, sometimes exchanging a letter a day. He eventually accepted her invitation for a return visit to the Henry's plantation. He arrived in the fall of 1939 with plans to stay for six weeks. He never returned to New York.

In all of Mignon's thousands of pages of writing, he never said why he was willing to leave New York and move so far away from friends and family, ultimately spending the rest of his life in distant, rural Louisiana. One reason might have been the pending transfer from New York to Puerto Rico of his close companion, Christian Belle. With Belle gone, Mignon would have been left alone to cope with his failing eyesight. At Melrose he would always have help.

On his departure from New York, Mignon began a daily journal that he would keep Sunday through Friday for the next thirty years. He opened his diary with the melancholy line, "It was dark when I said goodbye to Manhattan, and with few exceptions Manhattan, in all her luminous glory was unmindful that I was gone."[1]

## Mr. Mignon Is Not Mr. Mignon

In Louisiana, Mignon gave the impression that the looming war in Europe had disrupted his international import-export business in New York. There is no evidence, however, that he ever owned such a business. He claimed he had been a student of international law at Columbia University and acted as a consultant in France for the restoration and preservation of Marie Antoinette's farm at Versailles. He also said he had been an advisor on the preservation of the gardens at the former royal French domain at Marly.

The tale of his life-before-Melrose was believed by everyone, embellished on numerous occasions, but never denied by Mignon. He claimed to have been born in Paris and educated at the Sorbonne. Almost everything that was believed to be true about Mignon's early life turned out to be untrue.

François Mignon was well-spoken, cultured, and gave no one reason to doubt he was not an educated French scholar. At Melrose, Cammie Henry assigned him the job of plantation historian. He became her personal secretary and helped to organize her continuously expanding scrapbook collection. He knew a great deal about horticulture and designed several gardens on the plantation's grounds. He wrote more than seventeen thousand pages of daily

journal as well as thousands of letters and hundreds of newspaper columns. He received recognition for his writing on numerous occasions. The English department at Louisiana Tech University in Ruston, Louisiana, proclaimed him "Writer of the Year" in 1971. His newspaper column "Plantation Memo" received a "best in the state" award from the Louisiana Press Association.

François Mignon exchanged correspondence with a wide range of celebrities and important people, including first lady Eleanor Roosevelt, Alexander Woollcott, and Alice Toklas, the companion of Gertrude Stein. He was known to be a kind and gracious man. Those who knew him believed him to be Monsieur François Mignon of Paris, France. Even his closest acquaintances said he seemed to be the person he purported to be.[2]

Almost all that is known about Mignon's true birth identity comes from research done by Oliver Ford years after Mignon's death. At the time he uncovered the real Mignon, Ford was a faculty member of the English department of Fitchburg State College in Massachusetts. Ford discovered what he called "the mystery Mignon created" as he was researching the life of Cammie Henry. The revelation began when he found a postcard written to Mignon in 1930 that carried the salutation "Dear Frank": "Why, I wondered, would a friend have addressed him by this name and why would he have kept the card? As I continued to read, I realized that there were some rather significant gaps in his life that were not represented in the collection—his life before he moved to New York or any real details of his life in New York, nothing from his life in France, and little that revealed much of his personal relationships except for the friendship he had developed with Mrs. Henry."[3]

Ford combed the Mignon manuscripts and letters looking for clues to Mignon's true identity. In the vast correspondence collection he found seemingly insignificant letters addressed to Laura Jones. Laura Jones turned out to be a niece of Mignon. Ford contacted Jones, and she willingly filled him in on Mignon's identity: "The basic facts of the story are quite simple. The man known as François Mignon, said to be have been born in France and steeped since birth in its culture, educated at the Sorbonne and in postgraduate study at Columbia University, and whose name was associated with some of the famous names and achievements of French culture, was in fact born on May 9, 1899, in Cortland, New York, to Walter Fish Mineah and Mary Ella Mineah (née Howland)."[4]

At birth François Mignon was given the name Frank VerNooy Mineah. His niece told Ford that *VerNooy* was the name of the physician who delivered him. Mignon's grandfather had emigrated from Holland to New Jersey in the early 1800s, eventually moving to New York. Mignon's father was apparently from Dryden, New York, and his mother from Groton, New York. His mother's family immigrated to America from Canada. The family lived in Cortland, New York, at the time of Mignon's birth.[5]

"Nothing suggests that his family background is appreciably different from the vast majority of respectable, middle-class families who populate the United Sates," Ford wrote. "What is clear is that he was not born in Île-de-France, and if he was 'from childhood a veritable heir of the 17th and 18th centuries, steeped in the lore of Chateaux life in France and breathing the same cultural air that permeated Louisiana from the time of its initial founding' [Ora Williams quoted by Ford], he became so not by birth but by avid reading, formal and informal study, and visiting France over a period of years in his life."[6]

From 1932 to 1939 Mignon managed the French department of the large New York bookstore B. Westermann that was located near Rockefeller Center in Manhattan. At the bookstore, Mignon developed a close friendship with another employee, Erna Fasse. Fasse told Oliver Ford that Mignon possessed an impressive command of French and European history, especially of the seventeenth and eighteenth centuries and the reigns of Louis XIV, Louis V, and Louis XVI. She speculated that Mignon adopted a new identity because the name given him at birth was so unusual. He began to use François Mignon as early as 1935, four years before he left Manhattan for Melrose Plantation. Fasse said it became quite natural to address him not as Frank but as François.[7]

On August 11, 1980, in a letter to Fasse, Laura Jones said she knew of nothing in Mignon's past that would cause him to want to change his identity. She pointed out that his mother and sister understood how he felt more comfortable becoming François Mignon, but it was something about which his father and brother never approved. Jones told Fasse that Mignon's mother and his high school English teacher recognized his talent for writing and history. Against her husband's objections Mignon's mother helped him enroll in Columbia University. He attended Columbia during the fall of 1921 through the spring of 1922. His niece thought Mignon might have traveled in France

and Europe because he had once ask her to send his birth certificate to obtain a passport. She also thought he might have attended the Sorbonne in Paris. Oliver Ford found no evidence that Mignon had graduated from the Sorbonne, if he attended at all. His passport confirms he traveled in France.[8]

Mignon's close friendship with Erna Fasse continued for the rest of his life. It was to Fasse, who lived in New York, that he mailed his daily journal, the diary of life at Melrose. His journal eventually became the nucleus of his collection of writings. He usually sent her carbon copies of letters he wrote and followed that up by sending the reply to the letter he received. Original letters were often retyped so as to provide a copy for Fasse to file. When Mignon died in 1981, Fasse oversaw the delivery of the boxes of Mignon's writings and letters to the University of North Carolina, where they are permanently housed in the Wilson Library, Southern Historical Collection, on the campus at Chapel Hill.

There is not much known about Mignon's friend Christian Belle, the young Frenchman with whom he lived in New York and with whom he was traveling when he met Cammie Henry. In a letter to Mignon, written by Cammie Henry in April 1939, she asked Mignon how long he and Belle had been living in America. In several other letters she asked for information about the two, but there is no record of a response. While there is little written evidence, there is reason to believe that the relationship with Belle was romantic. Photographs and a letter found among Mignon's private papers seem to confirm this assumption.[9]

Belle was a French deputy counsel whom Mignon probably met in New York City. When Belle became consul de France in San Juan, Puerto Rico, Mignon was living at Melrose and agreed to store several items of antique furniture while Belle was out of the country. Those items were placed in storage in the Melrose barn and were still in storage on the plantation when it was sold decades later. Only a small nineteenth-century French chair survived the damage done by rats and water. Christian Belle visited Melrose on one occasion after Mignon became a resident. That was the only time Mignon saw Belle after they had both moved from New York.

Mignon never revealed his true life's story to anyone at Melrose. From the time he arrived until the day he died, he was to everyone François Mignon of Paris, France. In his final years the person closest to him was Cammie Henry's longtime friend Ora Williams. Williams, an English professor, edited Mignon's book *Plantation Memo: Plantation Life in Louisiana, 1750–1970, and Other Matter.*

Fig. 16. Rare photograph of a youthful François Mignon and Christian Belle, his close companion, before Mignon moved from New York City to Melrose in 1939. THOMAS N. WHITEHEAD.

When the Henry family eventually sold Melrose, Mignon had begun to age, and his eyesight had deteriorated to a great degree; he needed daily care. Williams invited him to come live at her family's guesthouse located at their home ten miles north of Melrose, in Natchitoches. Mignon accepted the invitation and promptly named his new residence "New Haven House." The Williamses cared for him from 1970 until his death in 1980. Only after Mignon died did Williams learn from letters she found in a box among Mignon's personal belongings that his real name was not François Mignon and that he was not a Frenchman by birth.

Ora Williams was shocked at the revelation and confessed to her daughter Ann (Ann Williams Brittain) she was "somewhat hurt" that the person she had known for so many years and cared for was not the person she had been led to believe.[10] By the time Oliver Ford's research came to light in 1991, Williams had died. She never knew the full details of how elaborately Mignon had altered and embellished his life's story.

## Tales, Legends, and Lies

Just as Mignon constructed the story of his life from dreams and desires, he also enhanced Melrose history by crafting a legend from half-truths, myths, and lies. David Morgan, director of the Southeast Archeological Center in Tallahassee, Florida, studied Cane River history and found numerous errors in the conventional Melrose story. He wrote, "It is apparent that François Mignon . . . created the backbone of the increasingly dubious Melrose legend."[11]

Soon after arriving at Melrose, Mignon began recasting the familiar Cane River Creole folktales to craft his version of the story of Marie-Thérèse Coincoin. Mignon was intrigued with the idea that an old mushroom-shaped building at Melrose might have been built by Africans, so he renamed the structure "African House." Prior to Mignon, the outbuilding had been called both "Casa Verde" and "Mushroom House."

He named another Melrose outbuilding "Yucca House" and claimed it had been the original home of Marie-Thérèse Coincoin. Mignon's Yucca House had been called the "Club House," the "Writer's Cabin," and "Lyle's House." It was never called Yucca until Mignon came along. The name Yucca first appears in

Fig. 17. Located on the grounds of Melrose, Yucca was restored by Cammie Henry and was where Lyle Saxon wrote his most famous book, *Children of Strangers*. François Mignon lived in the cottage during most of his more than thirty years as a guest of the Henry family. It was Mignon who named it "Yucca." CAMMIE G. HENRY RESEARCH CENTER, NORTHWESTERN STATE UNIVERSITY OF LOUISIANA.

Lyle Saxon's *Children of Strangers*. Saxon called the fictional plantation in his book Yucca. From this reference Mignon adopted the fictional name as the historical name for Melrose, certainly not one that had been used by the Metoyers.

Mignon proved to be a master storyteller with only a passing regard for factual history. While enslaved carpenters could have built the building called African House, it is closer in design to French architecture than to African. Marie-Thérèse Coincoin never lived in the building Mignon called Yucca House; it is quite likely that she never even saw it or even heard of it. A contemporary restoration expert trying to piece together the truth about Melrose remarked, "Lyle Saxon created fiction from fact, and François Mignon created fact from fiction."[12]

Mignon eventually became recognized as the expert on Melrose history. As gatekeeper to all things related to the plantation's history, his version of history ultimately became "fact." In an act of creativity worthy of a Hollywood screenwriter, Mignon crafted a wonderfully rich story of the three women of Melrose: Marie-Thérèse Coincoin, Cammie Henry, and Clementine Hunter. He told his story often and wrote about it in his newspaper columns. It has only been since the turn of the current century that scholars employed accepted scientific methods and archaeological techniques to separate the tangle of fact and fiction in Mignon's version of the Marie-Thérèse Coincoin story.[13]

## Mignon Discovers Clementine Hunter

François Mignon's sophistication and knowledge of art history, combined with his awareness of folk art, allowed him to appreciate Clementine Hunter's talent at a time when many others dismissed her art. He recognized her artistic ability as unique, but he needed a story. He soon created the story of the day Clementine Hunter became an artist. His made-up tale of Hunter's first painting is a good example of how stories told often enough soon pass as fact.

François Mignon arrived in Shreveport, Louisiana, by train from New York on the afternoon of October 28, 1939. A friend of Cammie Henry's, Robina Denholme, met him at the train station and drove him south the hundred miles to Melrose. In Mignon's earliest diary entries he was totally fascinated with everything about Melrose. He praised the food, the conversation, the servants, and the accommodations. Mignon's diary entry of December 19, 1939, has the first mention of Clementine Hunter, introduced to him as Clémence.

While some of the statements Mignon makes in this early observation about Hunter are incorrect, what he writes proves significant later, when he crafts his personal version of Hunter's life and her first painting. In his journal, in an entry written less than two months after his arrival at Melrose, flowered prose flowed from his pen:

December 19, Tuesday

Dawn came in Wagnerian trappings with the bang of thunder and the bleating of cows, which somehow supplemented in a bovine sort of way the mental pictures of the Valkyrie. All morning the rain descended and the thunder rolled and all day the cows were mooing in a kind of mournful protest at being separated from their calves and changed to a different pasture.

At ten, Clémence came over with our coffee. Clémence is an exceptional darkie, she is thin as a rail and looks about 35, but they say she is in her sixties. Although married, she has no children of her own but is bringing up a child [Mary Frances LaCour] that someone willed to her when the baby was but a few weeks old. [Mignon was incorrect: Hunter had children at this point in her life.]

Like the rest of the colored folk here about, I suppose Clémence cannot read, but for all that Clémence is probably one of the smartest Negresses one is likely to run across. She is bringing me one of her paintings within a few days. She is an artist and works in oils, using the bottom of a cardboard box or the side of a soapbox as a canvas. And they say her creations are something, whether they be still life, landscapes or portraits. The one she is going to bring me is a scene in a sick room, a man seated in a chair with a woman nursing him. When I ask her about her models, she explained that she never needed any. Sometimes at night, she explained, she has a vision, and getting up she searches around until she finds something to paint on and then just goes ahead with the paints that Albert McKennsie [sic] has given her.[14]

While this passage confirms Clementine Hunter had been painting before Mignon came to Melrose, the comment proves especially significant twenty years later, when Mignon will remember the story much differently. In the 1960s, in his newspaper column, and later reprinted in 1972 in his book *Plantation Memo*, Mignon wrote:

Plate 1. The historic African House can be seen today on the grounds of Melrose Plantation.

Plate 2. Hunter's famous murals on the second floor of African House. HISTORIC AMERICAN BUILDINGS SURVEY, NATIONAL PARK SERVICE. PHOTO BY JAMES ROSENTHAL.

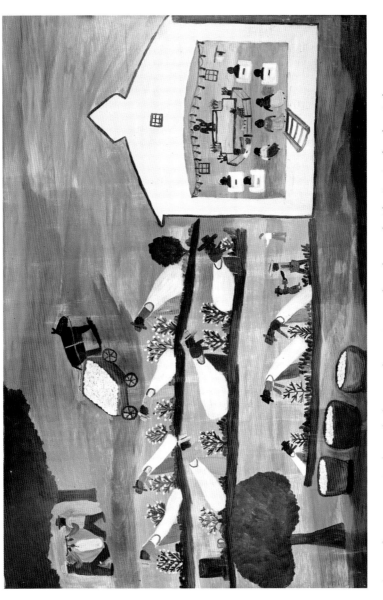

Plate 3. African House Murals panel. The cotton harvest images share the panel with a Baptist church revival scene. HISTORIC AMERICAN BUILDINGS SURVEY, NATIONAL PARK SERVICE. PHOTO BY JAMES ROSENTHAL.

Plate 4. Mignon gave Hunter a decorative plate to use as a model for her tondo panel in the African House Murals. PHOTO BY THOMAS N. WHITEHEAD.

Plate 5. While Hunter probably sought help in making the circle and certainly in lettering the small sign in the foreground, she painted her personal version of the decorative plate given to her by Mignon. HISTORIC AMERICAN BUILDINGS SURVEY, NATIONAL PARK SERVICE. PHOTO BY JAMES ROSENTHAL.

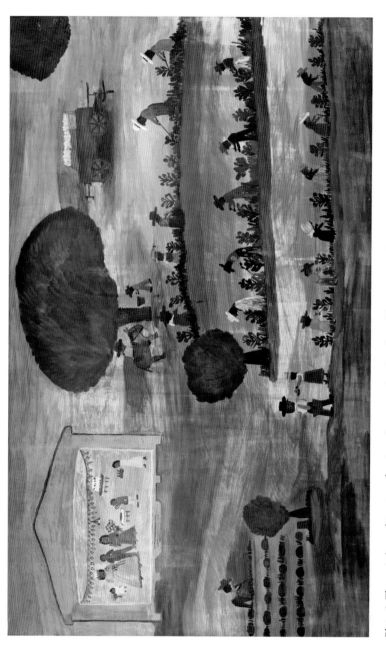

Plate 6. The artist's combination of spring planting and a church wedding suggests fertility. HISTORIC AMERICAN BUILDINGS SURVEY, NATIONAL PARK SERVICE. PHOTO BY JAMES ROSENTHAL.

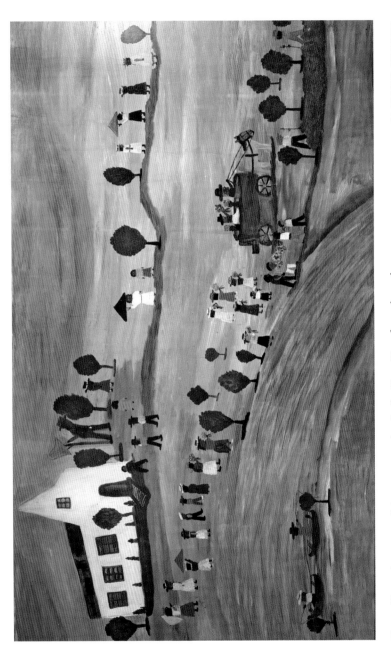

Plate 7. Plantation personalities come together in the Cane River funeral panel. HISTORIC AMERICAN BUILDINGS SURVEY, NATIONAL PARK SERVICE. PHOTO BY JAMES ROSENTHAL.

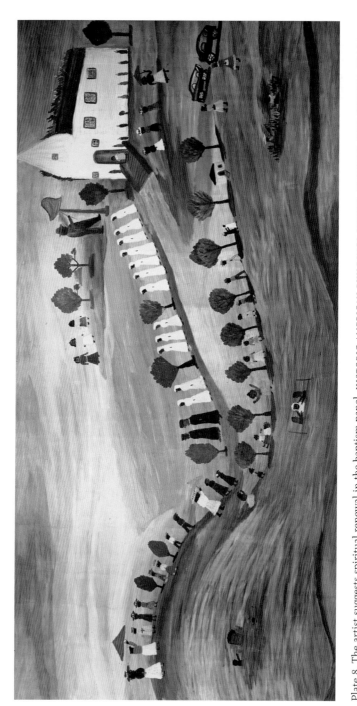

Plate 8. The artist suggests spiritual renewal in the baptism panel. HISTORIC AMERICAN BUILDINGS SURVEY, NATIONAL PARK SERVICE. PHOTO BY JAMES ROSENTHAL.

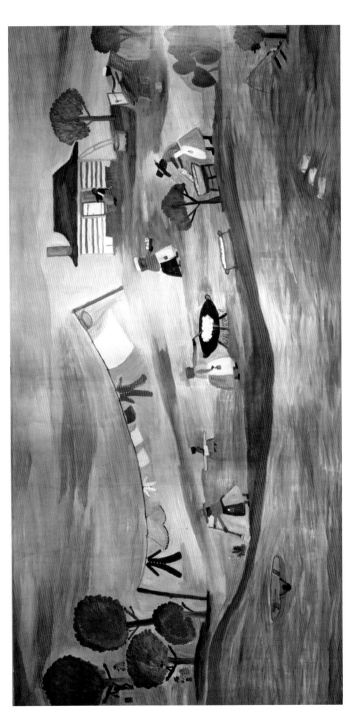

Plate 9. Mignon referred to this washday panel as "The Domestic Arts." HISTORIC AMERICAN BUILDINGS SURVEY, NATIONAL PARK SERVICE. PHOTO BY JAMES ROSENTHAL.

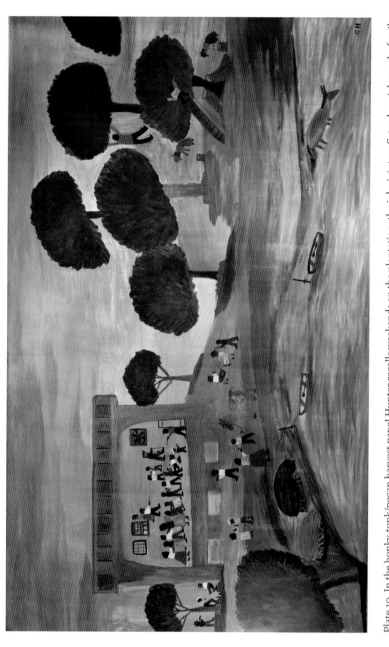

Plate 10. In the honky-tonk/pecan harvest panel Hunter recalls weekends on the plantation, the juke joint on Saturday night, and a family event picking pecans on Sunday morning. HISTORIC AMERICAN BUILDINGS SURVEY, NATIONAL PARK SERVICE. PHOTO BY JAMES ROSENTHAL.

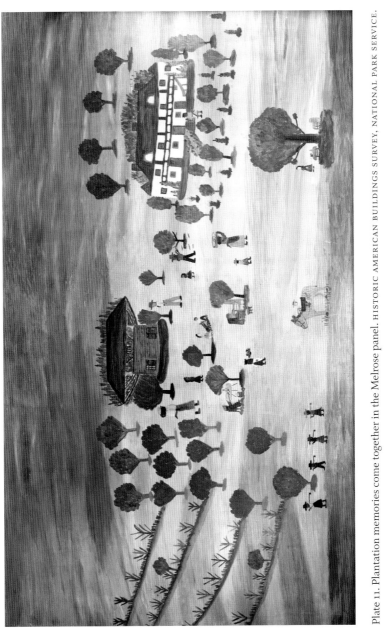

Plate 11. Plantation memories come together in the Melrose panel. HISTORIC AMERICAN BUILDINGS SURVEY, NATIONAL PARK SERVICE.

PHOTO BY JAMES ROSENTHAL.

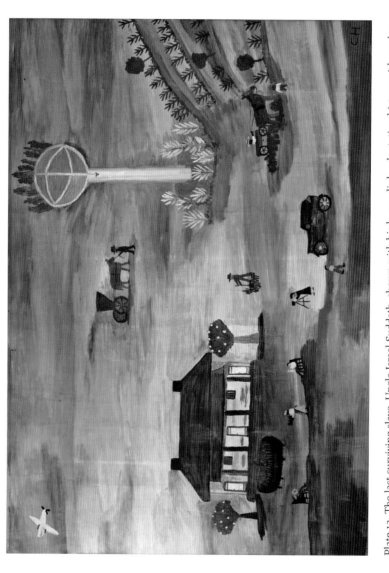

Plate 12. The last surviving slave, Uncle Israel Suddath, shown with his buggy, links plantation history with modern images of an auto and an airplane flying high above the scene. HISTORIC AMERICAN BUILDINGS SURVEY, NATIONAL PARK SERVICE. PHOTO BY JAMES ROSENTHAL.

The Remarkable and Enigmatic Mr. Mignon

Well, I do remember when Clementine Hunter, already many times a grand-mother, first tried her hand at painting. Alberta Kinsey of New Orleans had been here painting magnolias, using the antebellum outside kitchen as her studio. Late one afternoon, following Miss Alberta's return to New Orleans, it fell to Clementine Hunter to tidy up the place. About seven o'clock that evening, clutching a handful of discarded old tubes of paint, she tapped at my door, said that she had found these twisted tubes while cleaning up and that she believed she could "mark" a picture on her own hook if she "sot her mind to it." Knowing her as I did, I figured she could do anything she "sot her mind to" and, with a view to aiding her in her enterprise, I cast about and came up with an old window shade, a few brushes and a dab of turpentine.

At five o'clock the next morning, she tapped on my door again, explaining that she had brought me her first picture. I took one look at it, nearly fell out at the sight of it and exclaimed: "Sister, you don't know it but this is just the first of a whole lot of pictures you are going to bring me in the years ahead."[15]

Mignon's cleverly constructed version of how he discovered Hunter's talent and encouraged her to paint has been told and retold, printed and reprinted, so many times that it is widely accepted as truth. Even the artist herself heard the story so often that in her advancing years, she told the same story. When asked by interviewers on numerous occasions about the story of the first paint-ing, she confirmed Mignon's version was correct.[16]

Mignon understood that a well-made story inspires publicity. He knew that if he could get stories printed about the Cane River artist, public interest in her pictures would grow. He began promoting Hunter in the mid-1940s. At a time when there was only one phone for miles around and developing a photograph was a major undertaking, mounting something akin to a national public relations campaign from a plantation in rural Louisiana took consid-erable effort and a great deal of time. Mignon's best source for reaching the outside world came from the fact that Melrose was an official postal stop, and the mail train came through twice a day.

In the summer of 1949 Mignon assembled the first Cane River exhibition of Hunter's paintings for a visiting group of African American teachers. He displayed her art on the second floor of African House. Writing about it in his journal, he addressed the choice of venue: "Tomorrow morning I shall lay

Fig. 18. Hunter and Mignon watch themselves on TV following an appearance in Alexandria, La. Mignon discovered Hunter's artistic talent, and his efforts to promote her eventually brought her fame. THOMAS N. WHITEHEAD.

out a Clémence show on the upper floor of African House . . . I can't say the lighting of the second floor of the African House is ideal for the displaying paintings, but surely there never could be a more perfect atmosphere for a Cane River primitif [*sic*] exposition, all masterpieces of a person of color."[17] The pictures hung for several months and were seen by numerous groups who came to tour the plantation.

Blythe Rand lived in Alexandria, Louisiana, and had a family "camp" near Melrose. (The term *camp* is commonly used in Louisiana for a vacation house.) Rand brought her garden club members to Melrose for a visit, and they not only toured the plantation grounds but also were welcomed by the artist herself into the makeshift, second-floor exhibition of her colorful paintings in African House. The publicity resulted in a burst of business; several visitors

arranged immediately to purchase pictures and returned home with paintings and a wonderful story of the Cane River artist.

As a result of Mignon's constant promotion, Hunter's fame grew. She was always mentioned in Mignon's almost daily tours of the plantation. Her popularity eventually attracted collectors willing to pay for her paintings. Mignon promoted Hunter and her art for almost forty years. His dedication to promoting the artist attracted the attention of art enthusiasts and feature writers from across the South and around the United States. Although he was almost blind, Mignon deserves credit for "seeing" Hunter's innate talent. The fact that he recognized her for the artist she was and worked tirelessly to tell her story is the reason Mignon's arrival at Melrose was a key influence in the artist's life, second only to her arriving at Melrose, meeting artists, and experiencing art for the first time.

That François Mignon led a personal life that was to a large extent a fabrication seems insignificant as it relates to Clementine Hunter's artistic triumphs. One may ponder why he created his life story rather than accept the facts of his birth, but there is no doubt that Mignon's recognition of Hunter's talent and his promotion of her as an artist paved the way for her success. Lee Kogan, an art scholar and a recognized Hunter expert, said, "Mignon's role in furthering Hunter's success cannot be overstated. A person of unusual ability, he created a fictitious identity for himself, a romanticized version of Melrose, and an artistic persona for Hunter. This does not detract from her artistic talent and drive."[18] François Mignon discovered Clementine Hunter, and his efforts to promote her resulted in Hunter being recognized today as one of the most important, African American artists of the twentieth century.

# Mr. Pipes and the Artist

DURING THE DECADES OF THE 1940S, 1950S, and 1960S Clementine Hunter was supported and encouraged not only by François Mignon but also by another admirer, James Pipes Register. Hunter had many supporters over the years, but Register was second only to Mignon in the important role he played in Hunter's formative years as an artist. She enjoyed his company, and he became her trusted friend. Their friendship included a couple of bizarre periods when Register not only signed some of Hunter's earliest paintings but also attempted several years later to influence her art by teaching her a new painting style.

Register's background remains obscure. Even after interviewing living relatives, the authors found it challenging to determine what about his life was fact and what was fiction. On numerous occasions Register clearly misrepresented himself. Relatives confirm that he was born May 31, 1912, in Natchez, Mississippi. His father was William Register, and his mother, Rose Pipes Register, died when he was three months old. His grandfather may have owned a farm in the delta area of central Louisiana.[1]

Register claimed on several occasions to have been a member of the faculty at the University of Oklahoma at Norman. Records in the archives of the university confirm he worked there from 1947 to 1955, but he was not a member of the faculty. Departmental budgets and campus phone books clearly establish that he was a clerk in the audiovisual department of the agricultural extension office. He shipped films to farmers and county agents and rewound and restocked them when they were returned. He was not an academic and never taught classes.[2]

Before employment at the University of Oklahoma, Register worked for the United Service Organization, commonly called the "USO." He considered the move to the university a promotion, and soon after taking the job,

he wrote Mignon describing his duties: "[I] am working at the university in the audio-visual education department. That is the department that handles motion picture film for educational and recreational purposes. And believe me brother the stuff just flies in and out of the department. It's a grand program and quite interesting. It is operated like a book library . . . I am learning a lot and hope it will offer chances for advancement."[3]

There is no evidence Register had more than a secondary education, but he was articulate and well read. He published several books and numerous newspaper articles. In 1943 his only significant book, *Ziba*, explored dialect in African American folk poetry and tall tales. He said listening to customers while serving as a clerk in a rural general store patronized by the local African Americans inspired the book. The University of Oklahoma Press published *Ziba*, and the *New York Times* reviewed it favorably.[4] The success of *Ziba* established Register as a minor southern writer.

Fig. 19. James Pipes Register (1912–1983). CAMMIE G. HENRY RESEARCH CENTER, NORTH-WESTERN STATE UNIVERSITY OF LOUISIANA.

As a direct result of *Ziba*, Register attracted the attention of the Julius Rosenwald Foundation in Chicago. Rosenwald had been a successful president of Sears, Roebuck and Company, the catalog and department store chain. He funded the foundation in 1917 with a sixty-three million–dollar endowment, with instructions that the money be distributed "for the well-being of mankind."[5] Much of the money went to establish more than five thousand schools in the rural south for African American children. The foundation awarded James Register a four hundred–dollar fellowship for his book *Ziba*. Register's literary award from the fund was considered unusual recognition for a white man.

University of Oklahoma art professor Edith Mahier, a Baton Rouge artist who knew Cammie Henry from the days of the Natchitoches Art Colony in the late 1920s, met Register when they both lived in Norman. Mahier was a well-known artist and professor of fine art at the university. The two Louisiana expatriates became close friends. Mahier wrote a letter of introduction for Register to Cammie Henry on December 27, 1943. The letter sparkled with enthusiasm for her friend: "I have wanted to share James Pipes Register with you so much . . . May I box him up in Christmas ribbon and paste 'Happy New Year' on him and send him to you for a ten-day visit? He could be one of your sons, black eyes like J. H. He will do your heart good. He lived in Lake St. John near Ferriday [Louisiana] with his aunt who raised him. He is simple and sweet and gaily good-humored and you will talk and talk and talk and I will wish and wish to be there too."[6]

Register's job as a bookkeeper at the USO office prevented his traveling for the New Year holiday, but when he eventually managed to travel to Melrose in February 1944, he was immediately caught up in the romantic charm he saw in plantation life and Cane River Country. He met François Mignon and developed a friendship that lasted for thirty years. Mignon introduced Register to Clementine Hunter, and it was from that introduction that his friendship with the artist developed. Hunter always called Register "Mr. Pipes." Pipes was Register's middle name and his mother's maiden name. James Pipes was also Register's nom de plume.

Following his visit to Melrose, Register corresponded often with François Mignon, addressing him affectionately as "Lottie." Mignon responded in kind, addressing Register as "Dora." Often their correspondence concerned Hunter and her paintings and gossip about plantation life. Mignon kept Register in-

formed about the artist's development and reported in detail on her latest efforts. Mignon and Register provided supplies and financial support to the artist in exchange for paintings; as a direct result, the two men became the first serious collectors of Hunter's art.

The artist painted most evenings after her work was done and more often than not needed oil paints and canvas boards, items not readily available in rural Louisiana. Living in the University of Oklahoma community at Norman, Register could easily buy art supplies. Probably more important, he had an income from his job in the college extension office that provided the means to buy canvas, boards, brushes, and paint. He regularly shipped supplies to Mignon, who passed them along to Hunter. Both men also gave the artist small amounts of money, which she used to help support her family. There is no doubt without Register's friendship and financial support, Hunter's development as an artist would have been much more difficult and might not have happened.

In June 1944 Mignon commented in his daily journal on his and Register's support of Hunter and her art: "Mr. Pipes and I continue to 'nurse' Clémence along. Mr. Pipes is spending quite a bit of money on canvas, paints, drawing materials, etc., and now and then I toss in a little silver in Clémence's direction. The result of our cultivation is that she is turning out a flock of paintings. They are primitives—Cane River Primitives—but withal quite charming, and many of them distinctly Rousseau in feeling. Aside from the remarkable quality they possess, considering the fact that Clémence has never seen any pictures, and just 'knocks' them off out of a clear sky."[7]

Register arranged what might be considered the artist's first exhibition when in 1945 Edith Mahier sponsored a private showing in her home and invited members of the university community. A second exhibition took place a few months later at East Central State College in Ada, Oklahoma. Register was also responsible for several women's garden club exhibitions; two in Texas worthy of note were held in Brownwood and Waco in the same year.[8]

An exhibition at the Fort Worth Art Association, planned for the fall of 1945, was canceled for racial reasons. "I received a curiously phrased letter," Register wrote Mignon, "which was so clearly obvious that the reason the show could not be held after all was because our artist friend was not rightly colored herself. Her hues, I might say, were not pale enough for the dear old Fort Worth Art Association."[9]

## The Julius Rosenwald Award

James Register had been the recipient of a Rosenwald fellowship, so he felt sure Clementine Hunter would also qualify for a grant from the foundation because the Rosenwald Fund regularly made cash grants to worthy African Americans. William Haygood headed the organization during the 1940s, and correspondence suggests he seemed to understand the significance of Hunter's art and expressed interest in providing support.

The discussion of how the fund might help Clementine Hunter, whom they called "Cinderella," went on for a couple of years. During World War II Haygood's wife, Vandi, temporarily assumed his position at the fund until Haygood returned from wartime military service. She wrote on several occasions that she would like to travel to Melrose to visit with Hunter. Finally, in August 1946 official word came that the board had turned down Hunter's application for a Rosenwald grant.

Haygood expressed his personal disappointment about the board's decision, but by using his influence, he managed nevertheless to get approved a token of support: "The only thing that we can think of which might be an encouragement to Cinderella [Clementine Hunter] is this: we can make a two hundred item extension to your [Register's] 1944 fellowship with the understanding that it be used to buy supplies for the lady. This is unorthodox to say the least, but we feel that the case warrants it. If this approach strikes you as sound and if you think that this would be a constructive thing for the lady, please write me so I can arrange the details."[10]

Mignon and Register had hoped for a grant of possibly fifteen thousand dollars, large enough to mount a touring show of Hunter's works and thereby increase her visibility as well as the value of their collections. Their correspondence confirms their disappointment.[11] Yet in their own creative way they quickly recovered by announcing that Clementine Hunter had been awarded a grant from the Rosenwald Fund of Chicago. In the years ahead Mignon would often make mention in conversations as well as in his writings that Clementine Hunter had been the recipient of a "prestigious" Rosenwald grant. Whether the money was a grant or a handout seems insignificant. Register's correspondence confirms that most of the funds extended to him for Hunter's use eventually passed to Hunter. What funds that remained in 1955 were used to ship a trunk filled with Register's collection of Hunter's art back to Louisiana.[12]

The association with the Rosenwald Fund's management resulted in a major and important change to all of Hunter's art that proved significant for the rest of her artistic career. Haygood wrote Register on March 12, 1946, that Clara Baron Taylor, director of the Chicago Galleries of the Associated American Artists, had offered the suggestion that Register and Mignon "try to get Mrs. Hunter to work out some kind of signature, since without one a picture is somewhat meaningless . . . Also she strongly advises that each picture be given an individual title, preferably by the artist herself. And finally, since the pictures will have to be framed for gallery display, she suggests that some distinctive Louisiana grained wood be used."[13] All of Hunter's pictures were originally unsigned because she could not write and did not know enough about the business of art to know that it was important to sign a work with one's name or identifying mark as a way to signify authorship and hence authenticity.

Mignon and Register were never above deception. If the paintings needed a signature, then a signature they would have. Register told Mignon that he thought he could paint an imitation of Hunter's signature.[14] In fact what it seems he did was create a signature that might have looked like hers if she could have printed her name. On the paintings in his possession in Oklahoma, Register, mostly using yellow paint, signed each picture with his version of *Clémence*, intentionally written to appear as if the uneducated artist had painted it. Several years later someone, probably Mignon, taught the artist how to paint her initials. Hunter's initials eventually evolved into her famous signature (see app.).

During the decade between Register's 1944 visit and 1955 Register did not return to Melrose. He wrote about it often in his letters and obviously longed to return. He continued to send money and supplies for the artist. Mignon and Register shared hundreds of letters over the years. The letters were filled with stories about the artist and her talent to create a seemingly endless supply of paintings. In payment Mignon regularly shipped paintings for Register's growing collection.

Just as the supply of paintings from the hand of the artist seemed endless, so were the promotional ideas and schemes concocted by Register and Mignon to promote the artist. They exchanged ideas for exhibitions as well as potential newspaper and magazine stories. A selection of paintings sent to *Life* magazine remained for months until the editors decided against producing a story. Register proposed that Mignon contact first lady Eleanor Roosevelt and

ask her to sponsor Hunter. They had the idea for a plantation cookbook, note cards, and commemorative plates. Some of these ideas were eventually accomplished. None of their endeavors resulted in much income, but everything succeeded as promotion.

Promotion of an African American who painted in what was called a "primitive" style was not easy. In the pre–civil rights days newspapers in the South would not print photographs of black Americans. The only newspaper stories about blacks were in the police report. Writers from across the South and around America, however, came in search of stories about Melrose. In article after article about Cane River and the famous plantation Mignon never failed to encourage the reporters to include the story of the self-taught artist and her colorful paintings. When famous and influential visitors came to Melrose, Mignon told them the story of the plantation artist, and as word spread, slowly Hunter's celebrity grew. Mignon spent many hours each week writing letters and spreading the word about the plantation and Clementine Hunter.

Register eagerly joined Mignon's efforts to develop a widespread recognition of the remarkable artist from rural Cane River. Year after year the awareness of Hunter and her art grew. Tourists went out of their way to stop by the artist's cabin. Visitors to Melrose requested an introduction to the artist. Many bought souvenir paintings to take home, many paintings were sold before the oil dried, having been painted only the night before.

## James Register Moves from Oklahoma

James Register grew increasingly discontent with his job, and he decided in 1955 to end his employment at the University of Oklahoma. He may have planned to move permanently to Louisiana, but that is not clear. He wrote Mignon and asked about sending his art collection to Melrose so Mignon could look for opportunities to sell some of the paintings: "There is a matter I would like to take up with you in regard to the Cinderella paintings I have here. There are about a hundred matted and mounted paintings and about four hundred unmounted. I was thinking that you might . . . work some of these off to pilgrims [visitors to Melrose] . . . I have retained part of the Rosenwald balance with the idea of shipping you this trunk of paintings. The Rosenwald balance to Cinderella is about thirty dollars which part could be used in sending

you these things and the balance could be sent to the girl friend [Hunter]."[15]

Following his retirement Register had no apparent income, and since he was only forty-three, he was too young for Social Security. Register's wealth consisted of the trunk of Hunter's paintings, but in 1955 the value of the art would not have been sufficient to fund his remaining years. It is not clear how he planned to support himself after leaving the university; one has to assume he planned to look for another job. He stopped briefly at Melrose on his move from Oklahoma but soon left for Gainesville, Florida, to visit Byron Starnes, an employee of the University of Florida whom he had met in Norman.[16]

Mignon was well aware his friend was a man of limited means and expressed his concern about Register's ability to live comfortably without an income.[17] With that as his motivation, Mignon set out to be a matchmaker. He introduced Register to Kathleen O'Brien, the wealthy, middle-aged, niece of Mrs. Albert Storm. Storm, a widow, adopted O'Brien following the death of her parents. The two women lived at The Bluff, Storm's former rice plantation located on the Cooper River near Charleston, South Carolina.

Mignon had met O'Brien and her aunt years earlier while traveling with Cammie Henry on a pilgrimage to Natchez, Mississippi. Mignon's matchmaking worked. O'Brien seemed eager to find a husband, and James Register needed a rich wife. Despite the fact that they had known one another for only a few months, the couple decided to be married. Storm also enjoyed Register's company and immediately gave her approval for a wedding.

The couple married on June 15, 1955. They honeymooned along the Gulf Coast for several months, spending time in Florida and Mississippi, before arriving in New Orleans and eventually Natchitoches. Following the Natchitoches visit, the couple returned to the bride's home at The Bluff in South Carolina. The Registers established residence in both New Orleans and Baton Rouge before finally settling in Natchitoches in February 1962, eighteen years after Register's initial visit.

The couple's decision to live in Natchitoches allowed Register the opportunity at last to visit Melrose often. During 1962 he had a small cabin, or camp, on Cane River not far from Melrose. He made the ten-mile trip frequently, usually having lunch with Mignon at the plantation and spending time with Clementine Hunter. It was during this period that he undertook an unorthodox experiment with the artist: he attempted to teach her how to paint and understand nonrepresentational art.

## The Hunter Abstract Period

Most of what is known about the Hunter abstract period comes from Register's writings and the fact that more than a hundred of these strange and unusual paintings exist. Possibly even more curious is that seventy-six-year-old Clementine Hunter agreed to participate in the experiment given she was known for being headstrong and usually rejected all attempts designed to influence her visions. Nothing has been discovered that confirms the method Register used, but he claimed he cut out colorful shapes from magazines and catalogs and used transparent tape to mount them on boards, resulting in a kind of montage. He said he encouraged Clementine Hunter to copy what she saw. Register wrote that he used the cutouts to "jog her color sense and what translations she would give to these montages."[18] The result is nothing like anything else the artist produced.

The Register/Hunter abstracts are flat and seemingly uninspired. Multicolored, organic shapes twist and writhe over the canvas. In some paintings small birds roost on the flowing, abstract shapes. While Hunter had painted images of birds from her earliest days, the birds in the abstracts look like no other she painted. The Register/Hunter birds are carefully executed with a realistic bird shape, unlike the impressionistic bird shapes in the vast majority of Hunter's paintings. Register clearly provided a great deal of input in the abstract paintings, possibly even picking up the brush himself.

Mignon did not totally embrace Register's decision to attempt to influence the artist and sidetrack her from her personal style. He admitted that he did not like nonrepresentational art but expressed mixed emotions about Hunter's paintings. Following a visit to the Register's home in the Pecan Park subdivision in Natchitoches, Mignon recalled his reaction to Hunter's abstracts: "James had a number of Hunters he wanted me to see. There were half a dozen I thought superb and should love to have for my own . . . It's a pity such a remarkable fine artist should waste so much time painting trash when she can knock off a masterpiece every now and then and, I believe, always does wonderfully executed creative work in a single night."[19]

The abstract experiment that began in 1962 continued for a year. When it ended, Hunter promptly returned to painting the autobiographical scenes for which she was known. She said she did not enjoy painting the abstracts and, according to Register, remarked, "Those things make my head sweat."[20] The Register experiment is significant because it further proved that the artist had

the ability to learn techniques and styles beyond those she developed herself. In the years ahead Hunter painted several outstanding abstract works that seem to have been inspired partly as a result of Register's experiment. The latter Hunter abstracts, the ones she produced without help, stand out as bold, colorful, and unique works obviously from the hand of the artist alone.

James Register self-published a children's book, *The Joyous Coast*, in 1971. It is a tale of Tom John QwanQwan, a duck who lived on Cane River. Register used Hunter paintings to illustrate the book. It is not apparent the artist specifically did the paintings for the book. Most likely, they were paintings from an earlier period that Register used as illustrations.

Register sold his extraordinary collection of Hunter's early art during the last decade of his life. He sold paintings to Ann Brittain and Mildred Bailey, among others. What remained of the treasure chest of art he shipped from Oklahoma in 1955, he auctioned off in 1971.[21] Register donated some of his collection of Hunter's art to Louisiana public libraries, including the Natchitoches Parish Library. He gave his abstract collection to the Ouachita Parish Library in Monroe and the East Baton Rouge Parish Library in Scotlandville. The abstract paintings hang today in permanent exhibition at both facilities.

Fig. 20. James Register donated a large number of Hunter's abstract paintings to Louisiana public libraries. The paintings shown here hang above the stacks in the Scotlandville Branch, East Baton Rouge Parish Library. ART SHIVER.

Register's influence on the artist over a thirty-year period was profound. He supported her financially during her early days. He helped promote the artist and arranged for several early exhibitions. He taught her a new style, and he introduced her to illustration. He assembled, with the help of Mignon, an outstanding collection of early Hunters. He never hid the fact that he hoped someday to profit from his investment of time and money. While he ultimately generated a few thousand dollars from this collection, it never, in his lifetime, acquired significant value. Toward the end of his life, after committing so much of his time and money to the artist, he seemed to lose interest.

The Registers separated in 1970, and the marriage ended in divorce two years later.[22] James Register lived the remainder of his life in Natchitoches. After Melrose was sold and Mignon moved to Natchitoches in 1971, Register and Eugene Lavespere, who had been the Melrose postmaster, met for coffee every Sunday morning at Mignon's home on the Williams's property. Lavespere said one Sunday morning Register failed to show up, and he never came again. Lavespere said they had no idea why Register stopped coming.[23] James Register died September 24, 1983. He is buried in Memory Lawn Cemetery in Natchitoches. Clementine Hunter lived another four and a half years and continued to paint every day.

# Becoming an Artist

Clementine Hunter to my knowledge never had a lesson.
—Mildred Bailey

Self-taught art of the twentieth-century *is* contemporary art.
—Alice Rae Yelen, New Orleans Museum of Art

CLEMENTINE HUNTER WAS WELL PAST middle age when her work moved from outside to inside, from the cotton fields and pecan groves to the Melrose Big House. Cammie Henry and others soon noticed her wide-ranging artistic talents. Hunter made pictorial quilts, taught herself to sew, and demonstrated her cooking abilities.

By the time François Mignon arrived in 1939, Hunter's primary duties included working in the plantation kitchen and keeping house. Mignon was especially impressed by her ability to cook and praised her culinary talent in his journal entry of December 19, 1939, only a few months after he arrived: "She isn't the Melrose cook for Elmer holds that post, but when something goes wrong in the kitchen or if Elmer is laid up, Clémence can step into the breach, and turn out a dinner that surpasses anything Elmer could have contrived to dish up."[1]

Mignon mentioned other areas where Hunter's talents had been recognized. Using a bottle as a base, she made dolls with embroidered eyes:

This morning Clémence has a new creation to show us, not a painting, but some dolls. Using a bottle as a base, she crafted perfectly splendid little figures, whether it be an old woman leaning on a stick or a pretentiously dressed Hottentots, a seam made for his nose and a bit of embroidery for the eyes and mouth. She also has created in this year's group a beautifully dressed

black nun, and as she explained to us, the nun has a little girl, and that figure she made with a smaller bottle as a base, and dressed the child exactly as the mother-nun. It reminded me of the priest in the local church named father Aegis who begot a child by a local colored girl, and it was named Innocent. This was a number of years ago, and the child has now grown . . . and is working in Grand Isle [Louisiana] for a priest down there.[2]

Mignon praised Hunter's ability as a seamstress and said she could weave, but she did not like weaving and refused to do it. And—maybe even more important—was his early recollection that Hunter painted oil pictures on cardboard and the sides of soapboxes. He described a painting of a "sick room" scene in which a woman nurses a man seated in a chair.[3]

While there are numerous examples that demonstrate Hunter's ability to paint flowers in the early period of her development, Mignon's description in 1939 of the oil painting of a sick room points to Hunter's willingness early in her art career to tackle sophisticated subject matter. The picture she was said to have painted overnight on a window shade and delivered to Mignon the next morning clearly was not her first effort, if it happened at all. In a 1985 interview Hunter told an Associated Press reporter she had been painting long before she met Mignon.[4] Hunter did, however, paint detailed and complex scenes on numerous occasions on window shades. When she had no means and no sources for canvas, she expressed herself on a variety of discarded surfaces, including wallboards and wallpaper, corrugated boxes, as well as window shades.

One part of Mignon's story does seem credible: how the artist acquired paint. Before Mignon arrived and began to provide Hunter with supplies, there were few ways she could acquire paint. Alberta Kinsey visited Melrose more often than any other painter. Kinsey's works in oils included landscapes, buildings, patio scenes, and still life paintings of flowers. She painted in a sophisticated style using techniques reminiscent of regional American impressionism influenced by modernism. There is little doubt that Hunter observed Kinsey painting and that her first tubes of oil paint came from Kinsey's discards.

The Louisiana writer John Ed Bradley, author of *It Never Rains in Tiger Stadium*, *Restoration*, *Smoke*, and *Tupelo Nights*, among others, became captivated by Kinsey's life and work and at one time owned a large collection of her paintings. "Alberta [Kinsey] would have felt a kinship with Clementine Hunter," he wrote. "Alberta was plain and unpretentious. She had a strong work ethic and

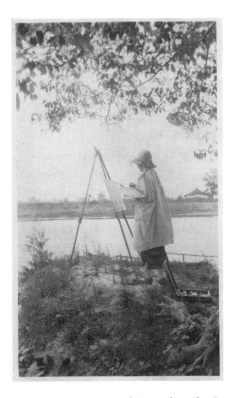

Fig. 21. Alberta Kinsey (1875–1952) paints en plein air along the Cane River. Clementine Hunter observed Kinsey as she painted and used her discarded paint tubes to paint her early pictures. CAMMIE G. HENRY RESEARCH CENTER, NORTHWESTERN STATE UNIVERSITY OF LOUISIANA.

ambition to do something special with her life. She would have been able to talk to Clementine. They had more in common than Alberta had with other visitors to Melrose . . . [Kinsey] had every reason to watch her money. She was totally self-made . . . she managed to make a living as an artist at a time when female artists weren't allowed membership into male-only art associations."[5] Bradley does not doubt Hunter acquired paint from Kinsey, but he says it would not have been a great deal of paint because Kinsey often ran short of funds with which to buy supplies and was known to leave very little oil in her discarded paint tubes.[6]

Hunter's lack of available paint might be justification for the technique the artist adopted during the earliest period of her development. To get as much

color as possible from old paint tubes, Hunter thinned the oils with kerosene or turpentine to such a degree that her color washes of diluted pigments are often mistaken for watercolors. Hunter never painted with watercolors; she only worked in oil. From unreliable Internet sources, as well as otherwise reliable sources, one can occasionally find someone claiming Hunter used discarded house paint. There is no evidence of that. Neither did she use acrylic paints. About acrylics she said, "They dry too quick."[7]

Alberta Kinsey was aware of Hunter's interest in painting. In a letter to James Register, dated March 12, 1944, Mignon related an encounter between the two artists: "Miss Alberta Kinsey continues to paint and to manifest interest in the arts. When Clémence passed by the house the other day, Miss A. grabbed her off, took her to the shop, and asked her to examine an impressionist painting she was doing. She asked Clémence where she would place the various colors, and lo! According to Miss A., Clémence indicated just the proper points, which greatly impressed Miss Alberta, and brought fourth the observation from the Madam [Cammie Henry] that Clémence was smarter than most people gave her credit."[8]

Before moving to New Orleans, Alberta Kinsey taught art at Lebanon University and Wilmington College in Ohio. During her more than thirty years living in New Orleans, she also taught painting at the Delgado Museum, now the New Orleans Museum of Art. Given her background in teaching, one has to wonder if she gave Clementine Hunter technical advice about how to create an oil painting. While that may seem reasonable, there is no evidence Kinsey did more than give Hunter discarded paint tubes and take only a curious interest in her talent. Mildred Bailey speculated that what Hunter learned from Kinsey, and possibly other painters, was acquired through observation: "Clementine to my knowledge never had a lesson. I feel certain she never did. I was always amazed how much intelligence Clementine had to have, and I think it's possible that her gift of observation . . . was such that she could see a lot in a very short period of time . . . I know life on a plantation: she was supposed to be in the kitchen cooking and tending to the chores, she was not supposed to be standing behind someone . . . and watching them paint. So, I think it's very possible that she observed the way people were doing things, but I don't think anybody ever pointed out to her that this is the way you do this or that."[9]

That Hunter was self-taught and initially received her supplies from Kinsey's discarded tubes of paint is supported by fact and enhanced by legend. Mignon

and Hunter both told the same story again and again. If it is not exactly true, it is certainly close. Hunter also was on more than one occasion adamant that no one had taught her to paint. "I just learned it myself," she told Bailey.[10]

## Hunter Taught Herself to Paint

Hunter demonstrated an innate understanding for the creative process. Even if she could not communicate concepts with language, she found ways to express her observations in art. Other than meeting artists at Melrose and watching them work, Hunter had no encounters with art or art lessons. Unaware of the canonic dimensions of art, she painted for years without direct influence from any instructor or knowledge of any school of art. She never visited an art museum before 1955, when she was allowed to see her own paintings on display at Northwestern State University in Natchitoches. Other than a few trips to the nearby Louisiana cities of Shreveport and Alexandria and two trips to Texas, to Port Arthur and Marshall, she never traveled. She could not read. Television was not a reality until she was well into her art career. Whatever style or technique she developed resulted from her own initiatives. When she made thick brushstrokes to cause her flower petals to stand out from the painting's surface or when she made thick dabs with white paint to create the texture of ripe, bursting cotton bolls, she did so with no knowledge that Vincent van Gogh had often employed the same impasto technique in his art. Hunter discovered the technique on her own and used it because it looked good to her. "I just go ahead and paint what's in my mind," she said.[11]

Hunter's self-confidence and independent thinking could be part of the reason she overcame incredible odds and became an artist. Her community did not understand her desire to paint, nor did her husband, Emmanuel.[12] Her acceptance as an artist by Mignon and Register clearly supported her self-confidence and established a bond of encouragement that led to success. When James Register attempted to teach Hunter a nonrepresentational art style, she obediently followed his direction but ultimately rejected his teachings and struck out on her own. Years later she took the experience she acquired from Register and created abstract paintings that proved far more original and further confirmed that even in her old age she was capable of creative growth.

In an interview with a Dallas television producer Mildred Bailey expressed her belief that Hunter was "driven to paint": "I think Clementine was driven

to paint. I think it was a compulsion, and I think she really had no control over it. Once she picked up a paintbrush and had a surface on which to paint, then, she painted until she died."[13]

Like most artists, Hunter, even without formal training, grew in her ability to express herself. How she created a painting evolved over the years. She painted her earliest works without underpainting. Then, when she discovered that background color could be done in advance and the subject of the picture painted over the background, she employed the technique for years. She referred to painting as "marking a picture" probably because once the pre-painted background dried, she would use pencil to draw, or mark, the outline of the content of the painting (as in Fig. 22).[14] On close examination of paintings one can occasionally see the original pencil line she failed to cover with paint.

During the 1930s and 1940s Hunter attracted the attention of Conrad Albrizio, a respected Louisiana artist. Albrizio is best known today for the murals governor Huey P. Long commissioned him to paint in the Louisiana State Capitol. Born in New York, he studied with George Luks at the Arts Students

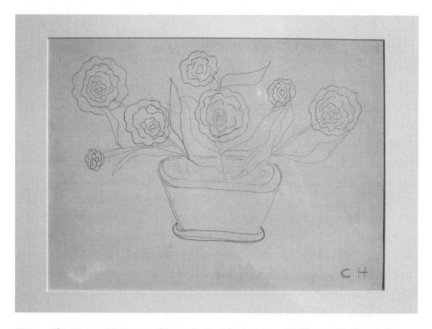

Fig. 22. Clementine Hunter would say she "marked a picture." This pencil sketch of a vase of flowers demonstrates the artist's technique. ANN AND JACK BRITTAIN & CHILDREN.

League. In 1935 Albrizio was appointed to the art faculty at Louisiana State University in Baton Rouge, where he continued to teach until 1954. In a 1944 letter to James Register, Mignon related Albrizio's observations about Hunter's art:

> Although I have not met nor talked with Cinderella [Clementine Hunter], I have had occasion to see a good deal of her work and have heard recounted the circumstances which led to a beginning of her painting . . . It seems to me that Cinderella is indeed an exceptional case and unexplainable excepting on the evidence of the merit of her work. I think very highly of it—so much so that I was very happy to use some of her paintings to illustrate a lecture to my students on the subjects of "creativeness in color and composition." There is a wealth of variety of subject matter in her work and what impresses me most is the diversification of treatment for the different subjects she treats. Her flowers are really a synthesis of many flowers and not just literally representational. Her compositions in which she treats people and familiar scenes of her environment are simple, strong in rhythm and color. Several that I have seen are truly monumental in their primitiveness. Her subject matter came from what she knew from her life on the plantation.[15]

## Toward an Understanding of Hunter's Art

The term *primitive* is often used to describe Hunter's art; this was especially true during her early years, before American folk art became an accepted and widely recognized genre. Clarence John Laughlin and François Mignon referred on more than one occasion to Hunter's paintings as "primitives." The term is still used to describe artists with little or no training whose painting style is outside the perceived mainstream.

While Hunter's art could be described as possessing the qualities associated with primitive art, it is far from the meaning of the word *primitive* as understood in common usage. In his book *Painting by Heart* Shelby Gilley wrote about his friendship with Hunter and the business of selling her art. He clearly appreciated the sophistication apparent in Hunter's paintings, and he preferred the term *folk art* to describe her works.

> In the time I have been handling works by Clementine Hunter, the comment that I have heard most often, especially from people who are not familiar with

folk art is—"I have a child (grandchild) that could do better than that." I some-times answer them in the words of one expert who says that: "What lifts her simplicity out of the terms of childishness is an unerring sense of color and composition, originality of treatment and her wit." I agree with him, but I would like to add something. I have come to realize that art is the creative property of the artist, no matter how simple it is. An artist always creates ac-cording to his experiences, and works, even by folk artists, are difficult to copy. Also, because Clementine did not spend much time blending colors, she was able to paint intuitively, and portray her subjects accurately, where if she "tried harder" it might have escaped her.[16]

Art historians and curators in the twenty-first century tend to reject *folk art* and *primitive art* on grounds the terminology suggests a nonacademic art-ist is less important than a formally educated painter. Hunter's art is more aptly described as self-taught. *Outsider art,* what the French call "art brut," is another term used to describe art by artists who had no contact with, or understanding of, traditional schools of art. Occasionally, the term *outsider* is used to describe Hunter's style. Outsider art originated from prison inmates and patients in mental institutions, certainly not a characteristic shared by Clementine Hunter.

*Memory painter* is yet another term used to describe Clementine Hunter. Anna Mary Robertson, known to the world as Grandma Moses, was also a memory painter. In the opening of her autobiography Grandma Moses wrote the line "memory is a painter." That could be the origin of the expression, but during the past thirty years *memory painter* has become the accepted term to describe self-taught artists who paint from memory.[17]

Comparisons between Hunter and Grandma Moses inevitably point out that both women started painting late in life and both painted autobiographic scenes from memory. Both women also had early exhibitions in drugstores. Hunter, who was called the "black Grandma Moses," began painting from memory early in her career, and, like Grandma Moses, eventually memory served as the primary inspiration for most of her paintings.[18] Understanding Hunter in the context of her place and time, her culture, and her influences, results in a description of the artist: Clementine Hunter was a contemporary, southern, female African American, self-taught memory painter.

In painting after painting Hunter recalls the backbreaking work of washing

clothes in an iron pot, picking cotton under the hot sun, or gathering pecans. She also painted hundreds of personal memories of family and friends. Without penning a word, her thousands of Melrose-inspired paintings became a visual narrative recalling her memories of plantation life.

Hunter's art never expresses complaints, nor does it convey discontent. Her painted memories of wakes and funerals are just as colorful as her recollection of sitting under a shade tree on a summer day enjoying a slice of watermelon. She painted boldly, and her message was direct and without irony. Her paintings are what they seem to be, and the often-revealing subtext in her art is not a result of the artist's conscious intentions. An example can be seen in her painting called *The Good Darkie.*

For many years there was a bronze, life-size statue in Natchitoches of a black gentleman in a frock coat bending forward and tipping his top hat in submission. The work, known as *Monument to the Good Darkie*, became a symbol of racism and bigotry during the civil rights struggles in the 1960s. In their

Fig. 23. *Uncle Jack* or *The Good Darkie.* Hunter's painting recalls the Jim Crow days of the South and causes modern viewers to wince. ANN AND JACK BRITTAIN & CHILDREN.

Fig. 24. *Wedding.* Hunter often painted female figures oversized in relation to men, a way of expressing her feelings about the significance of women. ALLEN HORTON JR., GILES MILLSPAUGH JR. COLLECTION.

wisdom officials removed the statue and banished it to the history heap in the Louisiana State University Rural Life Museum in Baton Rouge.

Hunter painted her version of this statue around 1945. While she could have been properly offended by it, there is no indication of that sentiment in her painting. The painting vividly recalls those unfortunate times and causes one to wince. Hunter painted what she saw and apparently did not allow the statue to offend her. It is safe to say the powerful subtext the painting communicates to contemporary viewers is far different from the artist's intention. In that sense the work becomes a significant painting worthy of historical and social notice.

When Hunter painted women larger than men, there was nothing subtle or implied. Her feelings were upfront and clear. She considered women the most significant part of the family and the community. Modern observers often see feminist overtones in Hunter's representations of women, as in some of her wedding scene paintings.

Members of her African American community on the plantation were said occasionally to reject Hunter's paintings because her colorful, cheerful images

failed to convey life's difficulties, which they experienced day in and day out. Mildred Bailey said, "I don't think that we can say that Clementine's life was happy and joyous. By any stretch of the imagination, it was a hard life; but somewhere in her latter days, in her paintings, she depicted it as a happy life. And I hope that she really felt that way about it."[19]

Intentional or not, Hunter's narratives in art subtly challenge the accepted white-centric zeitgeist by providing unique and revealing images of the life she experienced and witnessed in the African American community. Her paintings of dignified, hardworking blacks confirm her sense of racial pride. Without complaining, she emphatically reminds the viewer there were always two sides to the plantation fence. The simple act of picking up her brushes and painting what she remembered expanded cultural and historic awareness of plantation life during the twentieth century.

In 1955 Hunter combined her plantation memories with her sense of place when she painted, with Mignon as her guide, an expansive autobiographical mural for the Melrose outbuilding known as "African House." The African House Murals are recognized today as Clementine Hunter's most outstanding artistic accomplishment.

# The African House Murals

This is Clementine Hunter's story in her own terms
in her own time.

— de Teel Patterson Tiller, National Park Service (retired)

The monumental African House Murals epitomized
the breadth of this gifted artist's vision.

— Lee Kogan

BY THE SUMMER OF 1955 CLEMENTINE HUNTER had been painting for at
least fifteen years. She had developed the major themes that would dominate
her paintings in the years ahead. François Mignon persuaded her to create a
series of paintings that could be permanently displayed on the second floor
of the plantation outbuilding known as "African House." The murals, as he
envisioned them, would provide a panorama of plantation life at Melrose and
incorporate her major plantation-inspired themes. Hunter had never seen a
mural, but when Mignon explained to her, she accepted the assignment as
"something she wouldn't mind doing."[1]

African House stands today, an extraordinary structure both historically
and culturally (see Plate 1). Records indicate it may date from the 1820s. Louis
Metoyer, the third child born of the relationship between Marie-Thérèse and
Pierre Metoyer, possibly ordered construction of the building, but that cannot
be stated conclusively. E. Eean McNaughton, a New Orleans architect who
taught architecture at Tulane University and is an authority in historic resto-
ration, studied African House for many years. He says, "The form of African
House with its steep hipped roof and deep unsupported overhangs on all sides
is like nothing else at Melrose or for that matter in all of Creole Louisiana."[2]
Other students of historical architecture claim African House is more French

than African in design.³ For a hundred years it was called both "Casa Verde" and "Mushroom House." According to François Mignon, he was the first to call it "African House" when he named it in response to questions from a Historic American Buildings Survey (HABS) representative who visited the site in 1940.⁴ The hundreds of tourists who visit Melrose annually are told that enslaved carpenters built African House.

When Hunter started painting the African House Murals, major changes had already begun to take place in plantation life. The labor force, so critical to a plantation's success, had begun to erode after World War II, as workers moved north for more opportunities. Laborers came home from World War II with a realization that a chance for a better life might lay beyond the hand-to-mouth reality of sharecropping and tenant farming. Concurrently, the labor-intensive farm jobs were declining rapidly as more and more jobs traditionally done by hand were being done by machines. For the second time in a hundred years African Americans left the southern farms in search of better jobs in the auto plants, the steel mills, and the factories of the North and Midwest.⁵

As the artist began her work that summer on the mural panels, the South was in turmoil and undergoing change. In 1954, the year before Hunter's work began, the U.S. Supreme Court, in the landmark decision *Brown v. Board of Education* of Topeka, Kansas, had unanimously agreed that segregation of public schools was unconstitutional. As Hunter toiled away on her colorful, nostalgic pictures of the Old South, the civil rights movement nudged America toward a New South.

In December of the same year Hunter finished the murals, Rosa Parks's refusal to obey James F. Blake's order that she move to the back of a city bus launched the Montgomery bus boycott, and blacks in Montgomery, Alabama, refused to ride the city buses until they could sit wherever they wanted. Hunter seemed to have little awareness of growing racial unrest in America. Melrose, even in the mid-1950s, was still geographically remote, and no one, certainly not the illiterate artist, could imagine the dramatic social changes that lay ahead.

The idea to paint murals for the second floor of African House came to François Mignon on a late May morning, "a perfectly lovely day in these parts." He mentioned his inspiration to the plantation manager, James Hampton "Jady" Henry, the oldest son of the late Cammie Henry. Henry agreed to buy the lumber needed for the project. Mignon then told Hunter about his idea. "Anyone else would have been appalled by the extent of the murals I have

envisioned for the painting," Mignon wrote.[6] Hunter agreed without hesitation and reportedly told Mignon that painting the murals was "something she wouldn't mind doing."[7]

Mignon knew that if the painting went well, the result would represent a significant achievement by the artist. He wrote, "A primitive mural painted by a descendant of Africa in an African building—that really will be original, and perhaps arresting."[8] Jessica Dallow, associate professor of art history at the University of Alabama at Birmingham, wrote a scholarly chapter on Hunter's murals she titled "A Curious Collaboration: Clementine Hunter's African House Murals."[9] "Curious" is an apt description of the Mignon-Hunter partnership, as one can see in Mignon's detailed accounting in his journal:

June 5, 1955: I devoted the better part of the day to designing the general ideas . . . wherein the paintings by the local artist will eventually appear. Armed with a soft pencil I sketched in a general layout on wrapping paper which I had covered the plywood. I think this is imperative since the African artist has in mind doing the sections at home one at a time.

June 6, 1955: The artist came to see me this afternoon. I showed her the sketches I had made yesterday. She was entranced. They [the sketches] will help her with the distribution of the major subjects to be used in the African House.

June 10, 1955: Clémence has finished the first panel . . . I toted it across the cotton patch by myself . . . Clémence didn't seem in too happy a mood. She said she told J.H. [Henry] she wasn't going to do all that work for nothing . . . but she did take the next panel home with her.

June 15, 1955: I found a check from James for twenty dollars and this added to J.H.'s fifteen and twenty-five from Carolyn Ramsey, all of which suggests the artist will not be cheated as work progresses . . .

June 16, 1955: Clémence came to see me this morning saying she expected to finish the second of the panels by three o'clock this afternoon and could I send someone with the section designed for the baptism and to pick up the one on the Yucca section which she had nearly finished.

June 21, 1955: Clémence came to see me, apparently in a gay mood. She says she likes the baptism mural which she is "studying about" finishing tonight. She wants to do the funeral next, and as that is the adjoining section, I think it well she concentrate on that, even though in her own estimation, the one having to do with wash day is going to be her best and she is impatient to get to that.

June 22, 1955: Along about three o'clock little Miss Hunter arrived with her helper. They were toting the baptism section. The ample sky space gave the piece a certain magnitude and easily holds down about 50 different figures appearing in the ceremony. Simplicity of concept and a delightful childishness of execution inject a certain charm that is characteristic of the artist. She and her helper toted home the next section on which she is undoubtedly working tonight.

June 30, 1955: Along about five o'clock, Clémence passes this way having need of some color which she required for the six foot section dealing with the domestic arts—wash day and particularly the clothesline in the dominating position . . .

July 4, 1955: Miss Hunter came to see me this afternoon, hoping I might find a dab of wine for her . . . I was able to be of help . . . Miss Hunter was enchanted. She says she will be bringing the clothesline section in a day or two. Obviously she has been having fun doing it for she says, "It's alright" which means she likes it.

July 5, 1955: It [panel 5] is by far the finest and I feel certain she will not surpass it. The composition is simpler, the figures larger and the colors brighter than any of those that have gone before and I am altogether delighted with the whole business.

July 8, 1955: In the midst of one thing and another, Clémence appeared to ask for more paints. She thought she would have the pecan piece . . . completed this weekend. That will mean six finished and three to go. I hope she lives; may we all live, and I suspect we shall.

July 10, 1955: She finished the pecan mural. She did nicely. A big old sow with some little pigs grace the river bank just below the honky-tonk and the sow

appears to be about twice or thrice the size of the youths gaming outside the building and probably in the artist's mind the relative value of the animal and the gamblers is about perfect as portrayed by her facile bush.

July 21, 1955: The murals are finished![10]

The artist worked on the murals for approximately seven weeks (see Plate 2). Mignon prepared an affidavit describing the origin and the brief history of each panel. He attached it to the back of one of the sections. The document, signed by Mignon, was discovered in 1984, when the panels were removed for restoration.

At Mignon's suggestion Hunter attempted to copy for one of the panels a decorative china plate that featured a pictorial map of Melrose and Cane River Country (see Plate 4). The result is the ninth panel: a tondo representative of the region between Cane River and Red River (see Plate 5). Across the river from Melrose, on Isle Brevelle, she painted St. Augustine Catholic Church, which had been founded in 1803 by descendants of Marie-Thérèse Coincoin. In the center of the picture she painted her version of the Melrose Big House and, seeming to float around it, the plantation's famous outbuildings, Ghana House, Yucca House, and African House. Mignon asked Hunter to paint a copy of the decorative plate but got instead a pictorial map of Hunter's world.

## A Tour of the Murals

The murals hang on the four walls of the second floor of African House. The artist's figures stand out in celebration of her memories of time and place. To the left of the pictorial map Hunter painted scenes of cotton being picked and weighed. A Baptist church, in which a revival is taking place, shares the panel with images of a cotton harvest (see Plate 3).

In the next panel, in the northwest corner of the room, Hunter brings together the rites of spring with images of planting (see Plate 6). In the top corner of this section a wedding takes place, expanding further the images of fertility. The large colorful bride standing next to the small groom and the even smaller preacher brings to mind once again the strong matriarchal influences often apparent in Hunter's art.

Religious practices are repeatedly woven into the images Hunter painted. The mural panel on the southwest wall recalls a Cane River funeral (see Plate 7). The procession moves down and across the panel from the church in the upper left to the burial ground in the foreground. Like many of Hunter's paintings of plantation life, it has familiar plantation personalities. Worthy of note here is Aunt Attie. According to Mignon, Attie usually drove the funeral hearse and attended many funerals, but because she tragically burned to death in her home, she was deprived of having a traditional burial of her own.

The spirit of renewal reappears in the baptism mural, the second panel in the southwest corner of African House (see Plate 8). Although Hunter had been baptized Catholic, she regularly attended a Baptist church, so she was equally at home in her recollection of a Protestant baptism ceremony in the river. Again, a plantation personality makes a humorous addition to the scene. A woman identified only as Dorsey pretends to be seized by the Holy Spirit, jumps into the water, and attempts to steal the attention being paid to her daughters, who are being baptized. Dorsey, however, comes quickly out of the water when someone yells for her to look out for a big water moccasin. Clementine Hunter said, "Right then and there Dorsey done lost her religion and crawled slap out on the bank."[11]

Panels 6 and 7 of the series have been called "The Domestic Arts" or "Washday" murals (see Plate 9). In the upper right corner of this vignette Hunter adds a self-portrait, in which she is shown almost reclining as she paints an image of what appears to be a tree. François Mignon described the scene: "Here is as fine a mural of the primitive type, as you are ever likely to encounter. It presents wash day at the plantation and a clothesline on which plantation garments are flapping, including a pair of long red handlebars, a pair of yellow drawers with green lace and so on. For the most part, the gentlemen appearing in the composition are resting while the ladies present are busily engaged in stirring the wash pot, bending over the washtub and so forth."[12]

Mignon said the plantation honky-tonk, or juke joint, is as close as you can come to heaven on earth on a Saturday night. Hunter's paintings of the honky-tonk are populated with men and women drinking and dancing. She painted in a jazzy style that brought the experience to life. The juke joint portion of this panel is a fine example of the artist's tendency to compress time through sequential imagery (see Plate 10).

The plantation honky-tonk captured the drinking and gaiety that followed a hard week of labor. The right side of the panel escapes the foolishness of the honky-tonk and returns to a more family-oriented event, a pecan harvest. Youngsters hang from the trees to shake the nuts to the ground. We know it is taking place over the weekend because the overseer is nowhere in sight.

In the northeast corner of African House, just above the stairs, Hunter painted yet another vision of the Melrose Big House. This panel and the final one, called the "Yucca House panel," bring together a host of images both of place and personality (see Plates 11 and 12). The artist reappears in her role as domestic servant, carrying a tray of coffee or drinks. Members of the Henry family can be identified, including Jady Henry riding sidesaddle as he oversees his property. The writer Lyle Saxon holds pages he has written, and François Mignon examines one of his decorative china plates. Hunter recalled the legend of Marie-Thérèse and paints an especially robust image of her in comparison to the diminutive rendering of Thomas Metoyer.

In the center of the last panel, just above Yucca House, the artist remembered Uncle Israel Suddath, the last surviving Melrose slave who lived in Yucca House until his death in the early 1920s at the age of 106. Then, in the sky to the left, Cammie Henry's grandson Pat flies an airplane high above Melrose. With the addition of the airplane in the final panel, Hunter unconsciously foreshadowed the end of the old plantation days and the beginning of a mechanized new world ahead.

A group of teachers from Grambling College were the first to see the finished murals. While Hunter worked on the final touches, Mignon delayed the visitors' tour of African House. One of the visitors that day in 1955 was a six-year-old boy at the hand of his mother. Edward Ward grew up to become a leader in the Natchitoches African American community; his mother was a recognized leader in education. More than three decades later, Ward would be at Hunter's bedside when she died.[13]

Memory is a human experience that demonstrates what we believe, what we value, and how we interpret our history. Clementine Hunter's autobiographical African House Murals provide viewers today, just as Mignon had hoped, with a detailed and inspired documentation of plantation life as it once was. While the idea to paint the murals came from Mignon, Hunter took the paints and brushes and personally defined the final product. From the point of view of a participant, she deftly told her story of Melrose and what she

recalled about living and working there during the first half of the twentieth century.

## Ghana House Murals

Four years after the completion of the African House Murals, Mignon decided the time had come for Hunter to paint another series of plantation murals. He explained his project in a letter to Robert Wilson. Wilson had visited Melrose with his parents when he was a child. He eventually became a famous international stage designer, director, and producer who in 2011 conceived an opera *Zinnias: The Life of Clementine Hunter*. When Mignon wrote him on June 21, 1957, Wilson was a young man still living at home with his parents in Waco, Texas.

> I am rigging up the log cabin, a Negro cabin . . . I call it Ghana, have remudded the spaces between its legs, put in some crude furniture, planted a little vegetable garden, bordered with zinnias and had the south's most distinguished primitive artist embellish the rafters, above the beams, with scenes suitable for the neighborhood—the Cotton Crucifixion, the Gourd Harvest, Land of Uncle Tom and Plantation Sabbath. Murals for the Sistine Chapel are one thing but how they are going to pan out for the rafters of a little old Negro cabin, I know not—especially in the absence of one Michael Angelo [sic]. But one does what one can, and, if lucky, has a whale of a lot of fun in the doing.[14]

The Ghana House ceiling panels were not of the same magnitude as the African House Murals. While they were interesting and certainly worthy of preservation, they were sold off as individual pieces to collectors.

The African House Murals remain today available for public viewing by the thousands of people who tour Melrose each year. Just as they did when they were unveiled that summer in 1955, the African House Murals reconfirm Clementine Hunter's desire to verify and reclaim her lifetime experiences. The African House Murals, Hunter's magnum opus, is a treasured example of the artist's celebrations in paint of her work at Melrose and her life along the banks of the Cane River.

# A Lifetime Told in Art

I dream my painting, then I paint my dream.
  —Vincent van Gogh

In reminiscence my experiences do not fade,
they grow more vivid.
  —Marcel Proust

I paint for myself. The images come out of my head.
  —Clementine Hunter

CLEMENTINE HUNTER LEFT NO CORRESPONDENCE, no diaries, not even
a note on a scrap of paper from which one can learn firsthand about her life.
Interviews by reporters and researchers, with rare exception, provide little
revealing information about how and why she became an artist and even less
is revealed about her hopes and dreams. Her life spanned more than a half-
century before she started painting. After first picking up a brush, she painted
for a couple of decades before the world began to take notice. By the time she
became famous, Clementine Hunter had lived so long that most who knew her
in her youth had died. No enlightening stories from close family or friends,
either oral or written, exist. François Mignon's written version of Hunter's life
as he saw it from the time he met her in 1939 is the best source of information,
and as valuable as Mignon's writings are, there are long periods when there
is no record of what or how she was doing. The social reality of her day was
that she lived her entire life on the other side of the fence, and no one from
Hunter's side of the racial divide wrote her history.

While much has been written about Hunter and her work since she at-
tracted national attention, on examination the root of most stories and an-

ecdotes leads back to Mignon. Yet, despite the absence of written word, the artist's visual diary of her life on a plantation in the twentieth century goes a long way toward helping explain who she was, how she thought, and how she lived. From picking cotton to birthing babies, from the church house to the honky-tonk, from the courtroom to the sickroom, she painted it all. In her repetition of theme one hears her emphatic confirmation: "This is how it was." To understand the artist Clementine Hunter, one must experience her art.

## A Gallery Tour of Clementine Hunter's Art

### Cotton Needs Picking

King Cotton—the highly profitable crop of the Old South, so labor-intensive to produce that it helped to fuel a Civil War over slavery. Cotton created the wealth of many of the legendary plantation owners. When slavery ended, workers were free, but many remained and seamlessly continued with the only life they had ever known.

When Clementine Hunter was born, twenty-two years postbellum, cotton continued to hold its position as a major crop in Louisiana. While Hunter's parents had never been enslaved, her family worked in the same fields and labored at the same jobs as the enslaved men and women who preceded them. Clementine Hunter quite literally grew up in the sun-scorched cotton fields in and around Melrose Plantation. As a child, she joined her parents in the fields. She learned the cotton business from the point of view of the laborer: the planting, hoeing, chopping, hauling, ginning, and baling of cotton occupied the first half of her life. Throughout the second half of her life the indelible memories of her cotton field experiences became one of the dominant themes of her art.

Examining a progression of "picking cotton" pictures reveals that the artist evolved from her early complex and detailed scenes to what became in her latter days a less detailed, more impressionistic images. As Clementine Hunter aged, she suffered from painful arthritis in her hands. The well-defined scenes from the 1950s became less complex, and she lost the crispness and detail characteristic of her early years. Nevertheless, the memories of her cotton patch days remained fresh on her mind. She painted cotton-themed pictures again and again, in part because it was who she was and what she knew and

partly because her cotton pictures were always in high demand and provided guaranteed and immediate income.

A cotton patch painting from the late 1940s, possibly early 1950s, takes the form of a narrative (see Plate 13). The women pluck the ripe bolls and drag the heavy cotton sacks, the men collect the harvested cotton, and in the lower foreground two men weigh the cotton. The eye of the viewer is attracted to the upper left foreground image of Ghana House, a familiar antebellum cabin on Melrose that was used as a washhouse during Hunter's time. The artist stepped into the painting when she created a portrait of herself sitting next to Ghana House and appearing to paint the scene of the cotton pickers. She holds her canvas in her lap, as was her custom, and her brushes stand ready in a jar beside her chair. The addition of the self-portrait makes this rare, early, and exceptional work worthy of note.

Cotton bolls mature at different rates, so the picking of ripe bolls could not be completed in one pass. Cotton in the same field was often picked three or four times as pickers returned to glean the fields. The artist portrays the cotton pickers laboring under the weight of the cotton sack and straining forward in painful, backbreaking positions.

*Hoeing Cotton* is an early oil on paper painting by the artist that illustrates the necessary practice of loosening the dirt and removing the weeds around the cotton plants (see Plate 14). The artist's style and technique apparent in this work suggest it was done during the early 1940s. She added the signature in the 1950s or 1960s. Five women and two men labor with hoes in hand. In the lower left foreground the artist remembered the water jug with the common cup resting atop the canister. Working in the brutal Cane River sunshine made water an essential addition to any outdoor labor experience.

*Cotton Pickin' and Haulin' Cotton* provides the viewer with a richly detailed vision of the harvest (see Plate 15). This work, which is signed "CH," dates from the 1940s or early 1950s. The artist experimented with perspective by pulling the white fence down to a point in the center foreground of the picture. This action directs the eye of the viewer from the woman in the lower left foreground emptying a cotton sack toward the four women in the background dragging their bulging cotton sacks. In the lower right foreground a driver cracks his red buggy whip to encourage his mule or horse to pull the loaded cart to the cotton gin. Two children, one at the pile of cotton and another on the back of the cart, serve as another reminder that with no available

childcare, women were forced to take their young children to the fields when they worked.

Hunter often used stacked images to suggest perspective. In a painting called *Picking Cotton* she recalled six women picking two rows of cotton, three on each row (see Plate 16). In this oil on upon board from the mid- to late 1970s the women, all wearing red hats, stand tall as they collect the harvest. Between the rows are geese, which were used to control the growth of weeds and grass in the cotton patch. This practice was discontinued after the introduction in the 1970s of effective chemical herbicides.

Two other pictures demonstrating the progression of Hunter's cotton-picking theme are also from the mid-1980s, when the artist was in her mid-nineties (see Plates 17 and 18). *Pickin' Cotton* and *Late Cotton Picking* are representative of the hundreds of such works the artist produced. In the early days, when she had little paint, she thinned the colors; in the works from her final period she used heavy paint, thinned only slightly, if at all. The now familiar images of women picking ripe cotton bolls and pulling white cotton sacks grow less distinct, more abstract, but no less appealing.

*Late Cotton Picking* provides evidence of the artist's aging hand. She omitted an underpainting, and the impasto white cotton merges with the white canvas. Hunter painted the traditionally white cotton sacks blue to distinguish them from the white background, suggesting that while her memory may have been failing, her ingenuity was not.

Not all of Hunter's cotton-themed works illustrated cotton picking. She developed an entire range of paintings from the hoeing rows in the cotton patch to hauling bales to the cotton gin. Over three feet long and a foot high, the longitudinal *Cotton Mural* from the early 1970s is another illustrative vignette from the cotton harvest and contains the kinds of images for which Hunter became famous (see Plate 19). In it the artist brought together many images she often painted as single paintings. In the left foreground of the painting the women pick cotton; in the center of the work a mule pulls a wagon full of ripe, white cotton bolls. The work reveals the division of labor: women hoed and picked cotton; the men hauled and ginned cotton. In the background the white smoke streaming from the red building's tall smokestack indicates the gin is operating. Finally, in the right foreground the freshly ginned cotton, baled in brown burlap, is stacked for shipment. The artist seemed to be saying, "This is what we did." She painted her memory using bright colors, concealing

the painful reality of the long, hot days and the painful labor associated with the cotton harvest.

When Clementine Hunter began working in the cotton fields, engineering expertise to design and build a mechanical harvesting machine did not exist. She had been out of the fields and in the Big House at Melrose for decades before mechanical harvesting became a widespread reality in the 1960s. The cotton harvester profoundly revolutionized the cotton business. Work that took over a hundred man-hours per acre when Hunter had labored in the cotton fields could be accomplished in a fourth of that time using a cotton harvester. The plantation owners' labor demands declined almost overnight. Just as the Civil War ended slavery, the cotton harvester ended the sharecropper system. Like many of their ancestors had after the Civil War, a new, twentieth-century movement of unemployed African Americans moved from the farm jobs in the rural South in search of factory jobs in the North.

Hunter would not have understood the social implications that resulted from the arrival of the mechanical age to the cotton patch. She clearly watched the noisy, massive machines moving over multiple cotton rows accomplishing in hours the work at which she and so many others had labored for days. Eventually, in the 1970s she picked up her brushes and painted her version of a mechanized cotton harvest (see Plate 20). In her rendering the cotton stalks stand tall and heavy with ripe cotton bolls. The hauling wagon in the foreground is piled high, but for all the apparent effort, the only laborer in the picture is the man driving the bright-red cotton harvester. While she would return again and again in her remaining years to more nostalgic memories, this rare painting provides the perfect conclusion to her visual narratives of cotton field memories.

### The "Domestic Arts"

Just as Hunter drew influence from her experiences in the cotton fields, so too was she influenced by her duties as a domestic servant. Hunter painted hundreds of pictures of what François Mignon referred to as the "domestic arts."[1] Washday scenes bring to life Hunter's recollections of washing laundry in an iron pot and hanging the colorful clothing high on a line to dry in the sunshine. For decades after she left the cotton fields, Hunter regularly washed,

hung, and ironed laundry for the Henrys and several other white families who lived along Cane River.

In the artist's formative years she created one of her earliest washday paintings (see Plate 21). This richly detailed washday memory originally came from the James Register collection. The current owner purchased the work in the 1970s from Register. Dating from the 1940s, the oil on paper reveals the artist had not yet discovered the more familiar washday images she would eventually paint again and again. A woman in a red dress and blue apron wearing a large white bonnet labors over a black iron pot of boiling water. At her side in the foreground a scrubboard rests in what appears to be a washtub. In the right mid-ground a clothesline stretches from the image of a tree to the painting's edge. Three oversized birds, two black birds and one red bird, fly across the colorful, abstract sky. There is no underpainting; the artist painted various colors in broad strokes, filling the background to indicate the sky and ground. Initially unsigned by the artist, James Register used orange paint to sign the work "Clémence" in the late 1940s. Register added the artist's monograph in pencil in the 1960s.

Clementine Hunter included a self-portrait in an early 1940s washday painting. Titled *Artist Painting as Others Washing in Yard*, the oil on canvas board provides a rich and detailed narrative of domestic duties (see Plate 22). In addition to the central figure of the woman using a scrubboard, another figure tends to a small child, and a third woman sweeps the ground with a broom. The artist painted an image of herself under the canopy of a tree with blue leaves. Hunter added the painting's background as she painted.

The bright washday painting with the pink background is expertly composed and highly detailed: in the lower right foreground there is a rack on which to hang the ironed linens; white buttons highlight the red pair of long johns; white lace trims the pair of blue bloomers (see Plate 23). The artist painted a flock of three birds with a harmony of colors that complemented the windblown laundry. Hunter confirmed this was a Melrose memory by including the image of Ghana House in the background. But for all the color and beauty of the moment the four women bend diligently over their work, seemingly oblivious to each other and to the world around them.

The images of women doing laundry beneath a high-stretched line hung with brightly colored clothing and cloud white linens remained in Hunter's

mind and on her canvases (see Plate 24). The washday theme proved popular with Hunter's patrons, and she painted it often to fulfill demand. These pictures have become iconic images of bygone days and remain highly prized by collectors of Hunter's art.

Washday paintings evolved but changed very little during the 1970s and 1980s. One change worth noting is that the women laboring over the laundry cleaning duties tended in time to stand more erect. As Hunter aged and washing in an iron pot became more memory than realty, the recollection of bending all day over the washpot or scrubboard began to fade. A colorful washday memory from the 1980s recalls the experience but conceals the painful reality of toiling over hot pots and reaching high to hang clothing (see Plate 25).

Washday paintings were so popular with those collecting Hunter's art that she produced scores of small 8" x 10" oil on canvas board washday paintings (see Plate 26). Each work included the ubiquitous iron pot with a woman washing clothes beneath a clothesline of colorful laundry. These minimalist works in oil took the artist little time to produce; on close examination one can almost count the brushstrokes. The artist painted an intimate, well-composed washday scene that takes the viewer close to the subject. These paintings originally sold for very little, but because of their popularity, they provided the artist with an easy, dependable income.

## A Lifetime Fascination with Flowers

There is little doubt that the first and last paintings to come from the brush of Clementine Hunter were images of flowers. She clearly loved flowers and painted them during every period of her career. If one counts the wreaths and bouquets in her wedding, funeral, and wake paintings, she easily painted tens of thousands of colorful blossoms.

Alice Ray Yelen, the New Orleans Museum of Art scholar, points out: "Still lifes of flowers, common in the Western tradition of art history, are rare in the work of self-taught artists. But they are not uncommon in the work of Clementine Hunter."[2] There are two reasons this might be true: flowers at Melrose, both in the house and in the gardens, were part of Hunter's daily experience; and one of the artist's earliest influences to paint came from her witnessing Alberta Kinsey paint magnolia blossoms and floral still lifes.

A floral still life painting from the mid-1940s provides confirmation of the

artist's intrinsic ability to paint sophisticated images of flowers from the earliest days of her long career. The impressionistic rendering of blossoms in the painting in Plate 27 appears to be pastels or watercolors, but it was Hunter's heavily thinned oils that produced these images. The muted, soft colors from the flowers' petals stream into the background of the painting. The artist did not sign the painting, and it is the absence of a signature that permits the dating of the work. James Register's addition of *Clémence* in yellow paint confirms that this painting was sent by Mignon to Register when he was living in Oklahoma.

Of all Hunter's hundreds of zinnia paintings, a large still life called *Bowl of Zinnias* has received considerable attention over the past several years (see Plate 28). Whitfield Jack, grandson of the original owner of the work, dates the painting to the late 1930s, when Hunter gave the painting to his grandmother, Mrs. Blythe Rand of Alexandria, Louisiana.

The Rand family maintained a summerhouse on the Cane River on the Melrose Plantation grounds. Hunter often worked for Mrs. Rand when her family was in residence. While Jack would have been a young child during the time he spent summers with his grandmother, he knew Hunter and Mignon and remembers them. Both Mignon and Jack's grandmother told him *Bowl of Zinnias* was Hunter's first picture.

Although the gardens of Melrose were vast and plentiful, it was my grandmother's custom on her frequent visits to Melrose to take something from her own garden to Miss Cammie. On one of these occasions, when Alberta Kinsey was also there, the flowers happened to be a bunch of zinnias that were in a hammered copper pitcher.

As my grandmother related the story to me, she and Miss Kinsey were visiting together, and Miss Kinsey was so struck by the beauty of the zinnias and the copper pitcher, that she began to do a sketch for a still life of the arrangement. At one point Clementine came into the room and commented that she thought she might be able to paint a picture, too. Miss Kinsey stopped her sketching and rounded up a collection of partially used tubes of oil paint and gave them to Clementine, telling her to take the copper pitcher and the flowers and try her hand.

On my grandmother's return a few weeks later, Clementine presented her with the painting of the pitcher and the bouquet of zinnias. It was done on a

piece of corrugated cardboard, actually the side of a corrugated box; and in her enthusiasm Clementine had apparently used up the entire supply of paint. The oils were laid on with abandon in thick brush strokes and generous dabs. The zinnias seemed to almost come alive, ready to be picked.[3]

Jack also owned the original copper bowl seen in the painting. He said "The bowl really wasn't a bowl; it was a beaten copper pitcher with a handle on the side and a typical V-shaped pouring spout."[4] Whitfield recalled the pitcher sat on top of his grandmother's refrigerator for many years and passed to him when he was given the *Bowl of Zinnias* painting. "It was the container which my grandmother [Mrs. Blythe Rand] took to Melrose with zinnias in it . . . The *Bowl of Zinnias* painting hung on the wall next to the refrigerator where the pitcher resided. It was referred to by the family as 'the pitcher in the picture.'"[5] The copper pitcher was lost in a fire at Jack's Greenwich Village apartment in Manhattan in the mid-1960s.

There are numerous examples of Hunter's fascination with the zinnia. One, an oil painting on paper from around 1944, came originally from the James Register Collection (see Plate 29). The artist did not sign the work, but there is no doubt the painting originated from her hand. Hunter produced dozens of early paintings of flowers on black backgrounds.

François Mignon planted white zinnias in the summer of 1953. "The white zinnias are particularly impressive with each blossom being about four inches in diameter," he wrote. "Where they appear, as at the base of the sundial, in beds exclusively white, they seem wonderfully modernistic, while those which come into flower among the velvety reds, purples, oranges and yellows some-how contrive to give inordinate value to everything in their neighborhood."[6]

A colorful pot of zinnias painted around 1970 offers further confirmation of Hunter's ability and desire to paint images of her favorite flowers (see Plate 30). She includes the handle from the pitcher in some works; in others she only paints the bowl. The artist moved from painting her personal memories of actual flowers to painting memories of her own painted images of flowers.

While Clementine Hunter certainly had no knowledge of impression-ism, she created paintings during her early period with impressionistic tones. *House and Garden*, an oil on paper painting from her earliest period, appears to be pastels or watercolor (see Plate 31). The soft-brushed blossoms from the garden foreground blend with the sky and the house and saturate the paper

with soft shades of color. This work is unsigned and dates from the late 1930s or early 1940s.

Cheerful, bright-red spider lilies (*Lycoris radiata*) bloom overnight in southern gardens in late summer and early autumn. Tom Whitehead watched the artist as she sat in her yard and painted her version of a bouquet of three spider lilies on a sunny October afternoon in 1972 (see Plate 32). "She finished the whole picture in less than half an hour," he said. "I bought it immediately."[7] Hunter often painted floral still lifes, but this painting of spider lilies exploding into bloom is thought to be the only work painted en plein air. She often said that she could not look at something and paint it, but Whitehead witnessed the artist painting *Bouquet of Three Spider Lilies*.

*Religious Influences*

The cultural fabric of the South is woven with religious thread, but politics and society influenced religion far more than religion influenced politics and society. In the Old South the Society of Friends (Quakers) was the only religious group that preached against slavery and taught that all men are equal in the sight of God. While both races worshipped the same God, whites attended one church and blacks another. The custom of segregated worship continued well into the twentieth century, and remnants of those times remain today.

In the Jim Crow days of Clementine Hunter's life, it comes as no surprise that African Americans worshipped separately from whites. What might be surprising is that the Creole St. Augustine Catholic Church on the Cane River also segregated the races. The caste system enforced by the church permitted the Creoles to sit in the front, followed by white guests, then African Americans in the back of the sanctuary.

In the late 1950s the Catholic bishops determined the time had come gradually to break the color barrier between the light-complexioned Creoles and the more dark-complexioned African Americans. Because she was well-known and respected in her community, the church reached out to Clementine Hunter to become a highly visible Catholic.

In his January 6, 1957, diary entry, François Mignon mentioned the Catholic's attempt to recruit Hunter: "I was interested to learn today that May Balthazar of the prominent mulatto gentry hereabouts [Cane River Creole] is engineering Miss Hunter into the Catholic Church. When a mulatto recog-

nizes the existence of a Negro, that is news . . . apparently May, and some of the reverend fathers are going to break through that barrier [between African Americans and Creoles] . . . and so another blow for racial tomfoolery, or against it, is about to be struck."[8]

Hunter's conversion to Catholicism took an interesting route. For most of her life, approximately seventy years, Hunter was an evangelical Protestant who attended the African American St. Matthew Baptist Church. She worshipped as a Baptist despite the fact that several months after her birth, a traveling priest, following the traditions of the Holy Roman Catholic Church, had christened her into the Catholic Church. What little education Hunter had came from Catholic nuns who taught in the segregated primary school. She grew to adulthood and lived her entire life in the shadow of the spire of St. Augustine Catholic Church. And while she considered herself a Catholic during the later years of her life, she never became a traditional Catholic.

To attempt to understand Hunter's religious beliefs, one must return to the messages in her art. She left a rich legacy of paintings with religious imagery rooted in Catholic and Protestant teachings flavored with Africanisms. Some of Hunter's religious paintings can be interpreted as memory paintings; others are inspired by Bible stories or prayer cards; still others represent resourceful expressions of imagination.[9]

In her oral history recordings with the artist, Mildred Bailey said the first Hunter painting she bought was a *Black Jesus*, for which she paid three dollars (see Plate 33). She asked Hunter if she thought Jesus was black. Hunter said, "I think he was; everyone always said he was."[10] Whitfield Jack recalled seeing one of Hunter's Crucifixion paintings, in which she painted a black Jesus and two white thieves.[11] Ann Brittain believed whether it was "God or Jesus or Santa Claus," Hunter imagined they were all black.[12]

The black Christ on the Cross became a popular theme for the artist from the late 1950s until the end of her life. Could she have been inspired by Catholic prayer cards? Was she recalling statues of Christ on the Cross that she had observed in the Catholic church? While either or all of these suggestions might have inspired her, there is also another explanation. François Mignon suggested to Hunter in 1953 that she consider painting "a colored man on the Cross":[13]

> I asked her if she had ever tried painting a picture of Christ on the Cross. She hadn't. I pointed out that there had generally been something cock-eyed about

all such pictures, in that the background always suggests winter, or at least the end of the world, whereas all the pictures of Easter—only three days later—are always with vegetation. And so I suggested she do a colored man on the Cross and have a big old magnolia or some such tree in the bloom on one side, and perhaps a picture of the African House somewhere in the background. She thought a log cabin would be prettier than the African House and I told her I thought a log cabin would be just fine. Clémence never did paint anything of any account when it was done to order, but after she mulls over the above idea, she may eventually sense it as her own and bring forth something interesting.[14]

While the original idea came from Mignon, Hunter's paintings of Christ on the Cross are clearly her own interpretation. She demonstrated no concerns about mixing the scared with the secular; she put the Cross in a cotton field as though the Crucifixion were part of plantation life. Scholars point to a symbolic link between the suffering of African Americans and the Crucifixion of Jesus. Hunter would have never intentionally made that connection, but as any student of aesthetics knows, art often represents more than the artist's intentions.

The baptism painting on a window shade that Mignon identified to Bob Ryan as the artist's first painting was not her first effort, but possibly it could have been one of Hunter's early attempts to paint a Cane River baptism (see Plate 34). The degree of complexity in this work suggests it originated in the 1940s; the unsigned horizontal work executed in thinned oil is characteristic of her paintings from this period. St. Augustine's church dominates the work, and the action in the picture takes place in the left foreground of the painting. Hunter's overlapping images created a sense of space. The artist recalled her memories of a baptism by immersion, a Protestant custom, taking place in the Cane River. In the distance is a version of Yucca House. Hunter painted Cane River baptism scenes throughout her career. This painting would be considered an outstanding work by any measure, but the controversial provenance adds to its charm.

A painting from 1962 demonstrates the artist's development since she first painted a baptism work in the late 1930s (see Plate 35). Use of stacked perspective became a standard technique to provide separation among the various layers of action in the paintings. Hunter's recurring decision to mingle the custom of Protestant immersion within sight of the Catholic church speaks

to her personal religious feelings. Catholic priests appear to be performing a baptism by immersion in the foreground.

Influenced by her Protestant and Catholic teachings, Hunter painted hundreds of works with religious themes drawn from Christian symbolism. In addition to the Crucifixion and baptisms, she recalled the images she observed on Catholic prayer cards or inside Protestant biblical brochures.[15] Hunter's decision to paint Christian-themed scenes added her unique voice to a visual conversation about Christianity that began in the fourth century.

In the 1950s Hunter's painting *Mary and Child* seems to take place months, if not years, after the birth of the Christ child (see Plate 36). A seated Mary dominates the center foreground of the oil on paper work; the young Jesus stands at her knee. In the distance Joseph, with his curved staff, approaches the Holy Mother and Child. Anchoring Joseph to a patch of grass demonstrates Hunter's compositional ingenuity and prevents his image from appearing to float. Next to Mary the artist placed the symbolic lamb, painted in heavy white impasto style to give the impression of a full coat of wool. Worthy of note is Hunter's rendering of the angel above Mary. In later years her angels were either red or white, with less anthropomorphic detail. The tall beehive of the angel's hair suggests hair blowing from the winds of flight. The flowing beehive hair became more pronounced and cone-like during the decades of the 1970s and 1980s. The beehive hairstyle is reminiscent of one from the Republic of Senegal in western Africa, but Hunter claimed it was not a beehive but, rather, how she imagined hair blowing in the wind.

In the late 1970s Hunter painted a colorful and somewhat whimsical scene of the Nativity (see Plate 37). Whatever she saw that inspired this work was certainly different than her painted version. The pregnant Mary, guarded by one angel at her back and two in flight, walks on a zinnia-lined path toward a red manger on top of which the artist painted a Christmas tree. Signaling the Holy Birth is imminent, the artist painted the image of a doctor, medical bag in hand, rushing to be at Mary's side. By placing an anachronistic Cross on top of the church, the artist unknowingly foreshadows Jesus's ultimate death by crucifixion.

*Flight into Egypt* finds Mary, dressed in bright blue, riding on a white horse and cradling the baby Jesus in her arms (see Plate 38). Joseph, at one end of a long, taut rope, leads the horse along the path. Two large angels with yellow trumpets herald the Holy Family's arrival. Hunter takes ownership of the nar-

rative by including images of a winged, black cherub and two geese. This circular composition certainly resulted from stories Hunter had heard in church or from pictures she had observed in Christian literature. In the left foreground the paint has flaked off the wing of a white goose, revealing the artist's original pencil outline, where she had "marked" the picture before painting.

A rendering of a Protestant revival service, possibly taking place inside a tent, is an oil on upson board work painted sometime before 1955 (see Plate 39). This work predates the period when Hunter officially became a Catholic and seems to recall her memory of an old-fashioned Baptist revival. The pastor, his hand raised high, preaches from a raised platform to a gathering of mostly women. Two women stand and fan two others, who have been emotionally overcome by the preaching.

*Revival* presents a compositionally complex image. The action seems to be taking place inside a tent, or is it outside the tent? The arching blue sky, the green path to the gate, the curved altar, all work together creating an unsettling but nevertheless interesting composition.

While some artists eschew scenes related to death, Hunter never hesitated, and she painted hundreds, perhaps thousands, of pictures recalling wakes and funerals. Ann Brittain's first Hunter painting was an early funeral scene. When Ann Williams married Jack Brittain in 1955, François Mignon gave the couple a Cane River funeral scene as a wedding gift (see Plate 40). *Country Funeral* had been included in a famous Hunter exhibition in St. Louis in 1952. Mignon mentioned the gift in his daily journal: "I solved the gift problem with dispatch by going over to Clémence's house where I found a very lovely Cane River Funeral—of all things for a bride. But it was one of the items that had appeared in the Saturday Gallery show in St. Louis and was appropriately framed and so met my needs perfectly."[16]

The painting dates from the late 1940s and recalls the funeral procession as it exits St. Augustine church and makes its way to an open grave. The early work is important not only for its stellar provenance, but it foreshadowed many similar Cane River funeral scenes Hunter would paint in the years ahead. Mignon called the painting *Uncle Jack's Funeral*. By any name it is a richly detailed snapshot of early-twentieth-century life and death along the Cane River.

In 1966 the artist painted an especially colorful version of the Cane River funeral as a bright and joyous occasion (see Plate 41). In this work, which Tom Whitehead acquired while he was in college in Natchitoches, Hunter took her

pink brush and all but celebrated an event that by any other standard would be a solemn occasion. This painting conveys the artist's belief that the tears are shed at the wake, and the funeral is a happy occasion celebrating the departed one's journey from earth to a heavenly reward.

Without a doubt the most moving of all of Hunter's sacred themes is a famous painting from the mid-1970s called *Frenchie Goes to Heaven* (see Plate 42). Inspired by her attempt to come to terms with the death of her son, Hunter painted a work that dramatically illustrates her vision of Frenchie as he departs earth on his trip into eternity. Mildred Bailey thought the painting demonstrated the role of inspiration in Hunter's art:

> I went to see her one day and she said, "Frenchie is coming home to die," and I didn't even know who Frenchie was. And she said he was her oldest son and he always lived in California. So the next time I went down to see her, Frenchie was there and he really had come home to die. She cared from him and nursed him as though he were a little child.
>
> I went to Frenchie's funeral. And about two weeks later, I was coming home from Baton Rouge one day and I thought I would pay her a visit. We talked a while and then she said, "I have something to show you." She disappeared into another room and came back with this painting. It is the cemetery of St. Augustine Church, there is an angel dressed in white and coming from one of graves. [It was] Frenchie. There was also a little hole up in the sky and she pointed that out to me. "That is where Frenchie is going to get through to go to heaven." She said she had awakened one night in the middle of the night and had this picture in her mind.[17]

African influences in Hunter's art have always interested scholars and collectors for what they reveal about the artist and her community. Enslaved people originally tried to retain many of their native African ways and customs; during Hunter's day most attempts at African cultural retention had been lost, declined, or remained only in small ways. Oral traditions kept certain words of African origin alive in speech, words such as *gumbo* and *banjo*. Likewise, certain spices and foods with roots in Africa remained—okra, yams, and watermelon. One of the most obvious retentions of African influence was fashion, the tendency to favor bright colors and wear the hair in cornrows.

In *Woman Carrying Gourds* Hunter recalled women toting bundles on their

heads in the African custom (see Plate 43). In this early work the artist painted an especially robust woman carrying a tray of gourds on her head. Mignon grew gourds as a hobby and often hung them to dry around the edges of the porch at Yucca House. This work is a celebration of the gourd harvest. By including an image of African House, Hunter tells us the scene comes from her Melrose memories. Twisting and twining around the painting are gourd vines in various stages of growth, giving the work a flavor of art nouveau.

Hunter's many paintings of flying angels, celestial-white for the good angels and devil-red for the bad angels, suggest a blending of Christian teachings with the collective memory of spirits and demons originating from the oral traditions of her African heritage (see Plate 44). She once said that she thought everyone had his or her own angel.[18] "I just go ahead and paint what's in my mind." she said.[19]

Nothing Hunter painted appeared to illustrate African influence as much as a series of African women in profile (see Plate 45). She painted these women in pairs looking toward one another, and she painted them as singles. They are stately, proud, and all wear brightly colored tignons. The similarity of the cameo-like profiles suggest she had some kind of traceable form, but there is nothing to confirm that. These painting from the late 1960s through the mid-1980s raise questions about influence, but who or why or when is not known. François Mignon never mentioned the paintings. James Register influenced the artist to create mask images, but those abstract works were unlike Hunter's remarkable masklike images of African women in profile.

By the 1980s the larger formal images of African women were reduced in size and comingled with more familiar subject matter. *Two Ladies in Masks with a Man Hunting Birds* demonstrates how the theme evolved over time (see Plate 46). Hunter often reinterpreted scenes with merged images, as in this surreal combination of African images within a Cane River hunting scene.

### Scenes from Hunter's Private Life

From sunset on Saturday until sunrise on Monday most plantation workers had time off. For many years Clementine Hunter lived just across the road from Melrose and in sight of Bubba's, one of the nearby juke joints; the other was The Friendly Place (see Plate 47). She complained about hearing loud music and being awakened by the occasional gunshot.

The artist painted numerous versions of *Saturday Night at the Honky-Tonk,* and they were always populated with images of folks drinking, dancing, fighting, and dying (see Plate 48). In these paintings she created time-compressed narratives that recalled the characteristic scenes of drunkenness and violence that surrounded a crowd of Saturday night revelers at the juke joint. The wounded and dying man lies on the ground, but in some versions of this theme Hunter telescoped time and illustrated the bullets simultaneously leaving the gun and traveling in midair while concurrently the doctor or ambulance arrives. The red honky-tonk dominates the center of the picture, and the drinking and fighting surrounds the area outside the building. What at first appears to be a strange symbol painted on the building is actually Hunter's version of a large window fan. The image of the fan has been mistaken for a voodoo symbol.

Clementine Hunter painted hundreds of works that illustrated her personal experiences when she was not working. These paintings as a group are not unlike a photo album of snapshots from her life. In a broader sense the paintings reflect the lifestyle of the African Americans and Creoles from the community in which she lived.

In a pre-1955 work Hunter recalled the days of the midwife and the birth of a baby (see Plate 49). She tells the story in series of scenes that take place over the time span of the event. The new mother, dressed in white and reclining in a blue bed, seems to be straining as the midwife attends the birth. The newborn infant is being bathed. An attendant boils water on a potbellied stove. The family gathers around a crib to see the new child. A man, probably the father, overcome from the ordeal, lies on the sofa. In the open window Hunter imagined a young girl outside looking in the window and witnessing a scene that may well be part of her future. This popular painting has hung often in exhibition and been included in numerous publications. Probably one of a kind, *Birthing a Baby* is a rare work that allows an intimate glimpse into a very private moment.

Hunter condensed her view of plantation life in a window shade painting she created around 1960 (see Plate 50). In the foreground of the work the ever-present church and baptism suggest spiritual rebirth. In the midground of the canvas the artist recalled a lifetime of working in the cotton fields. Finally, the church again—this time a funeral takes place. She seems to be saying, "We are born; we work; we die."

*Art beyond the Canvas*

Hunter's artistic ability ranged far from the more traditional painted boards and canvases, cardboard and boxes. The artist surprised Cammie Henry when she demonstrated her ability to create decorative drapery fringe. Mignon also writes of the artist's ability to make dolls early in her development. There is a good chance that before she sewed fringe or made dolls, she made quilts. Hunter produced at least a couple of dozen quilts during the late 1930s, many more over her career. Hunter created both functional quilts, used for warmth, and decorative quilts. Whatever she touched, she provided further confirmation of her artistic ability.

Hunter probably learned quilting when she was an adolescent, but documentation of her quilting efforts did not come until some forty years later.[20] As early as 1945, Mignon in his journal recalls Hunter's quilting ability: "Ever so long ago, Clif Byrd [Clifton Ellis Byrd, a prominent Louisiana educator during the early part of the twentieth century] got a huge sheet of heavy brown wrapping paper and drew a large picture of Melrose on it—the house perhaps two and a half or three feet wide, overhead he put in some clouds, and to the side, both sides, some trees and bushes, and in the foreground the blue waters off Cane River. When completely sketched, it was the size of a bed quilt."[21] Mignon wrote that he took the large, brown paper drawing to Clementine Hunter's cabin, and "we figured it out that we could transfer the original design onto the thinner paper, on which the various pieces of cloth could be sewed, thus leaving the original pattern for us to refer to at any time."[22]

Mignon expressed his hope that "with Mr. Byrd's distinctly attractive creation as a sketch," Hunter should be able to "rig the thing up." He also nodded to Hunter's individuality: "Knowing Clémence as I do, she will be determined to get the thing into production. And I shall be amazed if she really does take time out to transfer the design."[23]

Gladys-Marie Fry, an authority on African American textiles and professor emerita at the University of Maryland, studied Hunter's quilts and visited with her on two occasions during the 1970s. She felt Hunter's quilting techniques differed little from those of her enslaved ancestors. "There was nothing fancy about her tools or her attitude toward them. Her quilting frame was an old stool with a wooden board placed on it, and she kept her sewing equipment in a tin coffee can," Fry wrote.[24] Fry saw in Hunter's pictorial quilts of Melrose a foreshadowing of the artist's African House Murals (see Plate 51).[25]

Fry found in Hunter's quilts West African influences in color, strip aesthetic, and appliqué. "Her quilting designs and technique show, in fact, distinct West African influences," she suggested. "West Africa, the area from which most African American slaves were taken, has long had a rich textile tradition, and it is not uncommon for elements of that tradition to appear strongly in quilts made in the New World, though the quilter is often not aware of her indebtedness to the old techniques" (see Plate 52).[26]

Lee Kogan, curator emerita of the American Folk Art Museum, put it this way: "It was color, motion, strong contrast and narrative that Hunter sought in her quilts—not tiny, even stitches. Her aesthetic, like that of some other African-American quilters, emphasized graphic design. The stitches are a means, not an end in themselves."[27]

Like her paintings, Hunter's quilts are uniquely her own (see Plate 53). Art dealer Shelby Gilley bought, sold commercially, and personally collected many of Hunter's quilts. He wrote, "A Clementine Hunter textile is as unmistakable as one of her paintings, and almost always shows her need for balance and bright colors."[28]

Painted objects are probably the most overlooked and understudied creations by the artist. When she had no canvases in her early painting days, Hunter turned to box cartons, discarded cardboard, window shades, and whatever else she found. After her friends and patrons began to supply canvas boards, she shifted away from painting on discarded material. She always painted on boards and canvases, but for no apparent reason, late in the 1960s, she once again became fascinated by painting on discarded objects.

Once her brush left the canvas and found objects, there was no stopping her: she painted on milk, snuff, and wine bottles (see Plates 54–56). She painted flowers and scenes on wooden roofing shingles that came from the African House when the roof was replaced (see Plate 57). She painted on thin wooden panels used to make purses, a commercial craft product popular with women in the 1960s and 1970s. On more than once occasion she painted scenes on an old wooden ironing board.

Patrons encouraged her painting on objects and began bringing her items they wanted painted. Dr. Robert Ryan glued tongue depressors to small boards he wanted painted. Shelby Gilley provided the artist with numerous wooden, semicircle shapes, like slices of watermelon, on which Hunter painted the deep red image of the sweet fruit complete with black seeds and a green rind.

As was often the case, when the artist ventured into a new form of expression, a commercial market soon followed. Outstanding examples of Hunter's object painting, efforts not influenced by others, confirm her ability to extend her talent into new and unexplored areas even as she was approaching the end of her career.

Clementine Hunter said she could not paint unless she first saw the painting in her head. Clearly, most of her paintings came from memories, dreams, and her imagination. When asked to produce items on commission, she reluctantly agreed if the price was right. Often these "on order" paintings confirmed the artist's talent for extending her art and her ability to learn and explore new subjects.

One such painting is a rare piece that demonstrates Hunter's willingness to paint beyond the horizon of her life experiences. When Seattle, Washington, advertising executive Bill Bailey Carter was an undergraduate at Northwestern State University in 1973, he convinced the artist to copy the Kappa Alpha Fraternity crest (see Plates 58 and 59).

Up the road from Melrose is a restored, stately plantation now called Cherokee (see Plate 60). The owners, friends of Hunter's, collected her art. They gave Hunter a photo of Cherokee and asked her to paint her version (see Plate 61). Without exception Hunter's interpretations were always uniquely her own.

In the 1970s Curtis Guillet, well-known Natchitoches photographer, took many photographs of Clementine Hunter over the years. His photographic study of her clutching a Rhode Island Red hen became one of the most famous photos of the artist (see Plate 62). The artist painted her version of the photograph (see Plate 63). Known for her flights of fantasy and humor, Hunter occasionally allowed her imagination to take over. Possibly inspired by scenes on commercial packaging, she clearly enjoyed painting large chickens or geese pulling carts of gourds (see Plate 64).

In 1977 the artist bought and paid for her own house trailer with money she made from selling her art (see Plate 65). In the fall of 1985 she moved her home to a location near Natchez, Louisiana, and there she lived out her final days. Hunter painted her version of her house (see Plate 66).

Before the artist moved to her last residence, she lived for most of her life on, near or just up the road from Melrose Plantation. By 1970 the days of Melrose as a working plantation were coming to an end. The Henry family decided to sell the famous house and grounds to the Southdown Land Company. For

two days in June 1970 over seven hundred items from Melrose were sold at public auction. François Mignon did not attend, but Clementine Hunter was there both days. She sat in the hot sun and watched as items she knew well were sold. The sale included farm equipment, furniture, historic papers, and art.

Hunter witnessed with little emotion as the auctioneer's gavel fell on lot after lot of paintings and dolls she had created. When the auction ended, the artist returned home and eventually produced a series of paintings recalling that day. She included a portrait of herself sitting among the items and watching the event. One of her quilts hangs in some of the paintings. African House is in the background. Hunter included the famous portrait of Augustin Metoyer, purchased at the auction by the Isle Breville community and hanging today in St. Augustine Catholic Church. Hunter's memory paintings of the Melrose auction became a colorful conclusion to her long life working and living at Melrose Plantation on the Cane River (see Plate 67).

Clementine Hunter's plantation paintings provide visual evidence of her strong sense of family and community. Her cotton patch paintings document her role and that of the plantation field hands. Her washday scenes recall times before mechanical washing machines. She returned often to painting scenes of children playing, women cooking, and grandparents babysitting. She painted scenes of recreation, including hunting and fishing. She recalled familiar moments such as women fixing each other's hair, playing cards, or installing a line for a new telephone. She always presented a dignified view of her race, and she refused to allow the social narrowness of her day to taint her beliefs about self-worth. From birth to burial and all that happens in between, Hunter painted revealing narratives of her life, her work, her friends, and her family. Without writing a word she told her stories with her art.

# Friends, Supporters, and Patrons

There is no difference between a self-taught artist and a
taught artist. Anyone who is really good is really good.
　—Lanford Wilson, Pulitzer Prize–winning playwright

I was playing Natchitoches, way down in the South—this
goes back to the '80s—and somebody asked, do you want to
meet this primitive artist named Clementine Hunter? She
was 101 then, an old, old, old lady who painted these insane
primitives, almost three-dimensional. I think the first
painting was slaves carrying cotton.
　—Joan Rivers, comedian

WHILE IT IS CLEAR THAT FRANÇOIS MIGNON and James Register were the
driving force managing and promoting Clementine Hunter, they were not
alone in their recognition of her art, nor were they alone in their support
and encouragement. Chance Harvey, the biographer of Louisiana writer Lyle
Saxon, offered evidence that Saxon was among the first to recognize Hunter's
talent. She pointed out that Saxon was a regular visitor to Melrose beginning
in 1923. From the 1930s, when Hunter's duties moved from the cotton fields to
the Big House, the two would have been acquainted. Hunter included an im-
age of Saxon in her African House Murals. Saxon included a humorous story
about Hunter in his posthumously published book *The Friends of Joe Gilmore*.[1]
Harvey cites a handwritten note by François Mignon that seems to confirm
Saxon's early recognition of Hunter's talent: "[Saxon] immediately sensed the
value of the Hunter canvases and not only acquired several for his New Or-
leans apartment, but also presented a fine example to the Louisiana Library
Commission, in the office of whose president, Essae Mae Culver, the picture
has hung for a number of years."[2]

The Clementine Hunter painting that passed to Essae Mae Culver from Lyle Saxon remains today in the Louisiana State Library archives (See Plate 68). The archivist typed a note and attached it to the back of the painting: "This is one of Clementine Hunter's early paintings. She gave this to Lyle Saxon who gave it the title: 'Socialized Medicine.' Mr. Saxon gave it to Miss Culver, who, in turn, presented it to the State Library."[3] Culver gave reason to believe that she did not realize the significance and value of the painting given to her by Saxon. Many years later, after the *Look* magazine article was published in 1953, Culver commented to Mignon in a letter: "I did see Clémence's picture and the article in *Look*. Isn't it strange that such an obscure person should get recognition as she has had?"[4]

Clearly, the painting Saxon gave to Culver originated from Hunter's earliest period in the late 1930s. Characteristic of this period, the pigments were highly thinned, and there is no signature. The dominant colors of yellow, blue, and black are painted on brown paper, with no underpainting. The artist painted the figure of a large woman in an oversized blue bonnet and apron dominating the picture. She seems to be leaning forward and examining a reclining figure. The scene also includes a yellow house and a large tree with blue foliage. Hunter used overlapping brushstrokes to give the woman's long dress a feeling of texture. In the hem area of the dress she darkened the strokes to provide emphasis and separation. Interestingly, the artist's concept of a painting extends beyond the paper to the surface of the timeworn wooden frame. She painted a small flower in the top center of the rustic frame. This painting from Hunter's earliest period, combined with its stellar provenance, is one of the more significant and valuable works in the artist's oeuvre.

*Socialized Medicine* is the only Hunter work that can be traced with certainty to Saxon. If he had others in his Vieux Carré apartment, there is no known record of what they were or where they might be. Lyle Saxon died in 1946, and the best years of Hunter's art career lay ahead.

## Clarence John Laughlin

The photographer Clarence John Laughlin, who was born in Lake Charles, Louisiana, in 1905, is best known for wandering Louisiana, visiting decaying plantations, and compiling a collection of photographs that captured the fading images of the Old South. Many of the photographs are included in

his successful 1948 book, *Ghosts along the Mississippi*. Laughlin was largely self-educated, having left high school in his freshman year. He taught himself photography when he was in his midtwenties, and he also wrote short stories and poems.

Laughlin had little success with his writing, but as a photographer he excelled. He worked for the U.S. government as a freelance architectural photographer and for *Vogue* magazine. Influenced by the French Symbolists Charles Baudelaire, Stéphane Mallarmé, and Paul Verlaine, Laughlin's photography took on an ethereal, often surreal quality. Laughlin, who was known to work alone, stretched the definition of photography with his stylized architectural abstracts and his use of models and props. He appears also to have been influenced by the French photographer Eugène Atget's 1920s images of a timeless Paris. Working on a project for the Library of Congress, Laughlin visited Melrose in 1951 and first saw the art of Clementine Hunter. Laughlin's artistic sophistication allowed him immediately to recognize Hunter's talent. Laughlin understood the prestige that would be afforded the person responsible for bringing Hunter's talent to the attention of the world.[5]

Clarence Laughlin left huge archives of his work, including more than seventeen thousand negatives, and hundreds of notes about the people and places he photographed. In a 1952 memo he recalls meeting Clementine Hunter:

> She is a true primitive—her work being executed almost completely from the instinctual levels of her being, with scarcely anything but the most superficial ordering by the conscious mind. She confesses that she cannot paint directly from nature. She attributes this merely to lack of skill. But actually, she paints entirely from within herself, from a deathless world where she has re-awakened the magic of the child's vision. In this world, shapes of vivid color and entranced gayety or gravity have triumphed over the harsh realities of her life, while still partaking of some of their inner essence.[6]

Laughlin knew many important people in the world of art and photography. His acquaintance with Missouri gallery owner Armand Winfield resulted in Hunter's first major public show outside Louisiana. James Register had arranged small shows in private homes, libraries, and garden clubs in Oklahoma and Texas, and Hunter's most significant public exhibition up until this time had been the New Orleans Arts and Crafts Gallery show in 1949. Winfield's

Saturday Gallery event in St. Louis, Missouri, was a major show for the artist. From November 17 to December 22, 1952, twenty of her finest early paintings hung in the gallery at 111 North Third Street in downtown St. Louis.

Immediately following the Saturday Gallery show, Winfield loaned the paintings to the People's Art Center in St. Louis for a second showing. The People's Art Center was the first racially integrated art gallery in St. Louis. It

Fig. 25. Saturday Gallery program. Several of the paintings exhibited in Hunter's 1952 Saturday Gallery show hang today in private collections. ANN AND JACK BRITTAIN & CHILDREN.

was, however, a largely African American facility, despite the fact that it was founded in 1942 "as a means of bringing together people of all racial origins, religious faiths, and economic levels, and all ages for creative self-expression through a common interest in arts and crafts."[7] The People's Art Center exhibition provided the first primarily African American venue for Hunter's art. The show hung in the People's Art Gallery at 3657 Grandel Square from January 12 through January 31, 1953.[8] Both the Saturday Gallery exhibition and the People's Art Gallery show were a direct result of Clarence Laughlin's acquaintance with Armand Winfield, and both events extended the awareness of Hunter's art beyond Louisiana.

Winfield eventually moved from St. Louis to Albuquerque, where he served until his retirement as director of the Training and Research Institute for Plastics at the University of New Mexico. In an interview in 2004 conducted by the authors in his home, he recalled that none of Hunter's pictures had sold during the Saturday Gallery show. He said he kept four of them to cover his costs for mounting, framing, and shipping.[9]

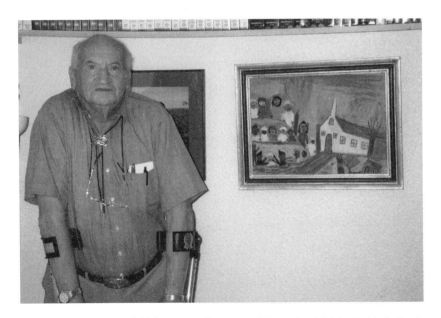

Fig. 26. Armand G. Winfield (1919–2009) sponsored Hunter's exhibition in his St. Louis gallery in 1952. He stands next to a painting that was included in the Saturday Gallery show. THOMAS N. WHITEHEAD.

*Boating Party,* one of the pictures from the show, was sent from St. Louis to Philadelphia to be considered for the 1953 Pennsylvania Academy of Fine Arts's 148th Annual Exhibition of American Painting and Sculpture. The selection committee rejected the painting, and it was returned.[10] Winfield held the paintings he reserved from his Saturday Gallery show the rest of his life. During the authors' visit the paintings were displayed in a bedroom of Win-

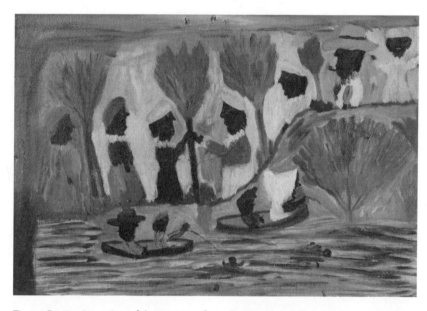

Fig. 27. *Boating Party.* One of the paintings from the Saturday Gallery exhibition. DOROTHY CARNAHAN BENEFIELD.

Fig. 28. En verso taggings confirm the painting *Boating Party* was included in the Saturday Gallery show. It was also sent to Philadelphia for consideration in the 1953 Pennsylvania Academy of Fine Arts Exhibition. It was not, however, selected for inclusion and was eventually returned to Mignon. DOROTHY CARNAHAN BENEFIELD.

field's home. In the spring of 2008, shortly before his death, Winfield put one painting up for auction in New Orleans.

Clarence John Laughlin visited Melrose and Clementine Hunter on several occasions after his initial visit in 1951. Of the photographs he took, one proved to be especially significant. The June 16, 1953, edition of *Look* magazine included a story about Hunter and featured an outstanding Laughlin photograph of Hunter surrounded by her art.

The press announcement in the St. Louis newspaper of the Saturday Gallery show offered Laughlin's assertion that he had discovered the artist: "Miss Hunter is the discovery of Clarence John Laughlin, New Orleans photographer, and formerly an artist himself, who has written an account of her life and work. She had been painting for fifteen years when he happened to visit her home in connection with a Library of Congress architectural photography project."[11] Laughlin remained adamant that he had been the first to discover Hunter's talent, despite the fact that the New Orleans Arts and Crafts Gallery show took place before he even met the artist.

In a press release for the Saturday Gallery show Laughlin proved he, like so many others, never hesitated to create "facts" about how Hunter's art career began: "In 1938, she [Hunter] secured work as a laundress in the home of Mrs. Cammie Henry, who was herself an art patron. Prior to that time, Mrs. Hunter had acquired a set of watercolors from a child and had from time to time begun to paint. Sensing this talent, Mrs. Henry encouraged her laundress in her painting during all of her spare time."[12] Well intentioned though Laughlin might have been, Hunter had been employed at Melrose long before 1938. Her first painting was done at Melrose, Hunter never painted with watercolors, and there is no evidence that Cammie Henry considered Hunter's art more than simply amusing.

Laughlin attempted several times to engage in promotion and expand his role in Hunter's story. His enthusiasm suggests a willingness to use his considerable national and international influence to provide increased recognition for her and concurrently add to his growing reputation. Laughlin correctly sensed, however, that he had intentionally been left out of Mignon's story of Hunter and her beginning days as an artist. He expressed his anger when he was not credited with discovery of the artist or even contacted about a historic exhibition at the Delgado Museum, now the New Orleans Museum of Art.

In 1955 the Delgado Museum selected Hunter for a one-woman show. Not only was it the museum's first solo showing for a woman; it was also the first showing for an African American. Robert Segleau, a New Orleans producer for WDSU-TV, played a significant role in influencing the Delgado to mount the spring exhibition of Hunter's art. Segleau produced the first television documentary featuring the artist, and he and his wife, Patty, had begun to acquire a collection of Hunter's paintings. Mignon liked Segleau and through frequent correspondence deftly guided Segleau's efforts to promote Hunter in New Orleans and tell her story. Segleau sought Mignon's approval for his broadcast and press announcements about the show. Soon after the Delgado exhibition opened for preview, Segleau received a telephone call from an angry Clarence Laughlin. Segleau recounted the call in a letter to Mignon: "The other night, Mr. Clarence Laughlin called me in a great state of perturbation. He was extremely annoyed, apparently, that he had not been consulted on the Delgado Show, and felt he had been slighted in the most objectionable way, considering the fact that he could have been of great help contributing both information as well as photographs and actual pictures of the artist."[13]

On reading Robert Segleau's account of Laughlin's phone call, Mignon commented in his journal: "The news passed along in Bob's letter arriving today seems to suggest that Clarence John is still in something of a tizzy . . . it seems as though he must be more nuts than I had supposed him to be, in this taking up the Hunter business with Bob. So far as both little Miss Hunter and I are concerned, Clarence John can go and sit on a tack."[14]

After Mignon began to take serious ownership of Hunter's career, he regularly controlled contact with the artist by writers and photographers. Mignon obviously disliked Laughlin and considered him a threat. Mignon denied Laughlin's repeated requests to visit Melrose and photograph the artist. Eventually, Laughlin gave up trying to compete with Mignon and never returned to Melrose.

Laughlin failed in his effort to be remembered as the one who discovered the plantation artist. In fact, his introduction to Hunter came more than a decade after Mignon first took notice. Nevertheless, Laughlin's famous *Look* magazine photograph of Clementine Hunter regally seated in her simple cabin and surrounded by carefully positioned examples of her art has become an iconic image representative of the artist in her early years. Clarence John Laughlin died in 1985; he is buried in Père Lachaise Cemetery in Paris.

## Edith Mahier

Edith Mahier was more of a friend to Cammie Henry and James Register than Clementine Hunter, but she deserves credit for recognizing Hunter's talent and arranging the private show in 1944 in Norman, Oklahoma. Miss Mahier, a professor of art at the University of Oklahoma, graduated in 1916 from Sophie Newcomb College in New Orleans and studied at the School of Fine and Applied Arts in New York as well as with the modernist painter Will Henry Stevens at the Art Student League in New Orleans. She also studied abroad in France and Italy and had been part of the Natchitoches Art Colony in 1926.

Edith Mahier's efforts in Oklahoma to preserve, not change, the technique and style of Native American art students ran contrary to the contemporary theory of art instruction that demanded the Native American students be taught to paint accepted European techniques. She saw in the paintings of young, untrained American Indians a sense of spontaneity and celebration of nature that she felt deserved encouragement. Her appreciation of Native American art demonstrated her understanding for self-taught artists. When James Register introduced Mahier to Clementine Hunter's early art, Mahier took the same approach to interpreting Hunter. This early validation of Hunter's talent by a successful regional artist and academic gave credence to the artist's growing reputation as a noteworthy self-taught painter.

## Robert F. Ryan, M.D.

Another important Hunter patron not only collected hundreds of paintings but also attempted to influence the artist's painting technique and style. Robert F. Ryan, a New Orleans surgeon, arrived on the scene in the late 1960s. Ryan recalls he first met Clementine Hunter when a medical resident with whom he worked at Huey Long Hospital in Pineville, Louisiana, invited him to go along on a visit to Hunter's cabin.[15] The story is familiar: Ryan bought a painting and soon found himself returning often to buy more. Bob Ryan's story differs from most of the other collectors in one respect; he met Hunter first and Mignon later. It is apparent from Mignon's journal that he never considered Ryan a close friend.[16]

Ryan served on the faculty of Tulane Medical School and used his social position in New Orleans to promote the artist. He even packed his car with

Hunter paintings and sold them to friends. He wrote articles about the artist; the most significant was a personal reminiscence in the fall 1988 issue of *Raw Vision,* an international journal of outsider art. Ryan's short article reached thousands of outsider art followers around the world, and in that sense it was important, but the article was mostly about Ryan and contained little new information about the artist.[17]

Ryan often commissioned the artist for specifically themed paintings. His favorite subject was medicine, and he convinced Hunter to paint a number of works with medical themes. He brought photographs to her and suggested she glue them to the canvas and incorporate them into her paintings. James Register originally introduced Hunter to collage, but Bob Ryan expanded the concept to include photographs. Years later, working alone and without influence, Hunter created collage paintings with photographs on numerous occasions.

On one occasion Ryan asked the artist to paint dozens of three-by-five-inch paintings of angels, which he planned to use as Christmas decorations. To make the small canvas boards easier to handle for the elderly artist, whose hands were crippled with arthritis, Ryan glued wooden tongue depressors to the backs of the boards, thus providing a handle with which she could hold the small board. Possibly his most dramatic attempt to influence the artist's style came when he gave her canvas boards on which he had supplied the underpainting. Bob Ryan obviously enjoyed his relationship with Hunter and the prestige it brought him in his New Orleans social community. Hunter obviously enjoyed the money he paid her because she willingly attempted to paint-to-order for him, not something she was willing to do for everyone.

Ryan recognized the growing value of his collection and anticipated the paintings would appreciate over time. On one occasion he maneuvered to make sure his investment paid off. When the Henry family sold Melrose and auctioned off the contents of the Big House and the outbuildings, there were fifty-eight paintings and objects by the artist included in the sale. The most impressive painting was an early window shade of a St. Augustine Catholic Church scene (see plate 34). Ryan said Mignon told him the painting was Hunter's first, and there is no reason to doubt that Mignon made the claim. Ryan bought the painting for less than two hundred dollars. He returned to his motel in Alexandria, Louisiana, and wrote on Holiday Inn motel stationery a statement later initialed by Hunter as "proof" the window shade painting he had purchased was her first painting. Ryan had the handwritten affidavit

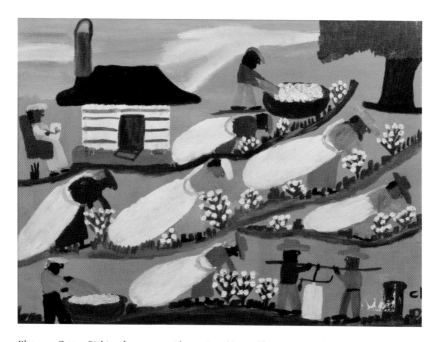

Plate 13. *Cotton Picking,* late 1940s. The artist adds a self-portrait as she paints, while others labor under the weight of heavy cotton sacks. IRIS RAYFORD COLLECTION. PHOTO BY GARY HARDAMON.

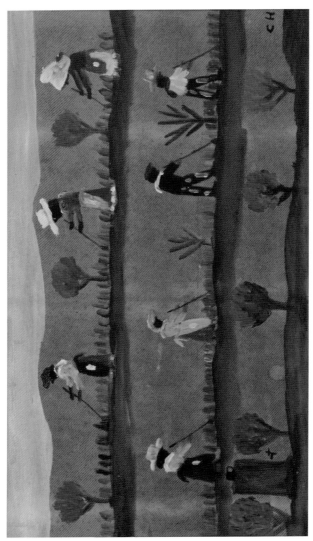

Plate 14. *Hoeing Cotton*, late 1940s. Workers break the soil and remove the weeds from around the young cotton plants. IRIS RAYFORD COLLECTION. PHOTO BY GARY HARDAMON.

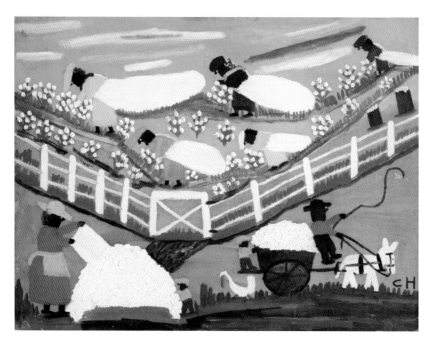

Plate 15. *Cotton Pickin' and Haulin' Cotton.* Hunter offers a richly detailed painting of a cotton harvest complete with a loaded cart headed for the cotton gin. ANN AND JACK BRITTAIN & CHILDREN.

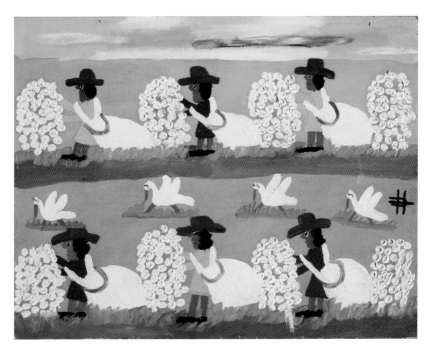

Plate 16. *Picking Cotton*. Women standing tall wearing colorful dresses and red hats suggest picking cotton is a joyous event; in reality it was backbreaking labor. ANN AND JACK BRIT-TAIN & CHILDREN.

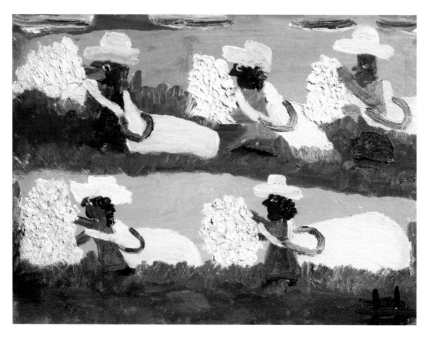

Plate 17. *Pickin' Cotton.* In 1985 Clementine Hunter continued to recall her cotton picking days in the 1920s and 1930s on Melrose Plantation. THOMAS N. WHITEHEAD.

Plate 18. *Late Cotton Picking.* As her memory began to fade, Hunter's images of women picking cotton grew more impressionistic, with less detail. ANN AND JACK BRITTAIN & CHILDREN.

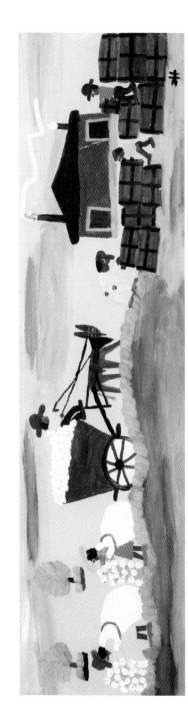

Plate 19. *Cotton Mural*. Three feet long and a foot high, this longitudinal painting brings together the artist's colorful memories of the cotton harvest. THOMAS N. WHITEHEAD.

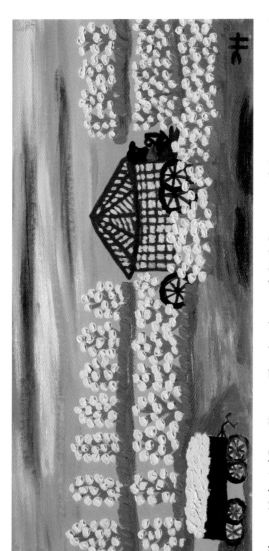

Plate 20. *Mechanical Cotton Harvester.* Thought to be one of a kind, this painting of a harvester represents a pictorial conclusion to the labor-intensive days of the cotton harvest. DON, SUSIE, AND BARRY HOLTON COLLECTION.

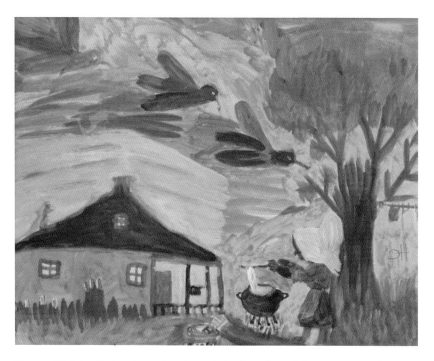

Plate 21. *Washday*. This early version of a washday dates from the late 1940s or early 1950s. It was originally included in the James Register collection. PRIVATE COLLECTION.

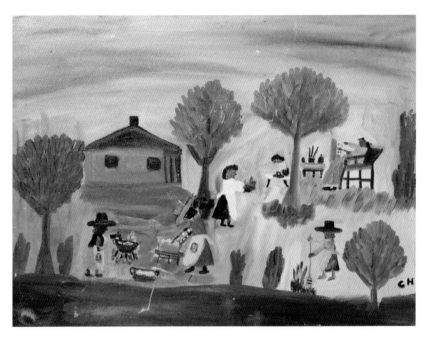

Plate 22. *Artist Painting and Others Washing in Yard.* In this painting from the 1940s the artist can be seen in the background painting under a tree while a richly detailed washday vignette takes place in the foreground. ANN AND JACK BRITTAIN & CHILDREN.

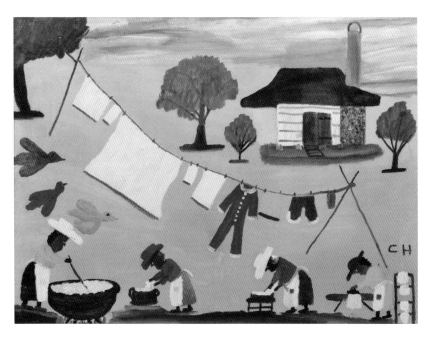

Plate 23. *Linens and Long Johns.* Colorful as this painting is, the real story is of the women bending diligently over their work seemingly unaware of each other or the world around them. IRIS RAYFORD COLLECTION. PHOTO BY GARY HARDAMON.

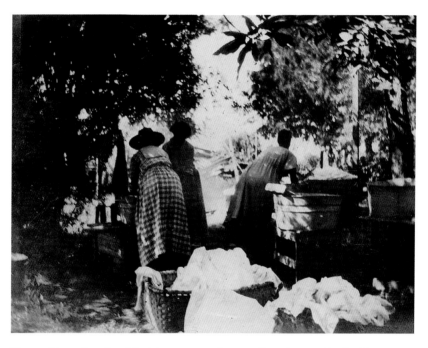

Plate 24. The reality of washday labor contrasts dramatically with Hunter's colorful paintings.

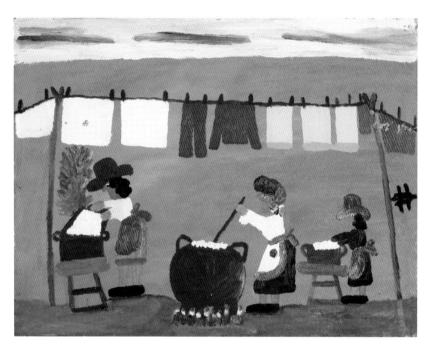

Plate 25. *Washday.* Painted in the 1980s, the artist recalls the indelible memories of her days as a domestic servant. ANN AND JACK BRITTAIN & CHILDREN.

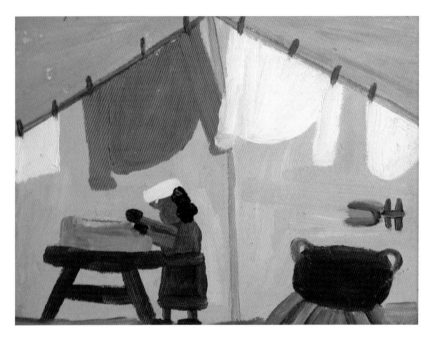

Plate 26. Small *Washday*. Hunter painted scores of these 8" x 10" intimate and well-composed paintings that proved popular with her customers and provided the artist with a steady income. MARGARET AND ART SHIVER COLLECTION.

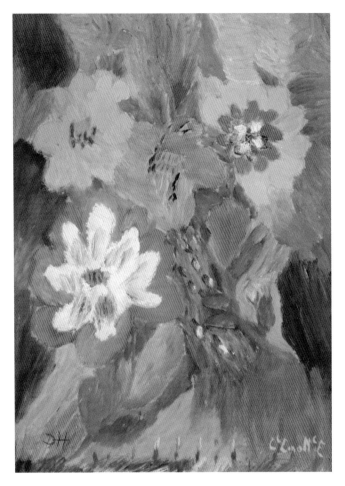

Plate 27. *Early Flowers.* This work confirms the artist's ability to paint sophisticated floral images early in her career. ANN AND JACK BRITTAIN & CHILDREN.

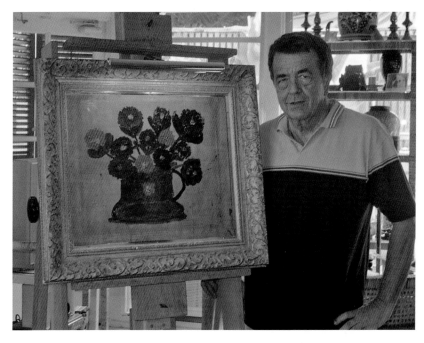

Plate 28. Whitfield Jack poses with *Bowl of Zinnias*. He inherited the famous picture from his grandmother, Mrs. Blythe Rand. Jack no longer owns the painting. PHOTO BY ART SHIVER.

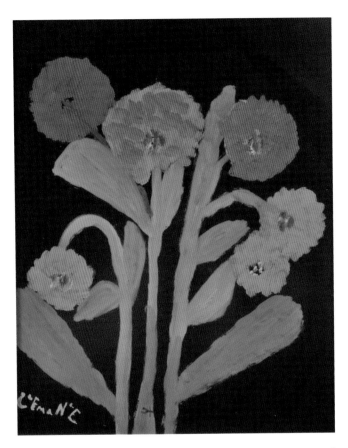

Plate 29. *Zinnias on Black Paper.* Clementine Hunter probably painted more zinnias than any other flower. This early work was signed not by the artist but by James Register around 1944; it is nevertheless from the hand of the artist. IRIS RAYFORD COLLECTION. PHOTO BY GARY HARDAMON.

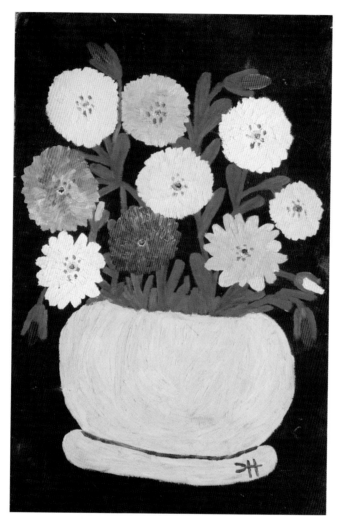

Plate 30. *Zinnias.* The artist returned often to the copper pot of flowers. She seemed to evolve from painting her memories of real flowers to painting her memories of her own paintings of flowers. ANN AND JACK BRITTAIN & CHILDREN.

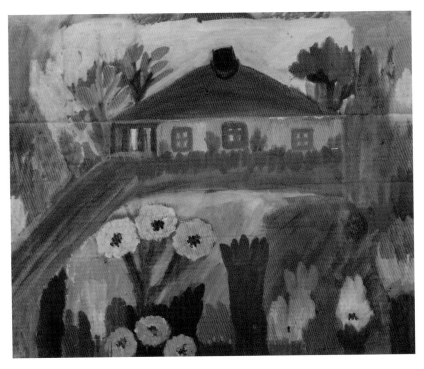

Plate 31. *House and Garden.* This early 1940s impressionist work demonstrates the artist's early talent for creating floral images. IRIS RAYFORD COLLECTION. PHOTO BY GARY HARDAMON.

Plate 32. *Bouquet of Three Spider Lilies*. The artist sat in her yard and painted her version of spider lilies as Tom Whitehead watched. THOMAS N. WHITEHEAD.

Plate 33. *Black Jesus.* The black Christ on the Cross became a popular sacred theme for the artist from the 1950s to the end of her career.
THOMAS N. WHITEHEAD.

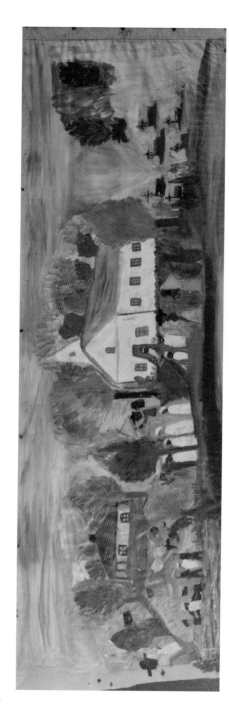

Plate 34. *Cane River Baptism*. This famous work, reported to be Hunter's first painting, was not her first work. It could be her first Cane River baptism, but nothing confirms that. IRIS RAYFORD COLLECTION. PHOTO BY GARY HARDAMON.

Plate 35. *Baptism*. Hunter mingles Protestant and Catholic rituals. In the foreground she paints Catholic priests performing baptism by immersion, a Protestant custom. ANN AND JACK BRITTAIN & CHILDREN.

Plate 36. *Mary and Child.* The artist imagines the Holy Mother with Jesus as a small child at her feet. Mignon laughed that Hunter painted all of her geese with red combs and wattles like a rooster; he called her geese "goosters." IRIS RAYFORD COLLECTION. PHOTO BY GARY HARDAMON.

Plate 37. *Nativity with Pregnant Mary.* This playful treatment of the Nativity includes, in the right foreground, a doctor with medical bag in hand rushing to deliver the baby Jesus. ANN AND JACK BRITTAIN & CHILDREN.

Plate 38. *Flight into Egypt*. In the left foreground of this pre-1955 work, the flaking paint from the goose's wing reveals the artist's pencil outline, where she had marked the picture before painting. ANN AND JACK BRITTAIN & CHILDREN.

Plate 39. *Revival.* This compositionally complex, pre-1955 painting predates Hunter's conversion to Catholicism. ANN AND JACK BRITTAIN & CHILDREN.

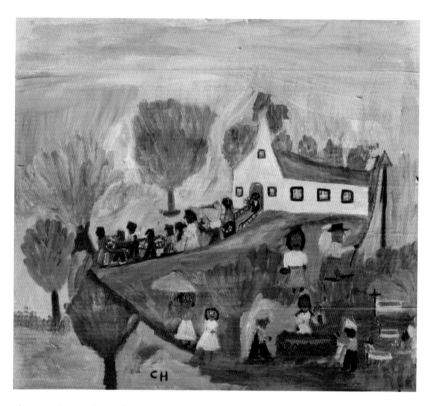

Plate 40. *Country Funeral.* Mignon presented this rare painting from the Saturday Gallery show to Ann Williams as a wedding gift when she married Jack Brittain in 1955. ANN AND JACK BRITTAIN & CHILDREN.

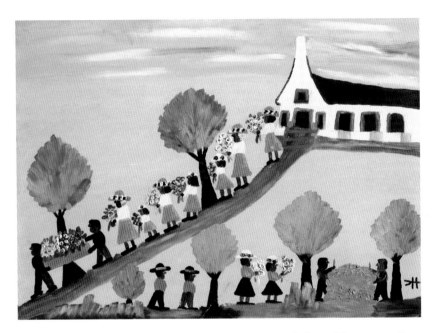

Plate 41. *A Funeral at Isle Brevelle*. In this colorful celebration of a funeral the artist confirms her belief that the tears are shed at the wake and the funeral is a happy occasion because the departed begins the journey to a heavenly reward. THOMAS N. WHITEHEAD.

Plate 42. *Frenchie Goin' to Heaven*. Hunter painted several versions of her vision of her son Frenchie as he departed earth for heaven. Hunter did not normally provide titles for her paintings; *Frenchie Goin' to Heaven* is one of the few works she personally titled. THOMAS N. WHITEHEAD.

Plate 43. *Woman Carrying Gourds*. François Mignon dried gourds around the porch of Yucca House. Hunter's painting, with gourd vines surrounding the frame, provides a flavor of art nouveau to the whimsical picture. IRIS RAYFORD COLLECTION. PHOTO BY GARY HARDAMON.

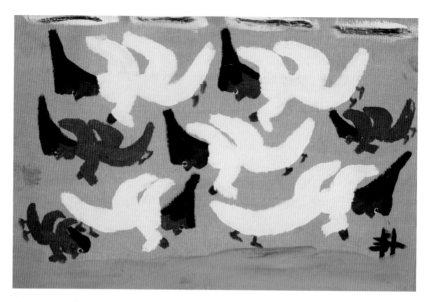

Plate 44. *Angels.* Hunter believed angels surround everyone. The white angels are the good angels, and the red ones are the devils. THOMAS N. WHITEHEAD.

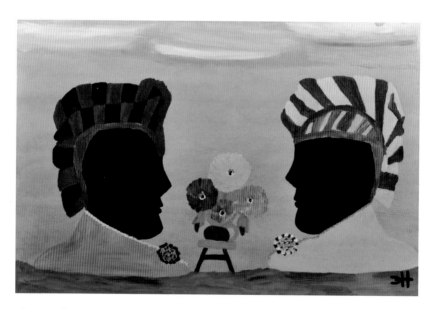

Plate 45. *African Women in Profile.* Mystery surrounds this unusual theme. There is no indication what inspired the artist to create these masklike images. This work was painted in the late 1960s, but during the last decades of her career the artist painted dozens of variations of African women in profile. IRIS RAYFORD COLLECTION. PHOTO BY GARY HARDAMON.

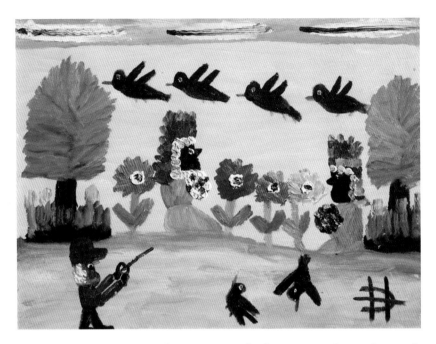

Plate 46. *Two Ladies in Masks and Man Hunting Birds.* The artist never hesitated to mingle images and themes. Here she crosses the threshold of surrealism when she combines the *African Women in Profile* with a Cane River bird hunt. THOMAS N. WHITEHEAD.

Plate 47. The artist featured the Friendly Place, an old juke joint, prominently in her honky-tonk paintings. There were two such palaces of weekend delight near Melrose; the other was Bubba's. PHOTO BY GARY HARDAMON.

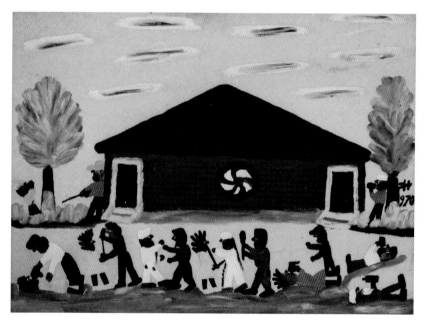

Plate 48. *Saturday Night at the Honky-Tonk.* Hunter lived near the juke joint and complained about the loud music and the occasional gunshot. In her vignette she tells the whole story of Saturday night revelry. THOMAS N. WHITEHEAD.

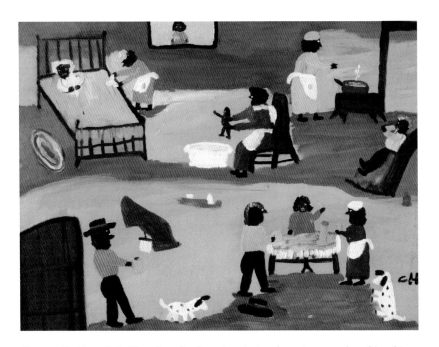

Plate 49. *Birthing a Baby.* Thought to be the only painting the artist created on this subject, *Birthing a Baby* is a richly detailed vignette of birth on the plantation. ANN AND JACK BRITTAIN & CHILDREN.

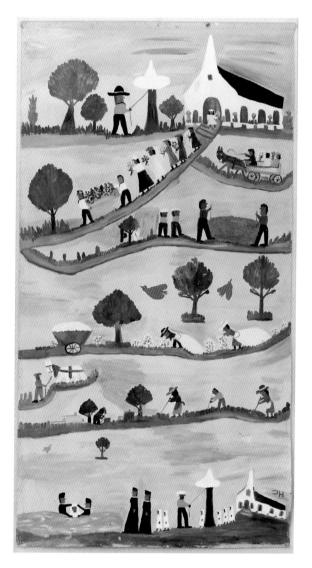

Plate 50. Window shade painting. Hunter painted many scenes
on window shades; the long shade provided a perfect canvas
for telling her story of life on the plantation. She seemed to be
saying, if one begins in the foreground, we are born, we work,
we die. SPECIAL COLLECTIONS AND ARCHIVES, KNOX COLLEGE,
GALESBURG, ILL.

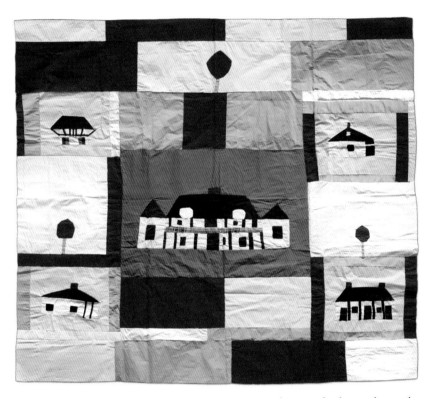

Plate 51. Melrose quilt. Probably better called a tapestry than a quilt, the textile was designed to be hung and not created for warmth. SPECIAL COLLECTIONS AND ARCHIVES, KNOX COLLEGE, GALESBURG, ILL.

Plate 52. Chevron quilt. Hunter created several versions of this traditional quilt pattern, which is made from scraps of cloth sewn into a herringbone pattern. PRIVATE COLLECTION.

Plate 53. *Clementine Makes a Quilt.* Hunter painted a psychologically revealing self-portrait in which she attempted to illustrate what takes place in her mind when creating a quilt. Possibly using the abstract techniques she observed from James Register, she painted an image of herself sewing a quilt and surrounded by a mélange of colors and shapes depicting the creative thought process. THOMAS N. WHITEHEAD.

Plate 55. Snuff bottle. There was never a shortage of snuff bottles, as the artist was known to dip on occasion. Here she turns the mundane into a work of art by adding one of her signature zinnias to the bottle's surface. THOMAS N. WHITEHEAD.

Plate 54. Milk bottle. Hunter's brush left the canvas often in her later years. She painted on scores of nontraditional surfaces. THOMAS N. WHITEHEAD.

Plate 57. Roofing shingle from African House. African House has undergone decades of seemingly endless restoration. After a roofing repair Hunter took home a souvenir shingle and soon covered it with a bright pot of her famous zinnias. THOMAS N. WHITEHEAD.

Plate 56. Wine bottle. The artist enjoyed a sip or two of wine. Here she recycles the empty bottle into a unique work of art. THOMAS N. WHITEHEAD.

Plate 58. Kappa Alpha fraternity crest. KAPPA ALPHA ORDER.

Plate 59. When Seattle advertising executive Bill Bailey Carter was a student at Northwestern, he asked Hunter to copy the Kappa Alpha crest. THOMAS N. WHITEHEAD.

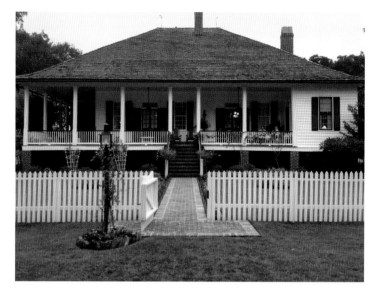

Plate 60. Hunter was asked to paint her version of Cherokee, a restored Cane River plantation. PHOTO BY THOMAS N. WHITEHEAD.

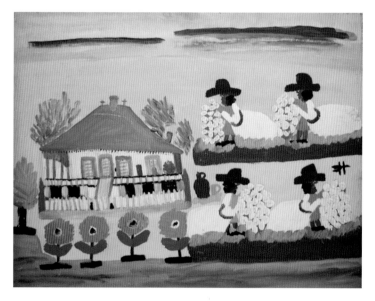

Plate 61. *Cherokee Plantation.* Hunter's version of Cherokee included cotton pickers as well as a foreground of colorful zinnias. PRIVATE COLLECTION.

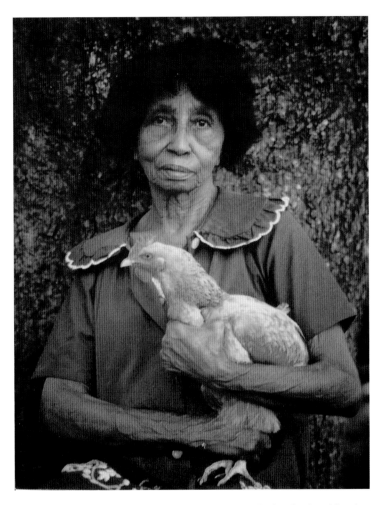

Plate 62. Curtis Guillet's photo of Hunter holding a Rhode Island Red hen be-
came one of the most famous images of the artist. JOHN CURTIS GUILLET.

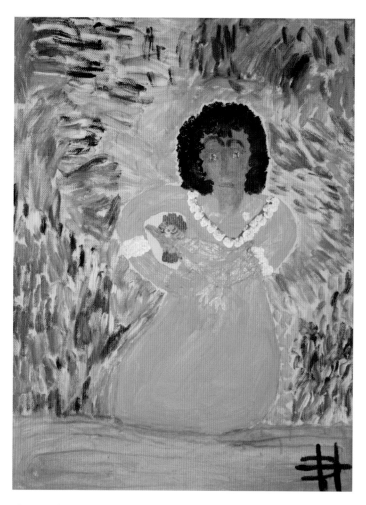

Plate 63. Clementine Hunter painted her version of the Guillet photo. PRIVATE
COLLECTION.

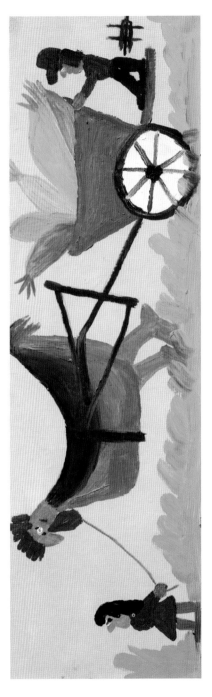

Plate 64. *Gooster Pulling a Cart of Gourds*. Hunter painted numerous pictures of geese or large chickens pulling carts of gourds. She might have been inspired by images on commercial flour sacks of chickens pulling wagons. THOMAS N. WHITEHEAD.

Plate 65. Hunter lived in several areas around Melrose and Cane River. She eventually bought a house trailer and paid for it by selling her art. This was her home during the final years of her life. PHOTO BY THOMAS N. WHITEHEAD.

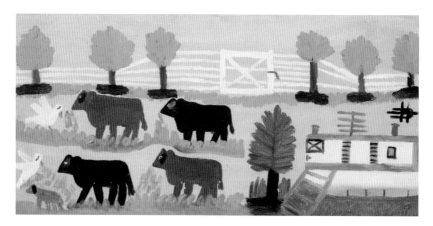

Plate 66. Hunter's painting of her home at Brittain's Bend, located not far from Melrose. The trailer is in the right foreground. JOHN BRITTAIN.

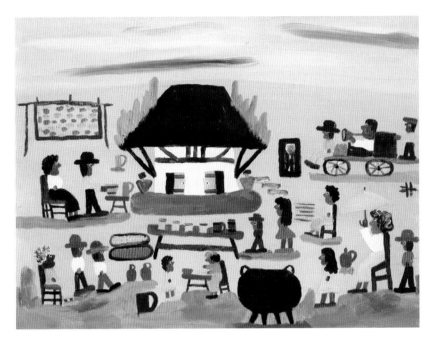

Plate 67. *Melrose Auction.* Hunter attended the auction, which was held after Melrose Plantation was sold. She watched and listened and turned her experience into art. THOMAS N. WHITEHEAD.

Plate 68. *Socialized Medicine.* This gift from Clementine Hunter to her friend Lyle Saxon was donated by Saxon to the Louisiana State Library. Saxon called it "Socialized Medicine." In 1978 Mignon admitted to Mildred Bailey that this was one of Hunter's earliest pictures, predating the famous *Cane River Funeral,* which he often claimed was her first picture.
LOUISIANA STATE LIBRARY.

witnessed by Hunter's daughter and notarized in an effort to confirm that the item he purchased at the auction was Clementine Hunter's first painting. The painting was an outstanding work, but it was not the artist's maiden effort.

Bob Ryan believed his purchase was Hunter's first painting. In a letter written in 1981 he said, "François showed me this painting [the window shade painting purchased at the auction] and identified it as Clementine's first, and it was there at Melrose." Later, in the same letter, he reconfirmed his belief about the painting: "From the repeated story told by François and others of her painting on the window shade, I believe the window shade painting is her first painting."[18] Ryan eventually sold his trophy painting and used the money to buy a new Chevrolet Suburban truck.[19] Today the controversial painting with the interesting provenance is mounted on a kitchen wall in a private residence only a few miles from where the artist created it by lantern light so long ago.

Over twenty years Ryan and his wife, Yvonne, amassed a collection of more than seven hundred of Hunter's paintings and objects. When the couple divorced, their collection was divided by value as opposed to number of items. Shelby Gilley, the Baton Rouge art dealer, appraised the paintings and objects for the couple's financial settlement.

Ryan donated several of his paintings to the Pensacola Museum of Art. He also self-published a strange series of four books of personal memories and aphorisms. These unusual books included reproductions of Hunter's art from his collection. Late in his life he sold a number of his remaining paintings to Shelby Gilley, and he attempted to market paintings on the Internet. Now in advanced age and suffering from Alzheimer's disease, he spends his final days in a Florida nursing home.

## Hugh Schoephoerster Takes the Hunter Story North

Mildred Bailey's professional friendship with Minnesota textbook author and educator Hugh Schoephoerster resulted in another important patron and collector of Clementine Hunter's art. Schoephoerster was an intelligent man with wide-ranging interests. He was fascinated by everything from coffee roasting to Renaissance art. He met Hunter and experienced her art in the 1970s while visiting Bailey in Natchitoches. He returned to Cane River once a year, sometimes more often, for almost twenty years.

Schoephoerster made a significant contribution to Hunter's legacy when in 1983 he made a generous gift to fund the restoration of the series of murals Hunter painted for African House.[20] Schoephoerster valued learning and funded a touring exhibition of Clementine Hunter's art that traveled to public schools in Minnesota. The manager for Young Audiences of Minnesota praised Schoephoerster's program: "Clearly, the opportunity to see original art and participate in a student centered discussion of the work is a powerful strategy for learning."[21]

On his many trips to Louisiana Schoephoerster bought scores of pictures and shipped them to his Anoka, Minnesota, home. He sponsored exhibitions at the Weisman Art Museum at the University of Minnesota in Minneapolis and at his alma mater, the University of Northern Colorado at Greeley. After his death in 2000, at age sixty-seven, it was discovered that in his enthusiasm to purchase paintings by the artist, he had unknowingly purchased several forgeries. At his death some of his collection, including several fake Hunter paintings, passed to the Weisman Art Museum. (The museum identified the forged paintings and has displayed them as fakes.) Hugh Schoephoerster is remembered for personally funding efforts to preserve and restore Hunter's famous African House Murals and for spreading the message about Clementine Hunter to a new audience from the upper Midwest to Colorado. At the time of his death he was writing a biography of the artist.

## Shelby R. Gilley, Art Dealer

Shelby Gilley, a native of Rayville, Louisiana, moved to Baton Rouge to begin his career as a social worker. His passion for the art and history of Louisiana soon led him to open Gilley's Gallery. Gilley traveled to Hunter's home in 1970 to meet the famous artist and purchased some of her paintings. The painter and the art purveyor became friends, and the friendship lasted the rest of Hunter's life. In 1978 Gilley began selling the artist's work as his Baton Rouge gallery grew in reputation.

Gilley's efforts to buy and sell Hunter's art throughout the country help to create a vigorous market for the artist's works. He regularly featured her work in prominent color ads in influential art publications. He displayed her quilts and paintings in important outsider and folk art events in New York and other

cities. In time Gilley became the person to call if one wanted to buy or sell an original Clementine Hunter painting. His attention to details resulted in Gilley being among the first to recognize efforts by several forgers attempting to cash in illegally on Hunter's success.

Gilley's book, *Painting by Heart: The Life and Art of Clementine Hunter, Louisiana Folk Artist*, published in 2000, has become an important addition to any library about the artist. The book contains his personal memories and scores of full color examples of Hunter's art. When Shelby Gilley died in January 2010, he was considered an expert on the subject of Clementine Hunter's art. He is significant in the life of the artist for his work in identifying forgeries and his efforts to develop a national market for paintings by the artist.

## Famous and Not So Famous

Many of the famous visitors to Melrose over the years assisted Mignon in the support and promotion of Clementine Hunter. Carolyn Ramsey, a writer, photographer, and filmmaker, was a friend of Mignon who enjoyed unlimited access to Hunter. During the 1940s and 1950s Ramsey took numerous photos of the artist and wrote several newspaper and magazine articles about her.

Ora Williams offered her assistance in a variety of ways, mostly proofing and editing Mignon's writings and providing Mignon a residence when Melrose was closed. Williams also collected Hunter paintings and inherited those that belonged to Mignon when he died. Her daughter, Ann Williams Brittain, became one of Hunter's most influential patrons. Ann Brittain died in 2003, and her large collection of Hunter's art passed to her heirs.

National celebrities and famous people who traveled through Natchitoches and Melrose acquired Hunter's paintings to take home. In the 1960s Mississippi native Craig Claiborne, food writer for the *New York Times*, loved the South and southern food. Credited with his discovery of the then unknown Louisiana chef Paul Prudhomme, Claiborne was collecting Creole and Cajun recipes when he visited Melrose. Mignon gave Claiborne a rare Clementine Hunter quilt as a memento of his visit. After he returned to The Spring, his home on Long Island, New York, Claiborne sent Mignon a handwritten note: "You were most generous to receive me, and I will remember for years to come my visit to Melrose. We stopped briefly to see Clementine Hunter and I

am so pleased to have one of her quilt patterns now hanging in my bedroom."[22] When Claiborne died in 2000, the Hunter quilt was bequeathed to the Culinary Institute of America in Hyde Park, New York.

Another famous Long Island resident, the late Pulitzer Prize–winning playwright Lanford Wilson, credited his purchase of a Hunter painting with igniting his interest in collecting outsider art. "I was down in Natchitoches, Louisiana, watching Herb Ross film *Steel Magnolias* . . . I bought a bright canvas with a vase of zinnias," he told a reporter for the Long Island edition of the *New York Times*.[23] First he became a student of outsider art and eventually a serious folk art collector. Wilson bought hundreds of works by self-taught artists. "You can't intellectualize about these things," he told the reporter. "Your eye has to be looking for an image that is original and strong and stays with you totally. An image that is unjaundiced and uncensored."[24]

Oprah Winfrey, the former television talk show host and cable network executive, bought several Hunter canvases for her Hawaii home. Joan Rivers, the comedian and television performer, was playing a club in Bossier City, Louisiana, when she found her way to Hunter's cabin and purchased a painting, which hangs in her Manhattan apartment. "I brought it home," she told the *New York Times*, "and Vincent Price, who was a great art collector, said 'Are you crazy?'"[25] Rivers owns at least six Hunter paintings. She once described the artist's work as "Grandma Moses on acid."[26] During the days in the late 1980s when the late director Herbert Ross was on location in Natchitoches filming *Steel Magnolias*, several members of the cast and crew bought Hunter paintings to take home.

## Friends Lend a Helping Hand

As Clementine Hunter approached the last decade of her life, it became increasingly difficult for her to paint. Not only was she not as sharp mentally, but also her hands were gnarled and crippled from arthritis. For half of her long life she had painted almost every day. Her desire to paint was further fueled by the reality that she needed the money that came from selling her art.

The income Hunter generated from art sales came without expenses, and she never paid taxes. Those who knew her say it is likely she never bought supplies. In the early days it was not uncommon for her to use two dollars worth of supplies for a picture she sold for seventy-five cents.

Critics occasionally point to the value of Hunter's art today and suggest her patrons took advantage of her because most paid so little for the works they hold. Gertrude Stein paid little for the Picasso paintings she hung in her Paris apartment; those paintings sell today for tens of millions of dollars. Hunter and Picasso are at different ends of the value scale, but neither artist reaped the ultimate value of their artistic endeavors. Within their own worlds, however, both were successful.

For years Clementine Hunter's steadily growing income from painting allowed her to live a life she could never have imagined when she was a young woman pulling cotton sacks from dawn to dark. She was never rich. There is no denying, however, that painting made her life easier than it might have been. What money she received, she spent.

Even though she could not drive, Hunter bought more than one used car because she liked "the way it looked in front of the house."[27] She had a telephone soon after they were available, when almost no one in her community could afford one. She selected her final resting place and made monthly payments until she fully paid for her mausoleum space in the St. Augustine Catholic Church. When she moved from Melrose, she bought a house trailer. There were always water bills, gas bills, and electricity bills as well as someone in the family needing a little financial help. While demands on her income increased, her ability to produce art declined. She had always worked and supported herself and her family, but as she approached her hundredth year, she needed help.

Three of her friends and patrons in Natchitoches realized Hunter's problems and decided it was time to come to her rescue. Ann Williams Brittain had always known Clementine Hunter. Her mother, Ora Williams, was a longtime friend of Melrose, and as a child, Ann had visited Melrose before she could walk. Mildred Hart Bailey had first observed Hunter's paintings on display at Millspaugh's Drug Store in Natchitoches many years before she met the artist. Tom Whitehead met Hunter in the late 1960s, when he was an undergraduate at Northwestern State University. After graduate school in Boston, Whitehead returned to teach journalism at Northwestern. Whitehead, like the others, developed a close friendship with Hunter. He regularly took her art supplies, ran errands, and bought paintings. Clementine Hunter called him her "white son." In a series of phone calls among themselves, the three concerned patrons and friends of Hunter discussed the artist's age and the problems she had begun to

face. There was nothing official: no letterhead, no announcement, no name, no personal compensation, and no idea what they might be called on to do. They agreed among themselves that they would help the aging artist.

Ann Brittain offered to handle the financial matters. Her husband Jack, an attorney, provided pro bono legal advice and founded the Cane River Art Corporation, legally establishing copyright and thus protecting all of the images that came from the hand of the artist.[28] Mrs. Brittain wrote the checks and made sure the bills were paid. When Hunter's funds ran low, someone in the

Fig. 29. *Left to right:* Mildred "dede" Bailey, Clementine Hunter, Ann Brittain, and Tom Whitehead. Hunter's close friends came to her assistance during her final years. THOMAS N. WHITEHEAD.

group provided financial assistance. Toward the end the three friends shared the artist's utility bills. Whitehead agreed to work with the many requests from television and newspaper reporters to visit the artist. He handled her publicity and guarded her public image. Mildred Bailey began to assemble a history of the artist, including an oral history. She collected material she planned to include in a book.

They each continued to buy art and order special items. The unspoken understanding was that each of them paid whatever the artist asked for paintings. They bought her paintings, but more important, the purchases allowed Hunter's income to continue. The three patrons brought her supplies and made sure she was comfortable. They celebrated her birthday each year, including one large public event in 1986 to mark her hundredth birthday. There is no doubt the decision by the three Natchitoches patrons and friends to come to Hunter's aid permitted the artist to live her final years in dignity.

# New Year's Day, 1988

To every thing there is a season . . . A time to be born,
and a time to die . . .

—Ecclesiastes 3:1–2

She had to create art from a background that art was not
part of. She found her self-expression and maintained it.

—John Bullard, director emeritus of the New Orleans
Museum of Art

CLEMENTINE HUNTER DIED AT 2:10 in the afternoon on Saturday, January 1,
1988. She was unable to eat and suffering from dehydration on Wednesday,
December 29, when her daughter Jackie (Mary) took her to Natchitoches Parish Hospital. Lottie Campbell, the charge nurse, listed the cause of death for
the 101-year-old artist as simply "old age."[1] Eleanor Worsley, MD, her doctor
for many years, whom she always called the "Lady Doctor," was at her bedside.
Edward Ward, who as a 6-year-old child had been among the first to see the
African House Murals, was also at Hunter's bedside. Her last word was *water*,
he said. "She asked in a low, whispered voice for water."[2]

Word of Hunter's death spread rapidly across the Cane River Country and
beyond. By Sunday people around the world learned of the artist's passing.
Mildred Bailey and Tom Whitehead were traveling in Kenya, Africa, when
they read the report in the *International Herald Tribune*. Reporters in many
languages retold the story of the domestic servant from rural Louisiana who
became a famous artist. Hunter was the granddaughter of an enslaved woman,
but many news reports, including those in local newspapers, mistakenly referred to Hunter as the "daughter of slaves."

Ann Brittain visited the artist several days before Thanksgiving in 1987. Hunter was weak, but she continued to paint. Brittain bought what she felt sure was Hunter's last picture, a bouquet of zinnias. "They [the flowers] are very bright—yellow, blue, red. It's bright," she told a newspaper reporter.[3] Brittain's picture may not have been Hunter's last. Edward Ward called on Hunter in December at her home a few days before she was hospitalized for the last time. He too bought a painting, a washday scene, that he was certain was the artist's last effort because the paint was not yet dry.

Fig. 30. *Zinnias*. Ann Brittain thought this painting she bought a few weeks before the artist died might have been Hunter's last picture. As it turned out, it could have been Hunter's penultimate work, but it was not her final painting. ANN AND JACK BRITTAIN & CHILDREN.

Fig. 31. *Washday.* Possibly Hunter's last picture. Ed Ward bought it from the artist a few days before she was hospitalized for the last time. ED WARD.

No one doubts the artist painted almost every day from her first attempt in the late 1930s until just a few days before her death. She once told a reporter for the *Dallas Morning News:* "I just paint what comes in my mind, I don't know if it's good or bad; I just paint."[4] And paint she did. No one will ever produce a catalogue raisonné; it would be impossible. Hunter painted on hundreds of objects and created thousands of paintings on boards, paper, cardboard, and canvas. No accurate count exists, and it never will. More than five thousand paintings and objects originated from the hand of Clementine Hunter.

The recitation of the Holy Rosary took place at 8 p.m., January 4, at the Winnfield Funeral Home in Natchitoches. At the wake Hunter's body lay in the casket she had purchased several years earlier with money she earned from selling her art. About the purchase of her casket she proudly proclaimed: "I bought my own casket . . . I went and picked out what I want. It's a nice one."[5] Flowers surrounded the bier at the wake, but there were none of her favorite

zinnias. Zinnias are a summer flower, and Hunter died during an especially cold period of winter.

More than two hundred of Hunter's friends and family came for her funeral mass at the historic St. Augustine Catholic Church on Isle Brevelle. Cars filled the church parking lot and lined the roadside along the Cane River. A television news truck with a giant satellite dish beamed the event back to WBRZ-TV in Baton Rouge. All of this was taking place within a mile of the little cabin with no plumbing or electricity where Hunter first discovered her talent.

The fifth of January was a dark, cold day in 1988, the kind of day Hunter was known to dislike. The white steeple of St. Augustine's, the church so familiar in Hunter's many Cane River funeral and baptism paintings, pointed on this day toward a gray and overcast sky. Inside the church Ann Brittain placed a Cane River funeral painting from her collection against the altar above the casket where Hunter's body lay.

Father Tom Miller, the church's pastor, celebrated the Holy Mass. Bishop John C. Favalora and eight other priests also attended the service. Reverend Miller told the mourners that Hunter's art "was a total extension of who she really was." "I believe she accepted her talent from God as a gift and gave it to us," he said.[6]

Fig. 32. St. Augustine Catholic Church parking lot during Hunter's funeral. A few miles from here the artist once painted by kerosene lantern. On the day of her funeral a satellite truck beamed her service back to a Baton Rouge TV station. ANN AND JACK BRITTAIN & CHILDREN.

Fig. 33. Bishop John C. Favalora and eight other priests celebrated a high funeral mass for Clementine Hunter. ANN AND JACK BRITTAIN & CHILDREN.

Diana Davis, one of Hunter's fifty-seven great-grandchildren, read an original poem she wrote for the occasion. "We know times were hard, for you have told us so, and you showed it in your paintings, so the world would know," Davis said. "For this day that you painted, was already in mind. The things that you have gone through—this life and time." She ended with "Though your presence may be gone, your smile lingers on."[7]

The service concluded with the priests leading the way to the back of the chapel. The pallbearers rolled Hunter's bier to the front door of the church, and it passed under the great portrait of Nicolas Augustine Metoyer, Marie-Thérèse Coincoin's son, who had donated the land and established the original church on this site for free men of color. The famous painting of the Grandpère of the Isle of Brevelle hangs today in the church's atrium, but on the day of Hunter's funeral, it hung in the rear of the sanctuary high above the church's double doors.

The mourners joined in behind the ornate casket as it was carried out of the church into the cold drizzle and along the narrow sidewalk to the mausoleum space Hunter had purchased with money she made from selling her

paintings. The priests delivered the final departing prayers of the Rite of Committal: "So let us commend our sister Clementine Hunter to the Lord, that the Lord may embrace her in peace and raise up her body on the last day."[8] The mourners joined in one final prayer, and the service ended. Her friends and family departed, seeking shelter from the cold, damp day. Clementine Hunter, the domestic servant who told the story of her life with her art, had become the most famous person to live and die along the banks of Cane River.

Hunter's final resting place is contiguous with that of her friend and mentor François Mignon. Now and into eternity their remains lie side by side in the historic Isle Brevelle cemetery.

Fig. 34. Hunter and Mignon's mausoleum space. THOMAS N. WHITEHEAD.

# Fakes, Forgeries, and the FBI

Ms. Hunter was a gem of the State of Louisiana.
Her artwork was her legacy to all of us.
—Stephanie A. Finley, United States attorney

JOSEPH BARABE PEERED INTENTLY into the eyepiece of a powerful, enhanced microscope. Magnified several thousand times, he meticulously studied the canvas, the strokes, and the chemistry of one of Clementine Hunter's paintings of African House. Barabe, director of scientific imaging for McCrone Associates, scanned the painting and examined the tiny pigment cracks, called "craquelure," that result when oils shrink as they age. Other chemical tests allowed for an almost exact estimation of the age of the paints used.

The FBI retained McCrone Associates, an internationally recognized firm experienced in microanalysis and materials characterization, to address authenticity questions surrounding questionable paintings. The data Barabe collected from proven Hunter originals were compared with data from paintings thought to be forgeries.

In addition to McCrone Associates, the FBI also hired another international expert, James Martin, to examine the questionable paintings. Martin employed forensic technology to study Hunter's art and provide authentication. Martin, founder of Orion Analytical, a materials analysis and consulting firm, often assisted the Federal Bureau of Investigation. Martin had once taught federal agents paint analysis and infrared spectroscopy at the FBI Counterterrorism and Forensic Science Research Unit. Martin ran an extensive analysis of Hunter's paintings as well as those in question.

Other than Barabe and Martin, Frank Preusser was the only other expert who had looked so closely at the works of the Cane River artist. Four years earlier Tom Whitehead, Jack Brittain, and Shelby Gilley privately hired Pre-

usser, a West Coast expert in art authentication for museums, to determine if the materials used in the dubious paintings were consistent with those used by the artist. Preusser's analysis provided the first scientific proof that forgeries of Hunter's art existed.

Presented with Preusser's conclusion and the mounting circumstantial evidence, the FBI special agent Randolph Deaton agreed to investigate the claims that criminals were selling fake paintings as original works by Clementine Hunter. Preusser, Barabe, and Martin, the three most recognized experts in America skilled in identifying art forgery, examined Hunter's art and the paintings in question. Each one, using separate methodology for authentication, reached the same conclusion.

Undertaken more than twenty years after her death, the FBI investigation was the most extensive examination ever made of Hunter's art. An artist imparts a unique "fingerprint" when creating a work of art. In Hunter's case the fingerprint was not only figurative but also often literal. Because Hunter never used an easel, she usually left her fingerprints around the back edges of

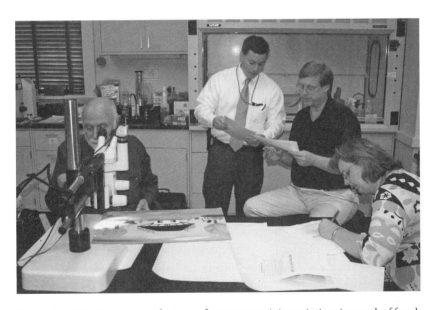

Fig. 35. Agent Deaton oversees the team of experts examining paintings in search of fraud. *Left to right:* Joseph G. Barabe from McCrone Associates; F.B.I. special agent Randolph Deaton IV; and Kirk Cordell and Mary Striegel from the National Center for Preservation Technology and Training. THOMAS N. WHITEHEAD.

the board or canvas she was painting. The prints left by her oil-stained fingers provide inarguable proof that a painting is indeed a work by the artist, but Deaton's investigation searched for more than just fingerprints.

For centuries it was all but impossible to prove a painting was beyond doubt a fake. With today's advanced, digital technology that is no longer the case. Forgers do not attempt to deceive with well-known paintings; they usually create fakes "in the style of" the artist. No matter how talented the criminal, whether it is fine art or folk art, the perfect fake or forgery does not exist.

When the data from the tests ordered by the FBI were compiled and interpreted, the results confirmed that a large collection of paintings existed that, while created by the same hand, had not been painted by Clementine Hunter. At last exhaustive, conclusive examinations by scientists using accepted techniques for authentication confirmed without a doubt what Hunter scholars had long suspected: someone was mimicking Hunter's style. Well-executed fakes were being introduced into the growing commercial market for Hunter's art. Even more important than the monetary theft, collectors and scholars recognized the insidious damage being done to the integrity of Hunter's oeuvre.

The successful sale of fake art depends on a conspiracy of mendacity and deceit. Painters talented enough to create convincing fakes usually do not work alone. A forgery also needs a believable and seemingly valid provenance. Ultimately, the painting must be sold to an unsuspecting buyer. Money, after all, is the motivation for the crime.

## Prevarication, Deception, and Cat Hair

Keaty Drive in Baton Rouge, Louisiana, is a short street located in a manicured, middle-class neighborhood. Sandwiched between the Baton Rouge Country Club to the northwest and Interstate Highway 12 to the southeast, Keaty Drive has little traffic; children safely play catch in the street. There is a two-story older house with a brick facade, overgrown with shrubs and large trees, that stands out from the mostly single-story, ranch-style homes that line the street. A visitor to the house once described it as "scary."[1] It was at this house, the residence of William and Beryl Toye, that on the morning of September 30, 2009, a squad of federal agents under the direction of FBI special agent Randolph Deaton disrupted the solitude of Keaty Drive. In a matter of minutes a police car, an ambulance, and a fire truck joined the dozen or so unmarked

federal cars successfully blocking the normally quiet street in front of 9054 Keaty Drive, the Toye's house. Armed with a search warrant issued by the United States district court, the agents spent hours collecting evidence to support the charge that Toye and his wife, Beryl, were responsible for creating and selling fake Clementine Hunter paintings.

The Toyes were far from a normal, elderly couple. Their bizarre, eccentric lifestyle suggested traces of insanity liberally punctuated with criminality. They lived in squalor. The house was piled with junk and overrun with cats. Their feline obsession resulted in urine-soaked carpets that produced an overwhelming stench.[2] It came as no surprise when one of the scientists examining the fake Hunter paintings under a microscope found a cat hair embedded in the paint.

While Toye now suffers from early stages of geriatric dementia, he has always demonstrated traits associated with bad character. He once borrowed money from a neighbor who had befriended him, paying him back with worthless art that Toye claimed was original work by Clementine Hunter.[3] He pulled the same scam on one of his doctors, paying his bills with worthless paintings he presented as original works by Hunter. As late as 2006, when a Baton Rouge bank turned down his request for a loan, Toye apparently convinced the banker personally to loan him money using fake Hunter paintings as his collateral.[4] The loquacious eighty-year-old Toye incessantly spun tales about his careers as an artist, symphony conductor, composer, and builder of opera sets. He claimed personal friendship with famous painters such as Jackson Pollock.[5] Little of what Toye claims is true. "It's like they're scripting their own reality," said Shannon Foley, a New Orleans art dealer scammed by the Toyes.[6]

Beryl Toye told authorities she had collected the Hunter paintings during many trips she made alone to Melrose in the late 1960s to visit the artist. She said her husband did not like Hunter's art and never painted in Hunter's style. There is, however, no evidence Beryl Toye ever met Clementine Hunter. While William Toye may or may not have appreciated Hunter's art, there is overwhelming evidence that he maliciously created paintings in Hunter's style and sold them as originals.

Over the past forty years the Toyes had had numerous encounters with the law. In 1969, in New Orleans, Toye collected a questionable insurance payment for paintings he had valued at over twenty-seven thousand dollars that he said had been destroyed when someone broke into his apartment. They were accused in 1996 of consigning forgeries in the style of Matisse and De-

gas to a now defunct Baton Rouge auction house. In 1974 he was charged by New Orleans police with twenty-two counts of forgery for allegedly creating paintings in the style of Clementine Hunter and forging her unique signature. Hunter, who was still alive in 1974, confirmed to New Orleans Police Department (NOPD) detective Roma Kent, when shown the Toye paintings, that she had not painted them. In spite of the evidence, Toye was released on bond, and the 1974 case never went to trial.

During the 2009 investigation FBI agent Deaton contacted NOPD detective Kent, who recalled traveling to Natchitoches and showing the fake paintings to Clementine Hunter. Kent also revealed that when she was in the Toye house in 1974, she witnessed William Toye drying in the kitchen oven a painting in the style of Clementine Hunter. Undaunted by the 1974 charges, Toye began to turn out Hunter fakes again around 1999 and forge each one with the artist's unique monogram. Up until sometime in 2005 Toye regularly sold his supply of worthless Hunter look-alikes to a New Orleans art dealer.

## Mr. Unlucky, the Art Dealer

Along with the Toyes the FBI affidavit also named Robert Lucky Jr., a well-known New Orleans art and antiques dealer who once owned and operated a gallery in Natchitoches. At the time of the 2009 affidavit Lucky no longer lived in Natchitoches but worked in New Orleans for M. S. Rau, an antiques gallery located on Royal Street in the French Quarter. His association with Rau apparently provided Lucky with a legitimate cover under which he continued his illicit art business. The M. S. Rau Company was not aware of Lucky's illegal art sales, and Rau was never implicated in the Hunter forgery case. Some of the Hunter paintings Lucky sold were bona fide, but many were not. He bought fake Hunter paintings from William and Beryl Toye and lied to customers about the origin of the paintings. FBI agent Deaton confirmed that Lucky intentionally misled buyers about the provenance of fifty to a hundred paintings he sold across the United States, with most being sold in Arkansas, Louisiana, New York, and Texas.

Lucky had a history of legal problems. The New Orleans Hunter collector Robert Ryan was forced to have Lucky's wages garnished in order to collect money for paintings he had sold for Ryan in 2000. In another case Lucky was arrested and charged with taking payment but not delivering Hunter paint-

ings a client had purchased. When challenged by buyers who discovered they had been deceived, Lucky initially returned the customer's money; later on he stopped doing that. The investigation established beyond a doubt that Lucky resold the same tainted paintings to other unsuspecting clients even when he knew they were not bona fide works from the hand of Clementine Hunter. The same fake paintings showed up again and again. Before the FBI entered the case, Shelby Gilley and Tom Whitehead had determined the counterfeit paintings were coming from Lucky, but they did not know who painted the fakes. The connection to Toye came quite by accident.

### The Aha Moment

In 2006 Gilley and Whitehead were shown a painting acquired from a prominent Baton Rouge businessman and art collector, Don Fuson. They recognized it was a fake Hunter, but more important, it clearly was the work of the same artist who had painted the forgeries being sold by Robert Lucky. Fuson said he was unaware the painting was fraudulent. In fact, Fuson told Gilley and Whitehead he had paid some thirty thousand dollars over a couple of months for an additional eighteen paintings, all from the same source.[7]

Don Fuson was not a folk art collector, but when approached by an old man who convinced him he and his wife were victims of Hurricane Katrina and needed to sell their Hunter art collection, Fuson felt compassion for the old man and agreed to buy the paintings.[8] Fuson identified the person from whom he bought the paintings as William Toye of Keaty Drive in Baton Rouge.

Fuson was not the only person Toye conned; after Lucky stopped buying from the Toyes around 2005, Toye started selling the forgeries himself. It soon became clear to Agent Deaton that Toye had sold worthless paintings to at least two other dealers in New Orleans and Baton Rouge. Eventually, the FBI search found fake Clementine Hunter paintings in outstanding private collections in several states as well as in a major midwestern museum.

Art dealers, private collectors, and auction houses are aware that several hundred fake Hunter paintings have yet to be located. The counterfeit paintings are gradually being identified as former clients of Robert Lucky learn of the Hunter art scam and come forward seeking authentication of their purchases. While Lucky also sold legitimate Hunter works, there is no indication William or Beryl Toye ever owned an authentic Clementine Hunter painting.

While there were no other known operations as large, as sophisticated, and as professionally criminal as the Toye/Lucky caper, there have been other forgers.[9] Random attempts to pass fake Hunter paintings turn up occasionally on eBay and other online sources. These paintings are poorly done and easily identified as illegitimate. Fake Hunter paintings occasionally show up for sale from as far away as France and Russia. Most of the larger attempts to copy the artist's art have either shut down or have been discouraged by increased public awareness.

## Case Closed

The evidence of crimes committed by the Toyes and Robert Lucky was presented to the attorney general of Louisiana, the U.S. attorney in the Middle District of Louisiana, the FBI office in Baton Rouge, the FBI office in Lafayette, the office of the sheriff of East Baton Rouge Parish, and the district attorney of East Baton Rouge Parish. All law enforcement officials contacted agreed egregious and illegal acts were probably committed, but no office seemed to understand the significance of the potential crimes, and no one agreed to take legal action.

That changed when the first assistant U.S. attorney in the Western District of Louisiana, Alexander C. Van Hook, and Randolph J. Deaton IV, special agent, FBI, Alexandria, Louisiana, heard the evidence and agreed to take the case. Van Hook and Deaton immediately recognized the importance of protecting the Hunter legacy. Agent Deaton mounted the remarkably detailed investigation, and as a direct result of his efforts, indictments were ultimately handed down.

After months of denial and many hours of negotiation, even when presented with irrefutable evidence, William Toye finally admitted guilt and accepted a plea bargain offered by the courts in the spring of 2011. He agreed never to paint again. Toye and his wife were each sentenced to two years' probation and ordered to pay $426,393 in restitution. Due to Toye's age and failing health, he may well live out his remaining years in a Baton Rouge nursing home. There is little chance, if any, he will ever be able to pay the restitution demanded by the court. Beryl Toye was ordered to remain with him in the nursing home for at least a year. Their home in Baton Rouge may be beyond repair, with destruction as the only alternative.

It is likely that lawsuits may surround the Toyes for the rest of their lives because others they scammed are seeking financial restitution. The U.S. Department of Immigration and Naturalization Service may eventually deport Beryl Toye, who is not a U.S. citizen, to her native England.

Robert Lucky Jr. was dismissed from M. S. Rau when the news of his criminal activity became public. He was ultimately indicted on one charge of mail fraud. He pled guilty, and on January 3, 2012, was sentenced in Alexandria, Louisiana, by U.S. district judge Dee Drell to twenty-five months in federal prison and ordered to pay $326,893 in restitution. Once out of prison, the court ordered that Robert Lucky be under supervised release for three years and serve two hundred hours of community service.

The federal government has prosecuted numerous art forgery cases over the years, but usually the crimes have involved old masters by famous artists. Rarely has there been a federal prosecution of self-taught art forgeries. The Toye/Lucky forgery cases recognized works by self-taught artists as a legitimate art form. Van Hook and Deaton's efforts underscored the integrity of Hunter's art and, in doing so, extended to folk art and self-taught artists oversight traditionally granted only to artists who produced what is called "fine art." Art publications, blogs, and national and international media realized the importance of the case and gave it extensive coverage.

John Ed Bradley, the well-known Louisiana author, is writing a book about the Toyes. There has been talk of a possible movie. Those who remember Mignon chuckle and say, "Oh my, wouldn't François have loved all this!"

# The Evolution of Hunter's Signature
## Dating Hunter's Art

SERIOUS STUDENTS OF CLEMENTINE HUNTER'S art are aware that the artist's signature evolved over the years. This evolution of signatures proves to be a beneficial tool when dating the various stages of Hunter's works. Initially, she did not sign her paintings. This unsigned period continues from her earliest days until around 1946, after William Haygood of the Rosenwald Fund advised James Register to "try to get Mrs. Hunter to work out some kind of signature." To address that concern, Register, using mostly yellow paint, personally signed *Clémence* to the collection of paintings he held in Oklahoma (fig. 36). Register signed *Clémence* to subsequent paintings he received from Mignon. He continued this unorthodox and misleading activity for several years. The signature *Clémence* all but guarantees the work is an early Hunter that was originally unsigned.

Fig. 36

Fig. 37

Transition from one period of the artist's signature development to the next is difficult to date exactly, but around 1950 she began to sign her works with a simple *CH* (fig. 37). How she began using her initials is not certain; Mignon taught her how to draw a *C* and an *H*. During most of the 1950s Hunter signed her works in black with the simple *CH* monogram.

## The *C* Turns Around

Fig. 38

In the early 1960s Hunter began to reverse the *C* in her signature and to include a space between the *C* and *H* (fig. 38). These changes in signature can be used to date Hunter's art within a five- to ten-year period, but the transitions are gradual and never exact. There are even works for which, for no apparent reason, she used a signature from an earlier period. The reversed *C* characterized her signature from around 1960 until her death, but the changing relationship between the reversed *C* and the *H* provides yet another means of dating the artist's periods of development.

The abstract paintings Hunter produced under the direction of James Register were created during 1962 and 1963, the period of the reversed *C* signature. Noteworthy on the Register abstract paintings are the markings on the back of the pictures. There were at least two rubber stamps: one with "J. Register" and a second stamp with "Artist: C Hunter" with the word *Owner* printed beneath it. Register also used marking pens to add date, title, number, and ownership.

Two different reasons have been given for Hunter's decision to reverse the *C* in her signature. The story told most often is that the artist turned the *C* around because it looked more inviting, like open arms. There

is no confirmation this story is true. Hunter said she turned the *C* around when she realized that Cammie Henry's initials were the same as hers. She did not want anyone to conclude mistakenly that Miss Cammie had painted the pictures, so she turned the *C* around.

## The *C* Makes Contact with the *H*

Fig. 39

Between the years 1966 and 1970 Hunter allowed her reverse *C* to come in contact with the *H*, with the crossbar of the *H* linking to the *C* (fig. 39). The contiguity of the two letters is further emphasized when in the mid-1970s she eventually allowed the crossbar of the letter *H* to pass freely through both the *C* and the *H*. This form of her signature was used on paintings done between about 1970 and 1975.

Fig. 40

In the 1970s, when living in Louisiana, James Register decided to sell some of his collection of early paintings. He took many of the works on which he had signed *Clémence* and penciled in a reverse *C* and *H* monogram, her normal signature at that time (fig. 40). Register probably wanted to confirm to potential customers who expected to see the reverse *C* and *H* as proof of authenticity that the work was indeed from the hand of the increasingly famous artist.

Fig. 41

Between 1970 and 1972 Hunter painted the year on some works but not all (fig. 41). Because she did not understand numbers, someone had to teach her how to draw the numbers for the date. There is no record to confirm who influenced her to add the year, but it was probably Robert Ryan. Mignon was no longer living at Melrose, and Ryan often visited Hunter during that period. Confusion resulted when Hunter did not

Fig. 42

know when the year changed that she had to change the date. At some point in 1972, she discontinued the practice of dating paintings.

## Hunter Superimposes the *C* over the *H*

The progression of the *C* in Hunter's signature continued moving toward the *H*, and around 1980 she completely superimposed the reverse *C* over the *H* (figs. 42 and 43). This reverse *C* over *H* monogram became her normal signature and continued for the rest of her life (fig. 44).

Fig. 43

Fig. 44

# Notes

### Foreword

1. The title *Louisiana Journal* was later changed to *Plantation Journal*.
2. Woodward, "Telling Stories," 4.
3. Ramsey, "Melrose Murals Are Unveiled."

### Preface

1. Eichstedt and Small, *Representations of Slavery*. Eichstedt and Small spent months visiting southern plantations, taking the public tours, and recording the observations made by docents.
2. Ibid.

### Chapter 1

*Note to epigraph:* Quote from a WBRZ-TV (Baton Rouge) television news report, May 17, 1985.
1. Hunter, audiotape interview by Bailey, 1976.
2. Mignon, Correspondence, folder 86, May 1955.
3. Walker, "Artist Given Honorary Degree."
4. Whitehead private collection; transcript of an interview for a television documentary, Simmons interviews Mildred Hart Bailey and Ann Brittain, 1992.
5. Letters in Whitehead's personal Hunter archive.
6. Bailey, transcript of interview, 1992.
7. Transcript of Orze's remarks in Whitehead's personal Hunter archive.
8. Bailey, transcript of interview, 1992.

### Chapter 2

*Note to epigraph:* Hunter, audiotape interview by Bailey, 1976.
1. Bailey, transcript of interview, 1992. Most sources for Hunter's genealogy cite writings from François Mignon. The source for this information is Bailey's recorded interviews with Hunter.

2. While it was well-known that Harriet Beecher Stowe spent a few months of her youth visiting Hidden Hill Plantation, it may not have been the only place from which she received inspiration for her fictional plantation, Little Eva. Hidden Hill Plantation, where the artist's parents worked when she was born, was nevertheless considered by many to be the model for Little Eva. Stowe may have based her character Simon Legree on the real-life plantation owner Robert McAlpin, but there is no proof. For a detailed and fascinating account of *Uncle Tom's Cabin,* see D. B. Corley's 1893 *A Visit to Uncle Tom's Cabin,* www.iath.virginia.edu/utc/articles/n2esdbcat.html.

3. Tom Whitehead personally located Hunter's baptismal records. Others who had searched for them failed, and Hunter was under the impression they had burned.

4. Mignon, Journal, September 18, 1949.

5. Hunter, audiotape interview by Bailey, 1976.

6. Doyle, "Theory of Synergy."

7. Hunter, audiotape interview by Bailey, 1976.

8. Ibid.

9. Hunter seldom spoke of race. This is her earliest observation of having to deal with racially inspired issues.

10. Hunter, audiotape interview by Bailey, 1976.

11. Ibid.

12. Ibid.

13. Ibid.

14. Bailey, transcript of interview by Simmons for a television documentary, 1992.

15. Hunter, audiotape interview by Bailey, 1976.

16. Ibid.

17. Register, "Clementine Hunter and the World around Us."

18. Mignon, Journal, April 7, 1946.

19. Mildred Hart Bailey Collection, box 1, handwritten note from James Register to Bailey: "Some of her [Mary Frances LaCour] paintings resembled the style of Clementine Hunter. However, Mary had her own style, she translated her own mental imagery to her paintings, evoking other places, other worlds. Dreams, dreams of better things."

## Chapter 3

*Note to epigraph:* Seale, Deblieux, and Guidry, *Natchitoches and Louisiana's Timeless Cane River,* quoted by Robert Harling in intro., 2.

1. Ibid.

2. Ibid.

3. Gregory, *Southern Diaspora.*

4. Mills, *Forgotten People.*

5. Morgan, MacDonald, and Handley, "Economics and Authenticity," 46.

6. Harling, intro., in Seale, Deblieux, and Guidry, *Natchitoches and Louisiana's Timeless Cane River,* 2.

7. Doris Ulmann photographed Hunter in the 1930s. Mignon sent the photograph to James Register in Oklahoma in 1945. "And the photo of the girl friend [Clementine Hunter] by Miss U.

[Ulmann] was the dearest kind of treasure," he wrote Mignon. That picture was included in a box of items purchased from Register by Gladys-Marie Fry, who at the time taught in the Department of English at the University of Maryland. In an August 13, 1973, letter to Ann Brittain, Fry said she was making arrangements for "Black Studies" to buy the material. A bill of sale listing the items confirms the transaction took place. At the authors' request the University of Maryland searched for but could not locate the material. Fry has since retired, and repeated attempts to reach her failed. It is not known what happened to the Ulmann photograph of Clementine Hunter.

8. Register, "Clementine Hunter and the World around Us."

9. Handwritten note by Cammie Henry in a Melrose scrapbook, Cammie Henry Research Center, Watson Library, Northwestern State University.

10. Hayes and Boardman, "Meatpies, Magnolias and Murals."

## Chapter 4

1. Mignon, Journal, folder 260, 1939.

2. Brittain, interview, 2003.

3. Ford, "François Mignon."

4. Ibid.

5. Ibid.

6. Ibid.

7. Ibid.

8. Mignon's passport was found among his belongings after his death.

9. These papers are in the Whitehead archives.

10. Brittain, interview, 2003.

11. Morgan, MacDonald, and Handley, "Economics and Authenticity," 52.

12. Quote from Fred Urban, former board member of Association for the Preservation of Historic Natchitoches (APHN) and retired member of Daniels Faculty of Architecture, Landscape and Design at the University of Toronto, 2010.

13. Morgan, MacDonald, and Handley, "Economics and Authenticity."

14. Mignon, Journal, December 19, 1939.

15. Mignon, *Plantation Memo,* 99–100.

16. Hunter, audiotape interview by Bailey, 1976.

17. Mignon, Journal, July 15, 1949.

18. Kogan, "Clementine Hunter," 193.

## Chapter 5

1. Register and Lioret, telephone interview, 2010.

2. The authors confirmed this information in 2004 by researching old personnel records in the University of Oklahoma archives in Norman.

3. Mignon, Correspondence, September 18, 1949.

4. Fletcher, "Negro Speaks."

5. Ascoli, *Julius Rosenwald*. 217.

6. Edith Mahier, letter to Cammie Henry, December 27, 1943, Cammie Henry Research Center, Watson Library, Northwestern State University.

7. Mignon, Journal, June 4, 1944.

8. Mignon, Correspondence, March 19, 1945.

9. Ibid., October 27, 1945.

10. Ibid., November 7, 1946.

11. Ibid.

12. Ibid., 1955.

13. Ibid., March 22, 1946.

14. Ibid.

15. Ibid., 1955.

16. Ibid.

17. Ibid.

18. Register, "Those Things Make My Head Sweat."

19. Mignon, Journal, January 27, 1963.

20. Register, "Those Things Make My Head Sweat," quoting Hunter.

21. Most, if not all, of the paintings Register received in Oklahoma were on paper. Shipping boards between Norman and Melrose certainly would have been more difficult, whereas paper could be wrapped and shipped. These early works are the ones on which Register painted *Clémence*. Later, before the paintings were put up for sale, it is thought that Register himself used pencil and copied the familiar Hunter monograph. Hunter works from this period that did not travel to Norman do not reflect Register's signature tampering.

22. Kathleen Register moved from Natchitoches after the divorce. She died at age seventy-seven in 1976. She willed her estate to the Kathleen Elizabeth O'Brien Foundation. Her expressed intention was to establish a wildlife preserve to fund perpetual care of the Bluff Plantation property and the family burial sites. Art Shiver visited the site in the summer of 2010 and discovered it had become a private hunting preserve, the opposite of what she intended. Kathleen O'Brien is buried under a grove of oaks in the family plot on the old Bluff Plantation grounds. There is no indication on her gravestone or in the name of her foundation that she ever carried the Register name.

23. Lavespere's account was related in conversation with Tom Whitehead.

## Chapter 6

*Note to first epigraph:* Bailey, transcript of interview, 1992.
*Note to second epigraph:* Yelen, *Passionate Visions*, 259.

1. Mignon, Journal, folder 260, 1939.

2. Ibid.

3. Ibid.

4. Oaks, "South's Very Own Grandma Moses Nears 100."

5. Bradley, e-mail to Shiver, March 29, 2009.

6. Ibid.

7. Comment made by the artist to Tom Whitehead.

8. Mignon, Correspondence, March 19, 1945.

9. Bailey, transcript of interview, 1992.

10. Hunter, audiotape interview by Bailey, 1976.

11. Oaks, "South's Very Own Grandma Moses Nears 100."

12. Brittain, interview, 2003.

13. Bailey, transcript of interview, 1992.

14. Hunter always used the term *mark a picture* to refer to painting a picture.

15. Mignon, Correspondence, 1944.

16. Gilley, *Painting by Heart,* 65.

17. Kallir, *Grandma Moses.*

18. Hunter was often called the "black Grandma Moses," but where the expression originated has not been confirmed.

19. Bailey, transcript of interview, 1992.

## Chapter 7

*Note to first epigraph:* Tiller, "Cultural Significance," 63.

*Note to second epigraph:* Kogan, "Artistic Significance of the Murals," 59.

1. Mignon, Journal, June 1, 1955.

2. McNaughton, "African House, a Brief History," 2.

3. Hayes and Boardman, "Meatpies, Magnolias and Murals."

4. Mignon, *Plantation Memo.*

5. Gregory, *Southern Diaspora.* 21.

6. Mignon, Journal, June 1, 1955.

7. Ibid.

8. Ibid.

9. Dallow, "Curious Collaboration."

10. Mignon, Journal, June 6–July 21, 1955.

11. Ibid.

12. Ibid.

13. Edward Ward, interviewed by the authors, Natchitoches, La., 2011.

14. Mignon, correspondence, letter to Robert Wilson, June 21, 1959.

## Chapter 8

1. Mignon, Journal, July 5, 1955.

2. Yelen, *Passionate Visions,* 259.

3. Jack, "Clementine Hunter's First Oil Painting," www.clementinehunterartist.com.

4. Jack, e-mail, 2011.

5. Ibid.

6. Mignon, Journal, June 10, 1953.

7. Personal comment from Whitehead recorded by Art Shiver.

8. Mignon, Journal, January 6, 1957.

9. Rivers, "Clementine Hunter." Rivers's thoughtful and fresh analysis of Clementine Hunter's Catholicism is both scholarly and enlightening.

10. Hunter, audiotape interview by Bailey, 1976.

11. Jack, interview, July 29, 2003.

12. Brittain, interview, 1992.

13. Rivers, "Clementine Hunter," 158.

14. Mignon, Journal, May 29, 1953.

15. Rivers, "Clementine Hunter," 160.

16. Mignon, Journal, November 17, 1955.

17. Bailey, transcript of interview, 1992.

18. Gilley, *Painting by Heart*, 83.

19. Oaks, "South's Very Own Grandma Moses Nears 100."

20. Doyle, "Theory of Synergy."

21. Mignon, Journal, December 5, 1945.

22. Ibid.

23. Ibid.

24. Fry, "Not by Rules but by Heart," 20.

25. Ibid., 21.

26. Ibid.

27. Kogan, "Clementine Hunter," 190.

28. Gilley, *Painting by Heart*, 73.

## Chapter 9

*Note to first epigraph:* Delatiner, "Lanford Wilson Tries a New Role," 8.

*Note to second epigraph:* Wadler, "Regrets Only."

1. Saxon, *Friends of Joe Gilmore*, 33.

2. Harvey, *Life and Selected Letters of Lyle Saxon*, 107.

3. Tom Whitehead discovered this rare Hunter painting in the Louisiana State Library in 2011.

4. Mignon, Correspondence, 1953.

5. Meek, *Clarence John Laughlin*, 86–87.

6. Laughlin's 1952 memo was among the notes used by Winfield in promoting and writing the brochure for the Saturday Gallery show, Winfield Papers, 1921–86.

7. Wright, *Discovering African American St. Louis*.

8. Winfield Papers, 1921–86.

9. Winfield, interview by the authors, August 20, 2004.

10. Confirmed by the authors by telephone, 2005.

11. "Oils by Primitive Painter at Riverfront Art Gallery."

12. Winfield Papers, 1921–86.

13. Mignon, Correspondence, June 1955.

14. Mignon, Journal, June 2, 1955.

15. Gilley, *Painting by Heart*, 123.

16. Mignon, Journal, May 16, 1969.

17. Ryan, "Clementine Hunter."

18. Letter from Robert Ryan to Whitfield Jack, April 2, 1981.

19. Ryan, comment made in the 1980s to Tom Whitehead.

20. Shiver and Whitehead, *Clementine Hunter,* 64.

21. Letter to Hugh Schoephoerster from Judi Petkau, July 9, 1999.

22. Mignon, Correspondence, n.d.

23. Delatiner, "Lanford Wilson Tries a New Role."

24. Ibid.

25. Wadler, "Regrets Only."

26. Ibid.

27. Hunter, comment made in the 1970s to Tom Whitehead.

28. Cane River Art Corporation holds the copyright for all images of Hunter's art. One can legally own a Hunter painting, but one cannot own the images. Whenever a picture is reprinted, permission must be granted from the Cane River Art Corporation, Natchitoches, La. This requirement includes all the Hunter images in this book.

## Chapter 10

*Note to epigraph:* Carwile, "Clementine Hunter, Famed Folk Artist, Dies."

1. "Clementine Hunter Dies at 101," 1.

2. Ed Ward, interview with the authors, November 2011.

3. Carwile, "Clementine Hunter, Famed Folk Artist, Dies."

4. Broadwater, "Memories in Paint."

5. Gilley, *Painting by Heart,* 16.

6. Carwile, "Hunter Funeral Held, Artist Eulogized in Country Church."

7. Poem printed in the funeral program.

8. From the "Holy Roman Catholic Church Rite of Committal."

## Chapter 11

1. Bradley, "Talented Mr. Toye," 92–99. Bradley quotes Don Fuson, who said, "The house was scary."

2. Laney, "F.B.I. Investigates Fake Clementine Hunter Paintings." Laney wrote Shannon Foley of New Orleans, "The stench of cat urine hit me in the face," 24C.

3. John Ed Bradley in conversation with Tom Whitehead.

4. Laney, "F.B.I. Investigates Fake Clementine Hunter Paintings," 24C.

5. Bradley, "Talented Mr. Toye."

6. Laney, "F.B.I. Investigates Fake Clementine Hunter Paintings," 24C.

7. Ibid.

8. Bradley, "Talented Mr. Toye," 94.

9. For a detailed discussion of how to identify Hunter forgeries, as well as examples of fake Hunter paintings, see the website for this book: www.clementinehunterthebook.com.

# Bibliography

## Unpublished Sources

Bailey, Mildred Hart. Transcript of an audio interview by producer/director Katina Simmons for a television documentary, 1992.

Brittain, Ann. Interview by the authors, 2003.

———. Transcript of an audio interview by producer Katina Simmons for a television documentary, 1992.

Doyle, Lynn Deal. "A Theory of Synergy: A Quilt Related Interpretation from a Modern Louisiana Plantation Based on the Creative Process and Human Experience." Master's thesis, University of Oklahoma, 2004.

Ford, Oliver. Telephone interview by the authors, 2007.

Hunter, Clementine. Audiotape interview by Mildred Bailey, 1976.

Jack, Whitfield. E-mail to Art Shiver, 2011.

Kinsey, Alberta. E-mail from John Ed Bradley to Art Shiver, 2009.

Mignon, François. Papers. Correspondence, ser. 1. Southern Historical Collection, Wilson Library, University of North Carolina, Chapel Hill.

———. Journal, 1939–69, ser. 2. Southern Historical Collection, Wilson Library, University of North Carolina, Chapel Hill.

Mildred Hart Bailey Collection. Archives and Special Collections. Eugene P. Watson Memorial Library, Northwestern State University, Natchitoches, La.

Register, Joseph Cordill, Jr., and June Lioret. Telephone interview with relatives of James Pipes Register, 2010.

Western Historical Manuscripts Collection. People's Art Center, vol. 1, folder 1. University of Missouri, St. Louis, 1942.

Whitehead, Thomas. Clementine Hunter archives. Material collected by the author about the life and art of Clementine Hunter.

Winfield, Armand. Interview by the authors, 2004.

———. Papers, 1921–86. The Saturday Gallery, 1952–53, box 2, folder 10. Center for Southwestern Research, Zimmerman Library, University of New Mexico, Albuquerque.

Bibliography

## Published Sources

Ascoli, Peter Max. *Julius Rosenwald: The Man Who Built Sears, Roebuck and Advanced the Cause of Black Education in the American South.* Bloomington: Indiana University Press, 2006.

Bailey, Mildred Hart. "Painted Memories of a Slave's Daughter." *Modern Maturity* (October–November 1981).

Bishop, Robert, and Jacqueline Marx Atkins. *Folk Art in American Life.* New York: Viking Studio Books, 1995.

Bradley, John Ed. "The Talented Mr. Toye." *Garden and Gun* (April–May 2010): 92–99.

Broadwater, Lisa. "Memories in Paint: Folk Artist Clementine Hunter's Work Captured Life on a Plantation." *Dallas Morning News*, April 29, 1994.

Carwile, Carol. "Clementine Hunter, Famed Folk Artist, Dies." *Alexandria Daily Town Talk*, January 2, 1988.

———. "Hunter Funeral Held, Artist Eulogized in Country Church." *Alexandria Daily Town Talk*, January 7, 1988.

"Clementine Hunter Dies at 101." *Natchitoches Times*, January 2, 1988.

"Clementine Hunter to Receive Honorary Doctorate." *Current Sauce*, April 30, 1985.

Dallow, Jessica. "A Curious Collaboration: Clementine Hunter's African House Murals." In *Sacred and Profane*, ed. Carol Crown and Charles Russell, 128–45. Jackson: University Press of Mississippi, 2007.

Danforth, Kenneth. "100 Year Old Artist Still Going Strong." *San Diego Union-Tribune*, January 4, 1987.

Delatiner, Barbara. "Lanford Wilson Tries a New Role." *New York Times*, August 26, 1980.

Eichstedt, Jennifer L., and Stephen Small. *Representations of Slavery: Race and Ideology in Southern Plantation Museums.* Washington D.C.: Smithsonian Books, 2002.

"Famed Folk Artist Clementine Hunter Dies in North Louisiana." *Baton Rouge Morning Advocate*, January 2, 1988.

Fletcher, John Gould. "The Negro Speaks." *New York Times*, January 2, 1944.

Ford, Oliver. "François Mignon: The Man Who Would Be French." *Southern Studies* (Spring 1991): 51–59.

Fry, Gladys-Marie. "Not by Rules but by Heart: The Quilts of Clementine Hunter." In *Clementine Hunter—American Folk Artist*, 18–22. Dallas: Museum of African American Life and Culture, 1993.

Gilley, Shelby R. *Painting by Heart: The Life and Art of Clementine Hunter, Louisiana Folk Artist.* Baton Rouge: St. Emma Press, 2000.

Gregory, James N. *The Southern Diaspora: How the Great Migrations of Black and White Southerners Transformed America.* Chapel Hill: University of North Carolina Press, 2005.

Hanna, Mark. "Making Her Mark." *Commercial Appeal*, April 11, 1976.

Harvey, Chance. *The Life and Selected Letters of Lyle Saxon.* Gretna, La.: Pelican Publishing, 2003.

Hayes, Blake, and Katie Boardman. "Meatpies, Magnolias and Murals: A New Interpretation Plan for Melrose Plantation." Paper presented at the Conference and Annual Meeting of the Association for Living History, Farm and Agricultural Museums, Baton Rouge, 2006.

Jack, Whitfield. "Clementine Hunter's First Oil Painting," www.clementinehunterartist.com.

Joyous Coast Foundation. *Images of Natchitoches*. Charleston, S.C.: Arcadia Publishing, 2003.

Kallir, Jane. *Grandma Moses: In the 21 Century*. Alexandria, Va.: Art Services International, 2001.

King, Elaine. "Clementine Hunter, Artist, Found on a Talkative Day." *Shreveport Times*, February 2, 1975, C-4.

Kogan, Lee. "Clementine Hunter: Self-Taught Louisiana Artist." In *Louisiana Women: Their Lives and Times*, ed. Janet Allured and Judith Gentry, 175–94. Athens: University of Georgia Press, 2009.

Laney, Ruth. "F.B.I. Investigates Fake Clementine Hunter Paintings." *Maine Antique Digest*, January 25, 2010.

Lilley, Laura Kathryn. *Marking Exodus: Death and Funerals in the Religious Paintings of Clementine Hunter*. Chapel Hill: University of North Carolina Press, 2008.

Martin, Margaret. "Beloved Artist Soon to Celebrate 100th Birthday." *Shreveport Times*, January 26, 1986.

McNaughton, E. Eean. "African House, a Brief History." In *Clementine Hunter: The African House Murals*, ed. Art Shiver and Tom Whitehead, 23–27. Natchitoches, La.: NSU Press, 2005.

Meek, A. J. *Clarence John Laughlin: Prophet without Honor*. Jackson: University Press of Mississippi, 2007.

Mignon, François. "More Rue Christine Letters." *Shreveport Times*, September 11, 1972.

———. *Plantation Memo: Plantation Life in Louisiana, 1750–1970, and Other Matter*. Ed. Ora Garland Williams. Baton Rouge: Claitor's Law Books and Publishing, 1972.

Mignon, François, and Clementine Hunter. *Melrose Plantation Cookbook*. New Orleans: A. F. Laborde and Sons, 1956.

Mills, Gary B. *The Forgotten People: Cane River's Creoles of Color*. Baton Rouge: Louisiana State University Press, 1977.

Morgan, David W., Kevin C. MacDonald, and Fiona J. L. Handley. "Economics and Authenticity: A Collision of Interpretations in Cane River National Heritage Area, Louisiana." *George Wright Forum* 23 (2006): 44–61.

Morris, Steven. "The Primitive Art of Clementine Hunter." *Ebony* 24, no. 7 (May 1969): 144–48.

Oaks, John. "South's Very Own Grandma Moses Nears 100." *Fort Worth Star-Telegram*, May 8, 1985.

"Oils by Primitive Painter at Riverfront Art Gallery." *St. Louis Post-Dispatch*, December 8, 1952.

Bibliography

Ramsey, Carolyn. "Melrose Murals Are Unveiled." *Baton Rouge Morning Advocate,* September 25, 1955.

Rankin, Allen. "The Hidden Genius of Melrose Plantation." *Reader's Digest,* December 1975, 118–22.

Read, Mimi. "Clementine Hunter." *New Orleans Times-Picayune,* April 14, 1985, 6–10 and 19–21.

Register, James. "Clementine Hunter and the World around Us." *Natchitoches Times,* December 17, 1972.

———. "Those Things Make My Head Sweat." *Natchitoches Times,* February 28, 1974.

Rivers, Cheryl. "Clementine Hunter: Chronicler of African American Catholicism." In *Sacred and Profane Voice and Vision in Southern Self-Taught Art,* ed. Carol Crown and Charles Russell, 146–71. Jackson: University Press of Mississippi, 2007.

Ryan, Robert, and Yvonne Ryan. "Clementine Hunter, A Personal Story." *Louisiana Life* (September–October 1981).

Ryan, Robert F. "Clementine Hunter: Robert F. Ryan MD Shares His Reminiscences of a Unique Folk Artist." *Raw Vision* 24 (Fall 1998), www.rawvision.com/articles/24/ hunter/hunter.html.

Saxon, Lyle. *The Friends of Joe Gilmore.* New York City: Hastings House, 1948.

Seale, Richard, Robert Deblieux, and Harlan Mark Guidry. *Natchitoches and Louisiana's Timeless Cane River.* Baton Rouge: Louisiana State University Press, 2002.

Shiver, Art, and Tom Whitehead, eds. *Clementine Hunter: The African House Murals.* Natchitoches, La.: NSU Press, 2005.

Tademy, Lalita. *Cane River.* New York: Warner Books, 2001.

Thomas, James W. *Lyle Saxon: A Critical Biography.* Southern Literary Series, vol. 3. Birmingham, Ala.: Suma Publications, 1991.

Tiller, deTeel Patterson. "The Cultural Significance in the Landscape and Narrative of Clementine Hunter." In *Clementine Hunter: The African House Murals,* ed. Art Shiver and Tom Whitehead, 61–63. Natchitoches, La.: NSU Press, 2005.

Vlach, John Michael. *The Afro-American Tradition in Decorative Arts.* Athens: University of Georgia Press, 1990.

Wadler, Joyce. "Regrets Only: Bad Decorating Can Happen to Good People." *New York Times,* November 9, 2006.

Walker, Don. "Artist Given Honorary Degree." *Shreveport Times,* May 19, 1985.

Ward, Gerald W. R., et al. *American Folk.* Boston: MFA Publications, 2001.

Willard, Charlotte. "Innocence Regained." *Look* Magazine, June 16, 1953, 102–5.

Woodward, Kathleen. "Telling Stories: Aging, Reminiscence, and the Life Review." Introduction to panel discussion on "Telling Stories." Occasional Papers. Doreen B. Townsend Center for the Humanities, March 1997, http://townsendcenter.berkeley .edu/pubs/OP09_Telling_Stories.pdf.

Wright, John Aaron. *Discovering African American St. Louis: A Guide to Historic Sites.* St. Louis: St. Louis People's Art Center, Missouri History Museum, 2002.

Yelen, Alice Rae. *Passionate Visions of the American South: Self-Taught Artists from 1940 to Present.* Jackson: University Press of Mississippi, 1995.

# Index

# Index

# Index

# Index